Printing with Adobe Photoshop CS4

Tim Daly

ELSEVIER

AMSTERDAM • BOSTON • HEIDELBERG • LONDON • NEW YORK • OXFORD
PARIS • SAN DIEGO • SAN FRANCISCO • SINGAPORE • SYDNEY • TOKYO
Focal Press is an imprint of Elsevier

Focal Press is an imprint of Elsevier
30 Corporate Drive, Suite 400, Burlington, MA 01803, USA
Linacre House, Jordan Hill, Oxford OX2 8DP, UK

∞ Recognizing the importance of preserving what has been written, Elsevier prints its books on
acid-free paper whenever possible.

Library of Congress Cataloging-in-Publication Data

Daly, Tim, 1964–
 Printing with Adobe Photoshop CS4 / Tim Daly.
 p. cm.
 Includes index.
 ISBN 978-0-240-81138-3 (pbk. : alk. paper) 1. Adobe Photoshop. 2. Photography--
Digital techniques--Handbooks, manuals, etc. 3. Digital printing--Handbooks, manuals,
etc. I. Title.
 TR267.5.A3D35 2009
 006.6'96--dc22

 2009011527

British Library Cataloguing-in-Publication Data

A catalogue record for this book is available from the British Library.

iSBN: 978-0-240-81138-3

> For information on all Focal Press publications
> visit our website at www.books.elsevier.com

Typeset by: diacriTech, Chennai, India

09 10 11 12 13 5 4 3 2 1

Printed in the United States of America

Contents

Printing in CS4: An Introduction

Creative digital photography has developed a long way over the last ten years, but there's never been a more exciting time to focus on output. However, although most photographers have mastered the skills required for shooting and processing digital files, the pursuit of exhibition quality prints remains elusive for many.

Printing with Adobe Photoshop CS4 aims to provide jargon-free guidance for navigating your way through the many factors determining final print quality, so that you can produce the very best results from your files. All great photographic prints are made possible by carefully controlled capture, so we start off with Shooting Essentials. Although most minor shooting mistakes can be corrected in Photoshop, it makes a real difference if you can start your print project with a perfectly exposed raw file.

Practical Color Management centers on getting colors consistent through shooting, processing, and output, and shows you exactly what you need to do with your camera, computer workstation, and software before any editing takes place.

Nowadays, with CS4's expanded nondestructive features, there's really only one way to prepare images for print that allows maximum creative freedom. File Processing Essentials and Elective Contrast provides key advice on how to bring the very best of your original image files, followed by Creative Emphasis for giving your files a hand-printed appearance.

For those entranced by black and white, Working in Monochrome outlines the key steps for developing and drawing out tone from your files and how to mimic darkroom styles without overcooking.

Preparing for PrintOut and Printing with Profiles = start the business of matching your files to an output media, both sections assuming no prior knowledge of confusing subjects such as resolution, image size, and paper profiles. After your first test prints have emerged, Evaluating Prints helps you identify imperfections and shows you how to solve them simply.

Creative Print Styles, Creative Print Edges, and Alternative Printing kicks off a more divergent approach to making great prints, outlining many techniques for making your work stand out from the crowd. Not all prints need to be made on glossy paper, so it pays to experiment with some of the more luxurious materials on offer.

Print Functions, Preview and Soft Proofing, and Print Output Functions cover all the fine-tuning tools in CS4, helping you to elevate your files into eye-catching final prints. With an emphasis on the practical, these three sections equip you with all the skills that you'll need to drive your prepared file through the maze of printer software functions.

Paper and Media Characteristics, Printer Types, and Inks focus firmly on the numerous choices available to Photoshop CS4 users, and most important, outline the practical consequences of using them. Digital On-Demand Services, the final section, illustrates how to get the best results out of a digital press, the latest must-have output fast becoming an essential skill for photographers making photobooks, wedding albums, and short-run publications.

Tim Daly
tim@photocollege.co.uk

About the Author

Further Information

Tim Daly is Senior Lecturer in Photography at the University of Chester in the United Kingdom and teaches digital printing workshops in the United Kingdom, Ireland, and at the Rocky Mountain School of Photography in Montana.

Tim also writes for many photography magazines, including *Photo-District News (PDN), The British Journal of Photography, AG: The International Journal of Photographic Art and Practice, Outdoor Photography, Black and White Photography,* and *Better Photoshop Techniques (Aus).*

Tim also runs Photocollege, the online learning resource center, which can be found at www.photocollege.co.uk. You can contact him by e-mail at timdaly@photocollege.co.uk or through his web site: http://www.timdaly.com.

Shooting Essentials

Hardware

The final destination of your image will have a significant bearing on its preparation and final formatting.

Whether for photographic print, paper publication, or online use, images must be prepared carefully to fit within these different restrictions. Different print mediums such as inkjet or c-type photographic paper demand careful tonal processing to produce best results, without reducing perceived image quality.

Hardware Essentials

At the heart of all professional photographers' arsenal is the camera kit. A digital SLR is the single must-have device, allowing the user to change lenses and plug into a wide range of lighting, timing, and high-speed storage media. Despite the professional tag, the price of a good quality digital SLR starts at a few hundred pounds and continues into the thousands. Increasing your budget effectively means increasing the ability to capture higher and

higher resolution images, which in turn can be printed at a much larger scale. Better SLRs are built to be rugged enough to withstand daily use and have high-speed interfaces to allow faster transfer of large volumes of data. Regardless of camera manufacturer, most cameras share common internal hardware, especially the light sensitive image sensor that determines the resolution of the captured image file. Resolution is determined by the number of actual pixels created in the chessboard-like image file and is measured in megapixels, or millions of pixels.

Sensor Resolution and Print Size

There's a clear link between the cost of a professional camera and its ability to create high-resolution files. At the prosumer end of the scale, most DSLRs will create a file good enough to print out at legal size. As the sensor resolution increases (and the cost of the device), so too does the maximum print size.

A simple way of working out how big an image a camera can create is to multiply the horizontal and vertical dimensions of an image to produce the megapixel value. A six-megapixel camera at best will produce a 3000 × 2000 pixel image, which in turn can be printed out as a pin sharp 15 × 10 inch inkjet print, such as this output.

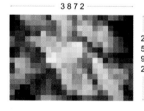

A basic DSLR creates 10 megapixels of data, which is big enough to make an 18 × 12 inch inkjet print at 200 pixels per inch.

3872

2
5
9
2

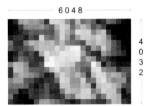

A top of the range professional DSLR creates 24 megapixels of data, which is big enough to make an 30 × 20 inch inkjet print at 200 pixels per inch.

6 0 4 8

4
0
3
2

A medium format–like camera with a digital back such as the PhaseOne SLR creates 60 megapixels of data, which is big enough to make an 45 × 34 inch inkjet print at 200 pixels per inch.

8 9 8 4

6
7
3
2

Camera Settings and Print Size

Print quality is heavily influenced by the camera settings that you choose from the outset.

Processing at the Point of Capture

When image files are first captured, they are irreversibly processed and packaged into a format by the camera's built-in software. Opting for camera settings, such as white balance, auto sharpening, and choice of file format like JPEG, determines a sequence of irreversible processing that is applied invisibly to your file. A much better option is to shoot in the RAW file format, which, although it makes greater demands on your storage media, creates an entirely unprocessed file that can be later stored in its original state and creatively interpreted in image editing software such as CS4.

Storage

The capacity of your in-camera storage media determines the number of image files that you can save on location. Storage media is available in many different formats such as Secure Digital (SD) and CompactFlash (CF), but your choice of camera will determine which one you can use. Storage media in excess of 1 Gb (gigabyte) is essential if you are shooting in the RAW file format. Like all other magnetic data media, cards are vulnerable to physical damage and valuable data is best backed up as soon as possible. There are many different options for backup storage devices for both location- and studio-based photographers. For travel, press, and public relations photographers, a handheld portable hard drive is an ideal product to dump data onto direct from your camera. This facility is also possible with a good quality MP3 player such as an iPod or a laptop. For studio shooting, image files are best stored on a large capacity external hard drive linked to your PC workstation.

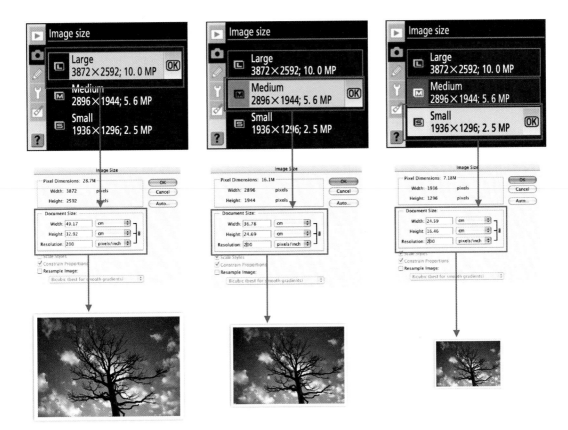

Image Size Setting

Independent from any choice of file format or presets, all digital cameras can create at least three different-sized pixel bitmaps, usually described as Large, Medium, and Small. As the above illustration shows, this choice of setting will radically alter the potential print size. Always shoot Large size, as it's easy to reduce the print size from a high-resolution original as opposed to enlarging a low-resolution file to make a bigger print than you planned.

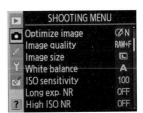

Pixels or Photosites?

Many camera manufacturers use the term *pixels* to describe the tiny individual light sensitive cells arranged on the surface of the image sensor, when a much better term for this is *photosite*. Always visualize pixels as the square blocks of color that create a bitmap image.

File Formats

Like all good inventions, common file formats such as TIFF, JPEG, and RAW were designed and launched into the world to make workflow simpler and easier for the end user.

File Formats: What Are They?

Digital data, whether contained in a word processing document or digital image file, is packaged at the point of creation into a file type or format of your choice. Your decision which one to adopt is based entirely on forward planning, i.e., you can share the file with others, send it through a network, or to preserve all of its original source information. Different types of format are identified by a three-character code called a file extension, such as .jpg or .psd, which is attached automatically on the end of your filename to help an application recognize compatible files.

RAW File Formats

Five good reasons for shooting RAW

When you want to create digital prints of the highest exhibition quality and size.

When you are shooting at high ISO values in low light.

When you are shooting a subject with a high dynamic range (extreme difference between highlight and shadow).

When you are uncertain about the color temperature of your subject.

When you want to make high-quality monochrome conversions.

RAW is an umbrella term applied to many different kinds of file format currently in development by the major hardware and software manufacturers. At this early stage, no universal format has been adopted and both Nikon and Canon have their own version of the RAW file format. Lagging behind, but rather ominously, is Adobe, who has developed the early contender for the universal format, the Digital Negative (DNG) file format. Currently, Adobe provide a free helper application to convert most types of proprietary files into the DNG format, so you can process in applications such as Camera Raw.

What's the Difference between Raw and Other Formats?

All digital cameras are fitted with a sensor, responsible for detecting light and creating a chessboard-like grid of pixels to make an image. With JPEG, TIFF, and other common formats, camera software automatically applies a range of hidden processing sequences at the point of exposure, to improve sharpness, contrast, color, and even compress data. Once captured and stored, all of these presets become embedded in your file and can never be removed, restricting your future editing and creative interpretation of your files. With RAW file formats, no such invisible processing takes place, resulting in an unadulterated file, able to cope with more hand-processing. In addition to "virgin data," RAW files also capture images with an extended 12-bit color palette, effectively making a gigantic 4096 color scale per color channel, which increases the data size considerably. In general terms, a RAW file creates 10 times as much data as an equivalent resolution JPEG.

Unprocessed Files

These two shots were taken within a minute of each other, with JPEG on the left and RAW on the right. Both images are straight out of the camera with no processing. On first inspection, the JPEG file appears slightly lower contrast and with more muted colors than the RAW version.

Sharpness Close-Up

Looking at close-up of both example files, there is little difference between the RAW and JPEG. Both files make a good job of capturing detail in the midtone areas but the RAW file does have the edge in sharpness. When all files are compressed, as happens in the JPEG saving routine, some sharpness will be sacrificed as an inevitable by-product.

RAW versus JPEG

The Latent Image Analogy

A good way to visualize the difference between RAW and JPEG is to think of the RAW file like the latent image found on a roll of exposed but undeveloped photographic film. Ready for hand-processing in special developers of your choice to enhance contrast, sharpness, or fine detail, this latent film image can be processed to your exact specifications, but once only. Similarly, the RAW file is digitally developed to match your requirements but more flexibly can be returned to its "latent" state once you've finished, ready to interpret again. Compared with the RAW file, the JPEG is a much lesser being equivalent to a drugstore processed color film where mechanical processes determine a fixed end result, which you can't alter.

Editing RAW

Like most emerging technology, the development of hardware and software to support RAW file capture is slightly out of sync with each other. As new cameras are brought onto the market, plug-in patches are released by software companies to ensure that the new files can be read by the older applications.

Repurpose Your Files

The single most important feature of shooting in the RAW format is the ability to reinterpret your original files after shooting. Exposure, color temperature, color, and tonal values can all be altered to suit your requirements after the shoot has occurred. For film photographers, this is equivalent to the ability to redevelop your negatives and reshoot on completely different film stock (without leaving the comfort of your own home)!

Five good reasons for shooting JPEG

When the end result is destined for small scale or low quality printout.

When you need a fast workflow.

When you need to produce low-resolution images for web or on-screen use.

When you need to shoot fast moving subjects in quick succession.

When the end result requires minimal processing.

After Levels and Saturation Adjustments

Each file was processed in Photoshop using exactly the same steps.
Both had an identical amount of Levels highlight adjustment and an
extra +18 Saturation edit in the Hue/Saturation dialog box. The RAW version,
above left, looks slightly warmer than the JPEG, above right, and has much
made a much better job of capturing detail in the shadow areas of the image.

Shadow Area Close-Up

This example shows the biggest difference
between both file formats: the ability to
capture detail in shadow areas. On the
left, the JPEG file merges black and near
black into one and the same, whereas
on the right, the RAW file makes a good
job of separating the same information
out. When faced with extremes of natural
lighting, RAW is easily the best choice.

Exposure Essentials

Despite the convenience of rescue tools found in digital imaging applications, there's no substitute for a perfect exposure.

How Light Meters Work

Correct exposure is achieved through the right combination of aperture and shutter speed and makes a world of difference to your final print quality. Every digital camera has a built-in light sensitive meter, which is used to determine all autoexposure functions, and on more advanced cameras, the manual exposure readout in the viewfinder. Light meters can only respond to the brightest values in your subject, regardless of their size, shape, or color and can consequently be fooled by everyday situations. Bad exposures occur when the photographer wrongly presumes that the meter knows the most important element of the picture, which of course it can't, and even a tiny light source can be the dominant influence on your meter. A perfect exposure results when the photographer guides the meter into capturing an even balance of highlight and shadow detail. Too much or too little light will have a profound effect on image detail, tone, and color reproduction in your final print.

Aperture, Shutter Speed, and ISO

These three independent variables are entirely interlinked and when one is changed, another needs to be changed to compensate. In addition to the creative consequences of using these scales, their primary function is to allow the photographer to shoot photographs in widely different lighting conditions. The ISO scale sets the sensitivity of the image sensor and works in an identical way to ISO speed in conventional film. At low-light levels, a higher ISO value like 800 is best selected, so the sensor can operate with less light than normal. At bright-light levels, a smaller value like 200 is set. On basic digital compact cameras, the ISO value is fixed but better models have a selection of different values such as 100, 200, 400, and 800. Once your sensitivity has been set, then the right combination of aperture and shutter speed is sought to make a good exposure. The aperture is found in your camera lens and is essentially a hole of varying size designed to let more or less light reach your sensor. Apertures are always a uniform size on all cameras and conform to an international scale described f numbers such as f2.8, f4, f5.6, f8, f11, f16, and f22. At the f2.8 end of the scale, an aperture is at its largest and lets in the most amount of light available. At the opposite end of the scale, such as f22, an aperture is at its smallest and lets in the least amount of light. To accompany the aperture scale is the shutter speed scale, again designed in a standardized range but in fractions of a second such as 1/1000th, 1/500th,

Stops

A stop is a photographic term used to describe a single shift along the exposure scale. The term is derived from the series of different aperture settings that were traditionally changed on the camera lens. With each shift up and down, the scale would be accompanied by an audible click stop, hence the term stop. When analyzing exposure or the quality of processed images, professional photographers refer to variations in brightness using "stop" as a key term.

1/250th, 1/125th, 1/60th, 1/30th, 1/15th, 1/8th, 1/4, 1/2, and 1s. At the 1/1000th end of the scale, the shutter remains open for short time, but at 1/2 second, the shutter remains open for long time.

In Camera Histogram

All digital SLRs and top quality compacts offer the useful benefit of a Levels histogram when an image is played back on the rear LCD preview monitor, so you can see exactly how an image has been recorded.

Where to Take Your Readings From

The most important fact to remember about photography is that the camera meter never knows which is the most important part of the image. The meter can only respond to variations in brightness, so in many circumstances you have to consciously trick the meter into behaving differently. With so many different levels of light reflecting off objects in your composition, the best exposure is a trade-off between recording simultaneous detail in both highlights and shadow areas.

Most good digital cameras have an exposure lock button located close to your shooting hand or accessible when the shutter is half-depressed. Exposure lock is a very useful device so that you can take meter readings from the important areas of your image, save the reading, and then recompose before shooting.

Metering Systems

Center-weighted metering works by making an exposure judgment based on subjects that are placed in the centre of the viewfinder. This is perfectly adequate for centrally placed compositions but can come unstuck if you intend to frame your subject's off-center. The much better matrix or segment metering system is designed to cope with the greater demands of more adventurous photographers. It works by taking individual brightness readings from the four quarters of your frame, plus an extra one from the center. These five readings are then averaged out into a single exposure reading, resulting in a better compromise between light and dark. The more complex spot metering system takes a reading from a much smaller area, typically the tiny center circle superimposed in your viewfinder. This is useful for getting accurate light readings from skin tones or other small and precise elements of a composition; a successful spot reading will emphasize this over other less important parts of your image.

There are three common metering systems used in digital cameras: center weighted on the left, matrix in the middle, and on the right, spot metering.

How to Recognize Underexposure

Underexposed images are dark, lack detail, and have muddy colors. With severe examples, so little light reaching the sensor cells has caused bright red or green error pixels called noise. On the histogram, the pixel count is high towards the left-hand side describing the large quantity of black or dark gray pixels present.

Underexposure and How It Is Caused

Underexposure occurs when too little light hits the camera sensor and causes dark images with muddy colors. Underexposed images can be rescued by imaging software, but excessive changes will result in the sudden appearance of randomly colored pixels and a deterioration in image quality. Underexposure frequently occurs when shooting in low light on automatic exposure mode, as the camera's shutter speed range may not extend beyond a few seconds. A common cause of underexposure when using flash occurs when the subject is further than five meters away, as the small burst of light is too weak to reach out to distant subjects.

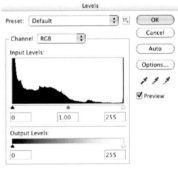

How to Recognize Overexposure

Overexposed images are bright, have little detail, and very washed-out colors. In extreme cases, so much light reaches the individual sensor cells that it spills over and influences adjacent cells, resulting in a spread-out effect called *blooming*. Overexposed images display a strong pixel count in the right-hand half of the histogram.

Overexposure and How It Is Caused

Too much light makes pale and low-contrast images with burned-out detail, which cannot be rescued by software trickery. Digital cameras rarely encounter overexposure when set to automatic exposure mode, but it can still occur if too high an ISO value, such as ISO 800, is selected under bright lighting conditions. The most common cause of overexposure with digital compacts occurs when using flash to light a nearby subject. Close-up flash can still be too much light for a small aperture value to cope with and will cause image highlights to white out. On fully manual mode, overexposure is caused by selecting a very slow shutter speed or a large aperture.

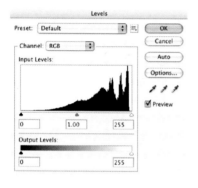

Bracketing

If you don't want to spend time worrying about achieving the right exposure with each and every shot, a sensible way to approach tricky exposure situations is to bracket instead. Adopted from the world of professional photography, many different exposure variations are taken of the same subject. Bracketing is essentially insurance against failure and even the most demanding situations can be covered within a five-shot range. Bracketing only works on stationery subject matter and is best done with your camera fixed to a tripod, so that five identical results are produced. If your camera doesn't offer an autobracketing function, you can easily do it manually using the exposure compensation dial.

Exposure Compensation and Photoshop's Exposure Dialog

A great recent addition to Photoshop is the Exposure dialog, where you can adjust the brightness of your image in the same-sized increments as camera exposure. Rather than use the abstract 0–255 scale, you can increase or decrease the brightness of an image by the values as the ± exposure compensation dial on your camera.

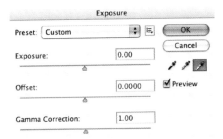

Exposure in Camera Raw

An identical tool is available in Camera Raw to enable incremental brightness adjustment.

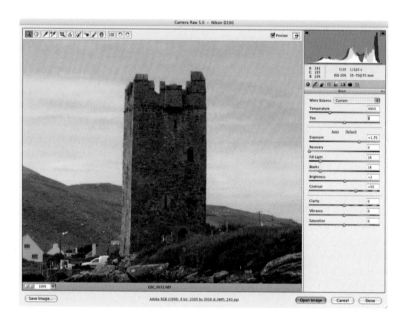

Lenses and Print Quality

Different types of lenses are described by a value called focal length, expressed in millimeters such as 50 mm or 18 mm. This measurement technically refers to the distance between the surface of the film or image sensor and a point inside the lens when it is focused on infinity. However, a much better way to understand this concept is to link focal length with how much of the scene can be seen through the lens, sometimes referred to as angle of view. In 35 mm film photography, the 50 mm lens is referred to as a "standard" lens because it shows a similar kind of view as the human eye. The smaller the focal length value, the more scene you will be able to see through your camera lens. Focal lengths for standard lenses change with different film formats, but they can be estimated by measuring a diagonal line from one corner of an exposed film frame to the other. With digital photography, image sensors such as the Nikon DX format are much smaller than 35 mm film and the standard lens has a much shorter focal length too. Each lens usually has its focal length printed on an inner rim, so you know exactly what its capabilities are.

The Prime Lens

Also called a fixed focal length lens, the prime lens cannot zoom closer or pull back from a subject. Fixed focal length lenses are found on cheaper compact cameras to keep costs low but are permanently fixed to the camera body. At the SLR end of the market, interchangeable prime lenses are used for their higher image quality. Many of the world's best photographers use prime lenses rather than multipurpose zoom lenses, but they have to physically move to capture their subjects. Prime lenses usually have wide and fast maximum apertures like f2.8 and are available from the specialist wide-angle fish eyes to the ultralong telephoto for sports and action photography.

The Zoom Lens

Zooms are multipurpose lenses that are designed with a variable focal length such as 28–105 mm. A zoom lens lets a photographer have the freedom to frame subjects at different distances without altering shooting position. At the 28 mm end of the lens, a wide angle of view is created for shooting in cramped circumstances. At the 105 mm, or telephoto, end, the subject is pulled closer like a telescope and is useful for filling the frame with bigger shapes to improve composition. Many midprice zooms have a disappointing maximum aperture such as f4/5.6, which is much less useful than a prime lens at f2.8. In shooting terms, this can prevent photography in low-light conditions will not produce such dramatic shallow depth of field effects. This maximum aperture value is very rarely constant across the entire zooms range, often changing from f4 at the wide-angle end to f5.6 at the telephoto end. Only the most expensive zoom lenses offer constant aperture values across the range. Maximum image quality is always achieved with the midpoint value on the aperture scale, frequently f8 or f11.

The Wide-Angle Lens

Wide-angle lenses such as a 28 mm are best used in confined spaces such as indoor photography or in situations when you are forced into a position very close to your intended subject. Wide angles have the visual effect of pushing a subject away from you and can be a very useful tool if you need to photograph an object to show its entire perimeter edges. With this versatility comes an unfortunate compromise with shape distortion. If you are not holding your camera in a level position, the wide-angle lens will exaggerate any vertical or horizontal lines into converging triangles. This can be a very effective way to make graphic and dynamic images out of mundane subjects, but it is much less useful for making a faithful documentary image. With portrait photography, this distortion will cause facial features to become pulled in all directions, leaving a very unflattering result. Avoid using the

In addition to affecting depth of field, aperture values also have a bearing on the amount of fine detail recorded. A lens recording the sharpest detail best of all if set to the value in the middle of the scale. On a lens that ranges from f2.8 to f22, the sharpest results will be produced at around f8.

wide angle in everyday situations because your subjects will be pushed away from you and appear much smaller and less recognizable on the final print. For photojournalists, the wider 24 mm is a well-established favorite and can be a much more versatile tool in tight situations compared with the 28 mm. Cheaper wide-angle lenses create barrel distortion and will never be able to capture parallel lines faithfully.

The Telephoto Lens

At the opposite end of the scale is the telephoto lens, loosely described as anything with a focal length greater than a standard lens. The telephoto is most useful for making distant subjects much bigger in your viewfinder and cropping out unwanted peripheral details. Many professional photographers have a telephoto lens as an essential part of their camera kit. In addition to travel, sports, and architectural photography, the telephoto is extremely useful for portrait photography, as it creates little distortion unlike a wide angle. All fashion magazine front cover photographs are taken with a long telephoto lens, as an effect called foreshortening creates a very flattering end result. With foreshortening, the physical distances between near and far elements become much more compressed, the exact opposite of the wide-angle effect. Telephoto lenses are physically longer than standard or wide-angle lenses and more like the shape of a telescope. With this extra increase in size comes extra weight and potential problems with the photographer's balance. Focused on a tiny object in the distance, an extended telephoto lens will start to wobble, making it essential to grip the camera steady or use an extra support like a monopod or tripod. For long lens work, it is essential to use a faster shutter speed like 1/250s to avoid the unwanted effects of camera shake. The most demanding of all subjects to photograph is a fast-moving spectator sport like soccer or baseball, as there's little or no time to focus and the subject keeps moving out of frame. Many horseracing action shots are shot by photographers who prefocus on a fixed point on the course, then wait for the horses to enter the zone before pressing the shutter.

Lens Care

Like spectacles and contact lenses, all camera lenses are manufactured with a special antireflective coating designed to help improve image quality. This multicoating improves both contrast and color reproduction, yet is easily affected by grease from fingers. Once smeared with a tiny amount of natural oil from your skin, the performance of a lens drops dramatically, creating flat contrast images with washed-out colors and much less sharpness. If your lens does get inadvertently greasy, clean it only with special lens cleaning tissues, or, for more serious cases, an alcohol-free spectacle wipe. Tiny specks of dust, sand, and human hair will also reduce your image sharpness and should be removed only with a blower brush, available from all photographic retailers, or a soft artists' paintbrush. Any grit or sand that comes into contact with your lens potentially can etch a permanent scratch and ruin it forever.

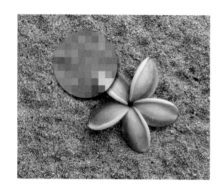

Hardware FAQ

What Are Pixels?

Pixels are the tiny building blocks of a digital photo and are stacked together in a chessboard-like grid, sometimes called a bitmap. Pixels are mostly square in shape and the more you have of them, the bigger and better quality print out you can make. You alone determine how big to make your pixels when you make a print out. At a small size such as 200 pixels per inch, they are invisible to the naked eye, but at larger 72 pixels per inch, the tell-tale blocks become noticeable on your print.

How Are They Colored?

Pixels are colored using only three ingredients: red, green, and blue. Each ingredient has 256 slight variations, and when combined they can form up to 16.7 million different colors, more than enough to mimic the look of a conventional photographic print.

How Big Is a Digital Image?

You can measure a digital print in centimeters or inches, but a better way to judge the size of a digital image file is to look at its pixel dimensions. A chessboard measures 8 × 8 squares, and this digital image measures 2500 × 1800 pixels.

What's a High-Resolution Image?

A high-resolution image is made with over a million pixels and is suitable for high-quality printout. High-resolution images take up much more storage space on your digital camera memory card and can take longer to process on your computer. High resolution images are able to describe fine subject details due to the large number of pixels used.

What's a Low-Resolution Image?

A low-resolution image is made with less than a million pixels and is only suitable for on-screen or web page use. Many low-resolution images can be shot and stored on your digital camera memory card and take no time to manipulate in your image editing application. Low-resolution images are not good at showing fine detail because many pixels are required to describe complex shapes.

What Are Megapixels?

Digital cameras are graded and priced according to how many pixels they can create. Megapixel is a term used to describe a million pixels, so a 2.1 megapixel camera can make an image containing 2.1 million individual pixels. If you prefer to think in height × width measurements then an 1800 × 1200 pixel image equals 2.1 million pixels.

How Is an Image Recreated in Computer Code?

Digital images are stored in the binary number code and create a lot of data. The color of each individual pixel is described by a string of twenty-four numbers as shown, and if you imagine a high-resolution image containing many millions of pixels, you quickly get the picture.

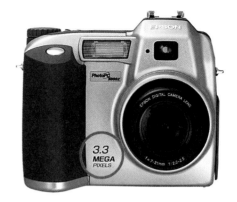

11001101100111010011010110

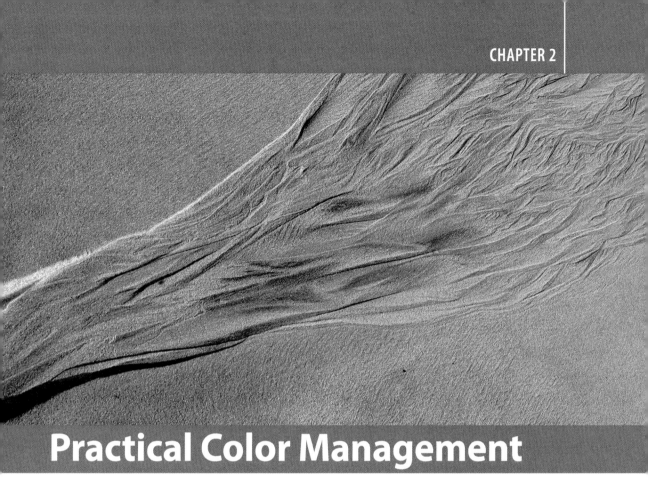

Practical Color Management

Color Space Essentials

The control of accurate color is at the top of every photographer's wish list, but how this is achieved can seem very complex for a novice user.

Display RGB and Printing CMYK

The fundamental issue at the center of reprographic technology is the incompatibility of two very different systems in common use. Colored light transmitted by a desktop monitor is different to colored light reflected from printing inks on paper. Both systems use unique technology for reproducing color in a fixed, characteristic range called a gamut. The range of reproducible colors available for a printed-out photographic image will always be smaller than the range that can be displayed on a monitor. In digital reprographics, the different color ranges produced by RGB and CMYK technologies are referred to as working or color spaces.

What Is a Color Space?

A more understandable term for color space is color palette. In today's digital world, there are three commonly used color spaces: sRGB, Adobe RGB (1998), and ProPhoto. sRGB has the smallest palette, ProPhoto the largest, and Adobe (1998) is the most commonly used by photo professionals. Yet, although each individual color in a digital image drawn from a palette of 16.7 million variations is determined by a unique string of numbers, the same numbers may not produce the same color when translated across different color space boundaries.

Color management is the term we use to describe how best to control the way color is translated from one space to another. Done badly, it ensures that you will experience unexpected results; but with proper management, you can edit out unwanted translations and fully preview the end result before committing to output.

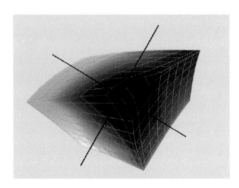

The large Adobe RGB (1998) color space.

Practical Issues

Most practical problems occur when an image created in a larger color space, such as Adobe RGB (1998), is forced into a smaller color space, such as sRGB. The resulting image is mapped across to the new palette but with some compromises occurring invisibly in the background. Before any image editing takes place, it's essential to have your workflow mapped out, so you can avoid these pitfalls of poor color management, thereby ensuring that your images are prepared properly and reproduced at top quality.

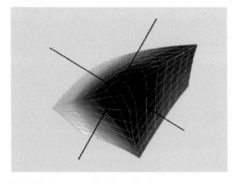

The sRGB color space, noticeably smaller than Adobe RGB (1998).

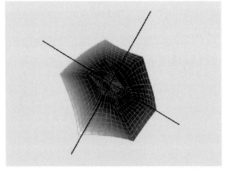

A CMYK color space, which is the smallest of the three examples.

Camera Color Space

Practical color management starts with setting the right color space in your camera.

Best Option: Shoot RAW Files

The best workflow decision is to shoot in the RAW file format. Unlike the TIFF and JPEG file formats available in your camera settings menu, which are all created with a color space tag, RAW files are untagged at the point of capture. Instead of an embedded tag that defines how the file will be interpreted later on in Photoshop, a specific color space is assigned to the RAW file in the Camera Raw plug-in or other RAW file processor used. Although the RAW file is not tagged with the color space set on the camera at the point of shooting, this information is recorded in the file's EXIF data, which transports other camera settings to applications like Bridge. However, you are not restricted to embedding the file's transported color space tag; you can easily assign a different one. In the Camera Raw plug-in, locate the single line of text that sits immediately underneath the image window, the single sentence that contains the description of the color space, image resolution, and file size, as shown below in the red box.

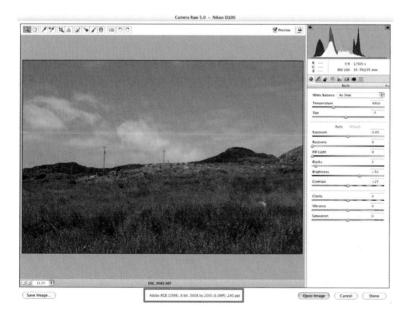

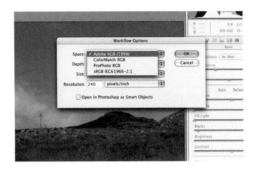

Next, click on this line to bring up the Workflow dialog, as shown above. Click into the top pop-up menu called Space and select the chosen space. You will see the ProPhoto and Adobe RGB (1998) options there too. You can also set the resolution of the file to 300 ppi at this stage, saving you the task later on. This is the most versatile scenario available, as it allows you to shoot as normal, with book, web, and inkjet outcomes all available from a single RAW file.

Option 2: Shoot Adobe RGB (1998)

The simplest, if not the ideal, way of managing color for a print project is to set your camera to use the Adobe RGB (1998) color space before shooting. Straight out of the box, most cameras will be set up with the sRGB color space, as shown below. Found within the shooting menu on most digital SLRs will be at least two options under the Color Space menu: Adobe (1998) and sRGB.

Before shooting, deselect the sRGB option and choose the bigger Adobe RGB space instead, as shown below. When your images are created and stored on the camera's internal drive, they will be tagged with this color space. The color space tag will be attached to all file types, including JPEG or TIFF, and any dual file-format saving routines. The downside of this method is that you are effectively setting a limited response to color from the outset, as there's no way of reassigning a bigger color space later on.

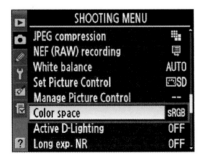

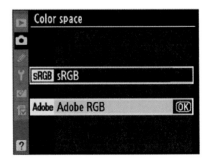

Camera White Balance

Curious as it may seem, both natural and artificial light in their many forms have very different color values.

What Is White Balance?

We're never aware of subtle differences in light color, as our eyes automatically adjust to compensate, and this leads to a false sense of security when we think that the camera will respond in the same way. White light is a perfect mix between all colors of the rainbow, but artificial light emits a much narrower spectrum, resulting in a color bias. Unlike the human eye, photographic film and digital sensors are designed to respond to a narrow range of light, typically neutral noon daylight. When exposed under different lighting conditions, conventional film appears dull and unexpectedly colored. Digital cameras have a built-in white balance control to take account of many different sources of lighting and are much more versatile than their film counterparts. It's vitally important to eliminate color casts in the shooting stage, as this will suppress other strong colors in the image. When not selected, most cameras default to Auto White Balance mode, but it's much better to choose the specific setting for the job. Common mistakes are made when shooting under fluorescent lighting with a daylight white balance setting, with image turning out a disturbing shade of green. Tungsten lights, otherwise called domestic light bulbs, create problems too by making a heavy warm orange cast on your images. Both problems can be easily solved by selecting the correct White balance option before shooting. Although the most severe of casts can be removed in your image editing package, the less corrective editing your image needs, the better image quality you'll achieve in the long run.

Found on all but the most basic digital compacts, the four common settings are auto, daylight, fluorescent, and tungsten, which can be set for each individual shot. Better cameras provide extra settings for cloudy daylight, flash, and even variations on different fluorescent tubes. Great for using when sunlight disappears, the cloudy daylight setting works by warming up images that would otherwise look blue, cold, and uninspiring. This setting too can be used to good effect when shooting with flash in both fill-in and full-on mode. Designed to be colorless, flash light can often strip a scene of all character, making bleak and unflattering end results.

Found on digital SLRs and advanced compacts, custom white balance settings allow advanced photographers to create and store a calibrated setting for use on color critical assignments. Like light, color can be precisely measured and different light sources can be calibrated on color temperature scale measured in Kelvins (K). Although you'd never realize, each different fluorescent

tube product is made with a specific color, so if you know its exact color temperature, you can calculate the precise custom white balance setting. Color temperature can only be measured using a special color temperature meter, an expensive option for all but the serious prophotographer. Yet with the use of your LCD preview screen, you can easily check and refine your custom settings before starting the shoot.

Despite the technical nature, white balance controls can also be used in a creative way where you can enhance the color of a scene. A great technique is to mimic a favorite film process much used by fashion photographers. Shooting tungsten-balanced film in daylight creates a weirdly attractive blue colored image, where flesh tones are cold but stylish. You can easily mimic this effect by selecting the Tungsten setting and shooting in daylight. To cope with the expected excess of orange, the setting overcompensates with blue, resulting in the kind of effect shown on page 30.

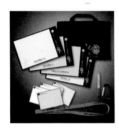

The most important aspect of using white balance is to avoid ruining the natural warm light effect of a location shot. Delicate sunsets and sunrises can all be stripped and converted into an unwanted result if you apply the balance too rigorously. The golden rule with atmospheric color is to experiment with auto white balance first, then follow this with a cloudy daylight setting or finally a custom color temperature setting of your own. As a general guide, color temperature settings below the natural daylight value of 5500 K result in warmer and more orange effects, whereas above this will create cool and bluish images. As always, shoot some variations so that you have a few to choose from later on.

Customizing Your White Balance

Professional photographers have used color correction filters on their lenses for many years. Delicate orange and blue filters have been used to warm up or cool down lighting without adversely affecting color balance. Especially good for enhancing skin tones, these warm-up lens filters create more flattering results. With many advanced digital cameras, custom white balance settings can be created, so you can make and store your own versions of these traditional lens filters for future use. Designed as a handheld reference card, the WarmCard products are printed with a special color to fool the camera into creating a custom white balance setting.

The photographer's worst nightmare is the mixed lighting scenario, where you've got more than one light source in the frame. Flash and daylight mix perfectly well, but any combination of tungsten, fluorescent, and daylight will create unusual effects. Found when shooting an indoor location lit by artificials, but with natural daylight streaming in through a window, mixed lighting can be a tricky task to balance. The best approach is to set the White Balance for the dominant light source and correct the cast later on in Photoshop.

ColorChecker products shown below enable you to refine your own individual white balance and camera's response to color critical applications such as lighting on location and variable daylight.

White balance settings can also be used in a creative way to produce stunning color effects such as this shot. Taken in natural daylight, but using the Tungsten white balance setting, the result is very evocative.

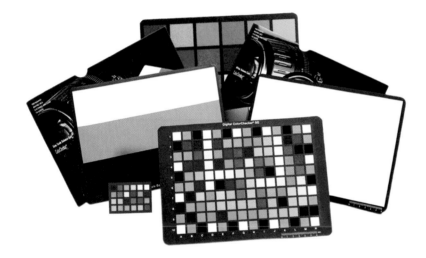

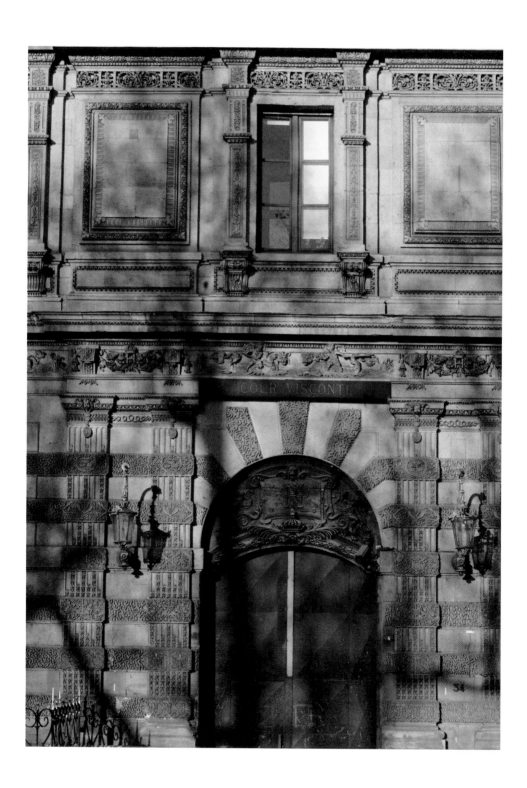

CS4 Color Settings

Once you've set up your monitor properly, you should spend a little extra time deciding how Photoshop's color management tools will work for you.

Color Modes

Color management seems like a tremendously technical concept for most keen photographers, but it's not complex and is there to help you keep your images in top-class condition. The central problem is that digital image colors rarely look the same when an image file is swapped between different workstations and other hardware devices. To counteract this issue, professional hardware and software have a range of tools to manage the transition without dropping original image color values. In your imaging workstation, you can choose to color-manage the monitor, all the input devices, and all the output devices, so that consistent colors are maintained. Many digital cameras and scanners capture their originals in the universal RGB color mode, but there are several subtle variations such as sRGB, Adobe RGB (1998), and ColorMatch RGB. These mode variations, sometimes referred to as a workspace, have their own unique color palettes, which can alter significantly when converted and viewed in a software application running under a different workspace. When converted from one workspace to another, such as Adobe RGB (1998) to sRGB, precise pixel color values are mapped to the new palette and can change, usually with a drop in color saturation.

Setting Up Photoshop's Color Settings

Some workspaces are less used and have a smaller color palette than others, such as the sRGB space, so the best option is to use the largest and most universally recognized workspace such as the Adobe RGB (1998). This workspace is the best for most accurate color printing and will not cause colors to change. Photoshop can be set to work with Adobe RGB (1998) as its default workspace by making the following command Edit > Color Settings.

When the dialog appears, pick the Custom option from the Settings pop-up menu found at the top. Next, click in the RGB pop-up and select Adobe RGB (1998) from the list, as shown on the next page.

CMYK

You should only work in the CMYK color space if you are preparing images for lithographic output. Never make assumptions about which variation of the CMYK profile to use, for there are many standards for many different presses, paper, and ink. Always ask for confirmation first from your client, as they may even supply you with a bespoke CMYK profile that has been designed to work with their own presses. Unlike desktop output devices, there are simply too many different kinds of CMYK output devices for generic profiles to work properly. If in doubt, work entirely in RGB, then leave the conversion to the end, or to others.

Synchronizing Color across Adobe CS Applications
If you are working with other Adobe products such as InDesign and Acrobat, you can synchronize your color settings. This option is offered only when the Adobe Creative Suite is purchased as complete bundle rather than individual applications. Once installed, the central color settings are set once and once only in Bridge, so you can work across color spaces and applications without concern.

Color Management Engines and Policies

To stop the kind of color conversion disaster happening, the conversion process can be managed by a tiny piece of software called the Color Management Module or Engine, sometimes referred to as CMM or CME. Both ColorSync and the Adobe (ACE) are management tools and common in both is to convert images from a smaller space into your current but larger workspace. The second option is to preserve the integrity of the image's workspace, useful if you are only viewing rather than editing. To set up these policies, make the same Photoshop > Color Settings command as before but click the Advanced Mode checkbox found at the top left of the dialog box. Next, choose Convert to Working RGB. When opening images that have been captured in another workspace, you can configure your CME to deal with the problem in a number of different ways called policies.

Profile Mismatch Reminder

While still in the Color Settings dialog, you can also set up Photoshop to prompt you with a visual reminder each time an image file is about to be opened or pasted from another source image. Most useful when a potentially damaging conversion is about to occur, the Ask When Opening option presents a pop-up panel and gives you the chance to decide what to do before the image is opened. In the Color Management Policies section, tick all options as shown.

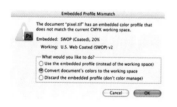

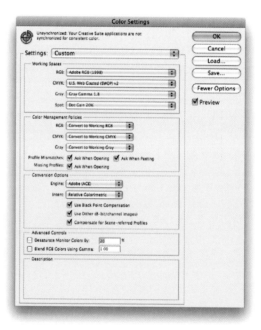

Tagging Your Documents

Once opened, worked on, and ready for saving, the third and final part of the color management workflow can be made. You can choose to save your images with your workspace color profile by doing a File > Save As command. At the bottom of the dialog box, tick the Embed Color profile option as shown.

Should I Bother?

Setting up color management is essential if you intend producing files that will be used in a commercial workflow and even more so if they are intended to be output via a CMYK device. If in any doubt, always talk to your client or printer to agree on common color space beforehand. If your work is solely for your own pleasure, then you may consider loading a workspace matched to your own desktop printer's characteristics. These are usually installed with your printer drivers and can be found by picking the Color Management Off option from the Settings menu, then there will appear a new option in the RGB working spaces menu.

Desaturate Monitor

In the Advanced Controls panel of the Color Settings, there's an additional option for desaturating the monitor. This option is best left unchecked, as the two examples show on next page. The top image is viewed with a 20% desaturation, the bottom with this control turned off. The resulting print matched the bottom example much more than the desaturated example.

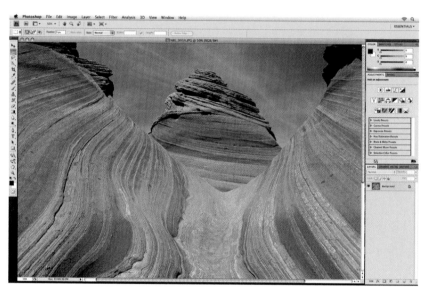

Monitors and Color

Using an uncalibrated monitor is like having colored photo filters permanently attached to your camera lens, and you'll never see true color.

Specifications to Aim For

Although you can buy LCD monitors relatively cheap, there's no guarantee that they will be any good. Always buy a brand which has an association with reprographic systems such as LaCie, Eizo, Mitsubishi, and Samsung. Look for a monitor with a dynamic range in excess of 600:1, with a resolution of 1600 × 1200 and with a brightness value of 250 cd/m2 or above.

The most important piece of equipment in an imaging workstation is the monitor. Invest in the best quality product that you can afford and spend time setting it up properly before you start printing out. If you have a limited budget, it's a good idea to sacrifice processor speed for a good quality monitor.

Positioning Your Monitor

It's essential to eliminate all possible influences when it comes to judging color on-screen. Avoid the temptation to use highly patterned or strongly colored desktop designs as this will impair your ability to judge any color imbalances in an image. A deep yellow surrounding desktop will make your images appear more yellow than they really are. Finally, position your monitor away from strongly colored walls and bright lights, especially fluorescent tubes.

Laptop Screens

Although laptop displays have improved enormously over the last three years, they can be tricky to use for color critical printing. Key to the successful use of a laptop is setting the correct angle of view, otherwise color and contrast will be incorrect. Open the lid of your laptop to around 120 degrees and adjust your seat so that your eyeline is at the horizontal center of the screen.

Monitor Hoods and Shades

An excellent addition to your workstation is a properly designed monitor hood, like this example from LaCie. Hoods work in exactly the same way as lens shades, by excluding unwanted light from the surrounding environment. Your display will look more saturated and with better contrast.

Monitor Calibration

You can't just switch a monitor on and hope for the best; it needs careful calibrating for a guaranteed cast-free color display.

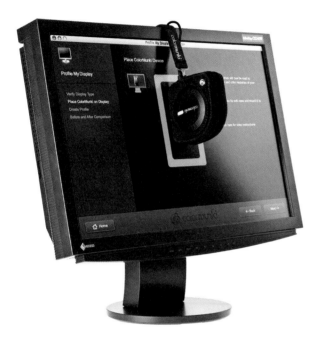

Setting Up Your Monitor

Even though the contrast and brightness of most monitors can be manually adjusted using dials and buttons, it is much better to use software-driven tools to drive your adjustments. Calibration is all about making your monitor display neutral color and is the first stage in establishing a color-controlled workflow. An uncorrected monitor will always give you a false representation of your image and make accurate color printing virtually impossible.

Before we get to this stage, lets look at the options involved when setting up your monitor for the first time. Most monitors can be set to display color at three different levels: 256 colors (8-bit), thousands of colors (16-bit), and millions of colors (24-bit). All monitors have a control for setting a fixed number of colors in a display regardless of the actual color depth of the image on show. It's a bad idea to view top quality digital images on anything

Monitor Profiler
This device works by plugging into monitors and laptops to create an accurate profile through its own, easy-to-follow software routine. Once the file is saved and stored, it is targeted each time the device is switched on.

less than millions of color mode as lower settings will not show the subtleties and tonal variations. Some recent PCs are capable of working in billions of color modes, but this will be squeezed back into 16.7 million by all desktop printers. In addition to color display settings, there are usually several screen resolutions to choose from too, depending on the quality of graphics card installed on your PC. These resolutions are measured in pixels and are commonly described as 640 × 480 or VGA, 800 × 600 or SVGA, or 1024 × 768 and beyond. High-resolution settings enable you to see more of your high-resolution image on-screen and will prevent less scrolling, yet menus and tool icons can become small and difficult to see. A good compromise is to try a midrange resolution such as 1024 × 768 to start with.

Using a Monitor Profiler

The Eye-One Match is a profiling solution that works by accurately setting the monitor to a standard brightness and neutral color balance. After attaching the profiling device to the screen, the software automatically generates a series of colored patches on-screen, which in turn are measured by the device. Once all measurements are taken, the software creates a tiny profile file that is automatically placed in your computer's system folder. The profile is independent from any application and is used as the default setting each time the monitor is switched on. Many photographers choose to reprofile their monitors every three months.

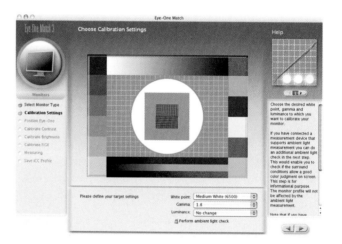

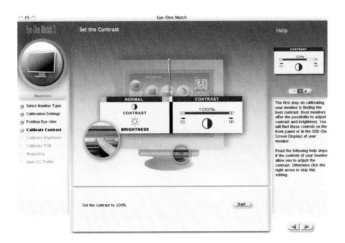

Should I Spend the Money?

Most printing problems are the result of nonexistent monitor calibration.
However, the cost of a basic monitor profiler is easily less than a year's supply
of wasted ink and paper.

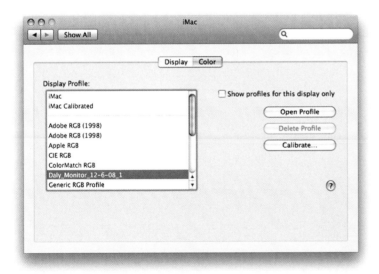

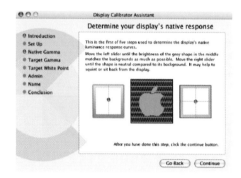

Color Management FAQs

What's the Difference Between Hardware and Software Calibration?

Most computer operating systems have their own built-in monitor calibration tools such as Apple's Display Calibrator and Adobe Gamma, bundled with older versions of Photoshop. Both of these software applications guide you through the process of color balancing your monitor, but they depend entirely on your own subjective perception of color.

A much better option is to use a hardware calibration device, like the ColorMunki, shown left, which makes objective measurements without the need for any judgments for the user.

What White Point Should I Set on My Monitor?

To establish a universal color setting for desktop digital output, opt for the D65 white point, sometimes referred to as 6500K or "daylight." The same illumination standard can also be specified for your workshop light source as fluorescent tubes.

What is the Best Color to Paint a Workshop?

The best kind of environment to prepare images for printout is a neutral gray room. Paint the walls with a midtone gray. There's no need to get an 18% Kodak Graycard equivalent, but you could take one along to your local paint matching store as a starting point.

What Is a Color Management Module?

Often referred to as the Color Management Engine, this is the tiny program that oversees color conversions. ColorSync and Adobe ACE are both CMM.

What is the Difference Between Display and Output Profiles?

Display profiles are workspaces designed for monitors and output profiles, sometimes referred to as destination profiles, are used to set reliable colors to suit an ink/paper/printer combination.

What does ICC Mean?

The International Color Consortium is a group established by leading software and hardware manufacturers with the aim to standardize color across different devices. Adobe Gamma creates ICC compatible profiles, which can be implemented by any ICC Color Management Engine. Most profile files have the .icc file extension at the end of the filename.

What is the Best Desktop Color to Use?

Set a neutral gray desktop color and you'll be able to see casts much better. Brightly colored desktop patterns, as shown right, can be really distracting compared to a neutral midtone gray. In your System Preferences, choose the most neutral color, or if you can specify the RGB values, set them to R:128, G:128, and B:128.

File Processing Essentials

RAW File Processing

To ensure maximum creative flexibility and to future-proof your work, it's now essential to shoot in the RAW file format.

What You Need to Know

Nowadays, most digital SLRs provide RAW file-capture facilities, so you can shoot and store a universal digital file. RAW files can never be overwritten in your imaging application and so provide the best way of archiving your work for future reuse and repurpose. For many photographers who are shooting for perhaps three very different outcomes such as web, desktop print, and on-demand book, this universal format makes perfect sense. RAW files can only be edited in the Photoshop Camera Raw plug-in, Lightroom, or Apple Aperture and will need to be exported after processing in as specific format to be layout-ready.

Nondestructive Essentials

Although the term *nondestructive* has only recently appeared as part of our technical language, image editing programs have able to work in this way for the last 15 years. In simple terms, nondestructive processing describes a wide range of methods by which original image data is protected throughout an editing sequence and not overwritten with each command. When a digital image is first opened, an image editor converts the complex strings of pixel data into colors, shapes, and lines. If the original file is never modified or resaved, this original data is left intact. Much in the same way as the quality of traditional film images degrade after duping and copying, so a digital file deteriorates when the cumulative effect of editing stacks up. At best, original digital files can be preserved as a kind of latent digital image, with the ability to return and reprocess the raw data created at the sensor. At worse, files can be overprocessed like a thick negative.

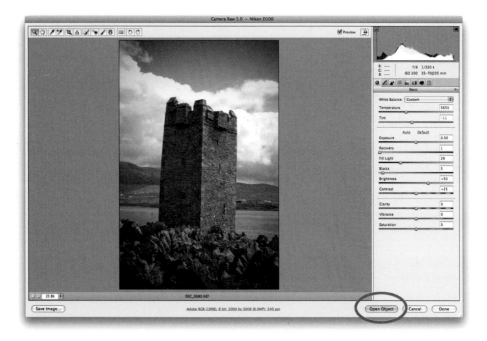

Moving Between Photoshop and Camera Raw

The ultimate in anxiety-free editing combines the RAW file plug-in Camera Raw with Photoshop's Smart Objects and permits return travel across both applications. This works by keeping the facility of reverse gear at all times, effectively maintaining nondestructive processing in two applications simultaneously. In a straight RAW workflow, files are first technically processed in Camera Raw to set white balance, contrast, and color, etc., before creative enhancements are applied in Photoshop. At the point of exporting into Photoshop, the link between Camera Raw is normally broken, i.e., you can't export the file back from Photoshop to Camera Raw without losing your creative work. Now, you can get around this by doing an Open Object command while your RAW file is still in Camera Raw, then place it in Photoshop ready for editing. To return back, simply click the tiny Smart Object layer icon in Photoshop and watch the RAW file ping back into the Camera Raw dialog for further architectural alterations, which are then reflected back in your Photoshop file.

Nondestructive Principles

In hindsight, it's simple to see the results of overprocessing an image file, but it's often invisible while you are working.

Nondestructive Tools in CS4

Examples of current nondestructive tools in Photoshop are Adjustment Layers and the innovative Smart Objects and Smart Filters. All of these functions, when combined with saving in the Photoshop PSD format, preserve original pixel data, leaving you the luxury to ponder on the suitability of your editing and return later if you need to. At the rough end of the workflow scale, every single edit applied through a dialog box or menu, accompanied with a save command, will permanently overwrite and distort the values of your original pixel colors. Many photographers edit their work in Photoshop through a process of reflection and contemplation.

However, this tendency to make changes, known as the fiddle factor, and work in a nonlinear manner is the primary cause of image degrading if a nondestructive workflow is used.

Noise and Nondestructive Editing

Despite the clear logic, the actual practice of using a nondestructive workflow won't guarantee a noise-free end result. Excessively applied commands will still create noise in your final file, whether you've made them with Adjustment Layers or straight through a sequence of dialog boxes. What you can do with nondestructive processing, however, is to return and address the cause of the wreckage and try something less severe instead. Above right is an example of an overprocessed image, clearly showing broken gradations of tone and random noise patterns. Above left is the Levels dialog for this image, also showing the tell-tale vertical gaps in the histogram caused by excessive tonal stretching.

Adjustment Layers

Imagine being able to "float" a creative command over your image without committing to its settings or worrying about losing it in the History palette. Adjustment Layers allow you to work in an entirely flexible manner, and unlike normal layers, they do not contain pixels but only settings. Most of Photoshop's critical commands, as found under the Image > Adjustment menu, are also available as Adjustment Layers and can be introduced to your image with ease. Levels, Curves, and Color Balance commands can all be

applied to your image and appear in their familiar dialog box state once actioned. Once applied to the image, the Adjustment Layer appears in your Layers Palette with the name of the command. After making an edit and quitting the Adjustment Layer, you can simply return to the command at any time in the future and pick up where you left off. The state of the dialog box is saved every time, so you're never in danger of overediting your image if you decide to change your command at a later stage.

Sliders, curves, and numerical text boxes remain unchanged with your last set of commands and give you the ultimate in flexibility and choice. Lying in the stacking order like normal layers, Adjustment Layers will apply themselves to the layers sitting underneath, but those above will remain unaffected. For precise application to a smaller area of a layer, Adjustment Layers can also be applied through masks or within previously selected areas, the latter being a very effective way of colorizing a single picture element. Strangely, despite not being constructed from pixels, Adjustment Layers can be partially removed by using the eraser tool set with brush properties. If you can imagine cutting holes into a command applied over an entire layer, then you're well on the way to thinking about the unique applications of these creative commands. Best of all and unlike using the History palette, Photoshop's Adjustment Layers can be saved and stored in the PSD file format, so you can really leave your image file open to creative interpretation at any time.

Smart Objects and Filters

What You Need to Know

If you use Lightroom, Aperture, or Camera Raw as your sole image editor, then you will already be using a nondestructive workflow. However, if you are using Photoshop, then the simple use of Adjustment Layers, retouching to a separate or duplicate layer, and using masks will all ensure that you protect the original pixel values while you render your masterpiece from file to print. Masks are perhaps the easiest way to mitigate the results of your editing, as they can be hollowed out and filled in until the correct shape is achieved, all without touching the important underlying image information.

Smart Objects and Smart Filters

In Photoshop CS3, a brand new nondestructive function appeared: the Smart Object and Smart Filter. Despite the complex-sounding terminology, both are the same kind of device that you've used already if you've played with layer effects or Adjustment Layers. Put simply, they allow you to return to a dialog box and change your previous settings without stacking cumulative transformations on your original file. Instead of bogging yourself down making duplicate background layers to apply your corrections to, start by making the background into a Smart Object instead. In CS4, either do Layer > Smart Objects > Convert to Smart Objects command, or even easier, do File > Open as Smart Object to make an immediate Smart Object background layer. This versatile new image state is tagged as a Smart Object, denoted by a tiny two-page icon in the bottom right-hand side of the layer icon. Once created, a variety of editable commands can be applied to the Smart Object as Smart Filters (confusing not just filters) including filters, some transformations, and some color/contrast controls that currently lie outside the Adjustment Layer options. With this bigger raft of Photoshop functions able to be applied through the smart scenario, a further benefit is the opportunity to use them through masks and blending modes. Just like normal pixel-containing layers, the fluid settings of a Smart Filter layer can be blended, faded-in gently, or masked off from certain areas of your image.

Smart Filter Sharpening

For many Photoshop users, playing with the sharpening functions was a high-risk activity: pushed too far and the results looked obvious and, even worse, if the command was saved by mistake, it was embedded permanently in the file. What often complicated matters was the need to print or prepare files at many different sizes and resolutions, so no single Unsharp Mask setting would ever suffice. In CS4, sharpening can be applied as a clever Smart Filter, floating over your image, either edge to edge or through a mask and permanently editable. This effectively means that you can now save a sharpening-based command with your file, without any danger of limiting your future editing. To clear up any confusion, the new Smart Sharpen filter does not as its name suggests, apply a nondestructive command straight out of the tin. It's merely called Smart, because it's, well, smarter than the previous sharpening filters.

Smart Object Cropping: The No-Risk Haircut

Cropping your image can be a fraught process, especially if you have been a victim of overeagerness or plain old impatience. When extraneous parts appear on the edges of your images, the natural reaction is to trim them off with the Crop Tool. However, there's no going back to restore a section of pixels that have just, metaphorically, landed on the cutting room floor. An excellent nondestructive process that makes for agony-free use of the Crop Tool allows you to still visibly remove the excess at the edges, but magically

keeps it hidden in the background, ready to restore, should you change your mind at a later date. To do this, first convert the background layer into a Smart Object, then select the Crop Tool from the toolbox and drag this across your image as usual. Before committing to your intended crop, first select the tiny Hide button on the top menu bar, then go ahead as normal. The unwanted area disappears as usual but miraculously can be retrieved at any time with an Image > Reveal All command. You can also bring the bits back by stretching the Crop Tool over the "lost" area, but I find this a bit weird, as you can't fully remember the measurements involved. The whole process is a bit like having your hair cut, but with the option of having it all put back again if you don't like the end result.

Nondestructive Plug-In

An acceptable halfway house between Lightroom's hands-off approach and Photoshop's microscopic level of control is the innovative Viveza plug-in from NikSoftware.

Unlike other specialized plug-ins designed to extend the functionality of the host application, Viveza offers a touchy-feely, more intuitive way of working with your images, which will appeal to Photoshop users who feel creatively restricted. Vivezas can be used in a nondestructive workflow by simply launching it in the Filters menu, when you have made your source images into a Smart Object. All work in plug-ins is then applied as a Smart Filter, allowing you the chance to return back to the dialog to rework your adjustments or create a mask to further define the changes.

Viveza works by providing a toolbox, which is a cross between Photoshop's desktop Color Sampler combined with Lightroom's excellent Targeted Adjustment tool. Like Lightroom's TAT tool, Viveza provides a similar in-image kind of editing, without resorting to distracting desktop palettes and dialog boxes. The plug-in uses Control Points, which are defined by the user in areas that need to be changed, and offers a selection-free way of editing your image. The Control Points are simply clicked into your image, producing three clever foldout sliders for adjusting Brightness, Contrast, and Color Saturation together with a top handle bar, which helps determine the range of your edit. This top handle control allows you to spread the editing extent across your image, like changing brush size or transforming a selection in Photoshop. A simple click on any three editing sliders shows a simple in-image scale, allowing you to precisely alter its value in real time and all within the image itself. Hidden within the Control Points bar are further five controls: Hue, Red, Green, Blue, and Warmth, which can also be modified to give you greater control over your image. In use, Viveza works a little like Photoshop's Replace Color dialog, where you make a selection based on color, grow with the fuzziness slider, then make your color and tonal changes with the sliders.

Viveza also offers the same kind of selection mask preview for each sampled area, so you can see if you've grabbed the right bits of your image to change. However, where Viveza wins hands down is in its ability to work on many different sampled parts of the image through its use of the floating Control Points.

The Control Point is placed over the head and spread out to include a little of the surrounding area. The Brightness slider can then be used to make changes.

For those who enjoy using darkroom style techniques for preparing an image for printout, Viveza's Control Point technology can be used to for really effective burning-in and holding back. Like creating custom brushes in Photoshop, but without the aggravation, each Control Point can be duplicated, then repositioned in the image until it hits the right spot. In practice, this works in real time, so it's like dragging a floating burning-in patch across your image and watching how it reacts with what's underneath.

Viveza also provides a simplified selection preview, so you can see the extent of your forthcoming edit. All editable regions appear as white while unaffected parts show as black.

This before and after illustrates how Viveza can pinpoint extreme contrast problems and apply changes without the need for selections or complex masks.

Control Points can be placed with a high level of accuracy using the magnified Loupe view window, bottom right. This Control Point will be spread across the image to include all instances of green.

The most versatile way of burning-in is to duplicate Control Points and then drag them around your image like floating neutral density filters.

This before and after shows an unprocessed image, top, and a version made using Viveza tools applied as a Smart Filter.

Color Essentials

Even the best photographers end up with color casts on their prints, but the real secret is knowing how to correct these problems without destroying image quality.

Faithful color reproduction is a never-ending pursuit for professional photographers and printers, a process made much more complex by the introduction of an enormous variety of cameras, scanners, and printers working with completely different standards. Color casts make an image look dull and muddy and prevent the bright colors you'd expected from singing at the tops of their voice. Yet casts are easily removed as long as you know the fundamental principles of the color wheel. In all color reproduction, there are six colors broken into three opposite pairings: Red and Cyan, Magenta and Green, Blue and Yellow. When color casts appear, they are caused by an exaggerated amount of one of these six colors. Casts are simply removed by increasing the opposite color until it disappears altogether. There's no mystery to the process, just a commonsense approach.

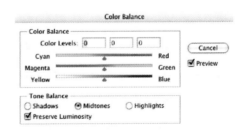

Casts Created on Location

Surprisingly, the color of natural daylight is far from consistent and can vary depending on location and time of day. Photographs taken in the early morning time will inevitably appear more bluish than the same subject shot under a midday sun, looking "colder" and perhaps less appealing. Towards the end of the day, natural light becomes redder and produces warmer and more inviting results. Your choice of location can also have a dramatic effect on color reproduction with even an innocuous canopy of trees will cast a deathly green color across any portrait sitter unlucky enough to be positioned underneath.

Removing Casts in CS4
The simplest tool to remove color casts is the Color Balance dialog. Each of the three pairs shares a slider, so you can move along the scale to remove or increase color.

Casts Created by Artificial Lighting

The color of light produced by an artificial light source is not drawn from an even spread of the spectrum like natural light. Instead, this kind of light is produced in a narrow range such as green or orange. Domestic lightbulbs are usually based on a tungsten filament and produce deep red orange results. In contrast, fluorescent tubes produce heavy green cast, which will instantly suck the life out of any color photograph.

Casts Created During Printing

Despite the care and attention you take during shooting, color casts can occur due to the combination of ink and printing paper from different manufacturers. Very few inkjet papers will work without some prior tweaking, with the cheapest adding a persistent color cast to all your images. If it still appears on your print, even though you've corrected your image on-screen, try using a dedicated profile.

Correcting White Balance Errors

Unlike slight color casts caused by fluctuations in natural light, casts created by artificial lighting can be tricky to remove. Most normal color balance corrections can be made using Photoshop's Variations or Color Balance dialog box, where the cast is best removed in the Midtone areas only. Yet if you've shot an artificially lit scene with the wrong white balance setting, the color cast needs to be removed in the Highlight areas as well. Start the process off by opening your image and then selecting the Highlight option in your chosen color removal tool. Remove the cast, then select the Midtone option and remove the weaker cast, and your image will be fully corrected.

CS4 Color Control Tools

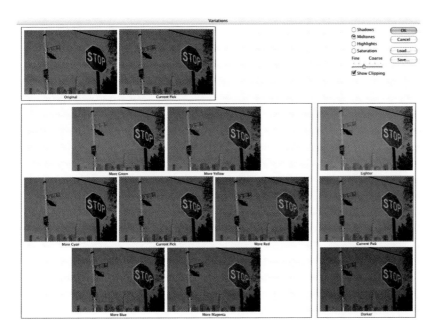

Using Variations

The Variations dialog is the first place to start if you've never done any color printing before. Your image is displayed in six different variations with the original at the center and casts are removed by simply clicking on the best looking option. Control over more delicate shifts in color can be made by sliding the scale from Coarse towards Fine and best results are achieved working with the Midtone option selected. To use the control, do Image > Adjustments > Variations.

Smart Variations

To minimize the risk of a bad decision, it's best to apply the Variations as a Smart Filter, as shown right. Make your background layer into a Smart Object, then apply the Variations command as normal. Once applied, you can always return to your last command by clicking the tiny Variations tag in the Layers Palette.

Where to Spot Color Casts

The best place to observe color casts in your photographs is in a neutral color area, preferably gray (top). Strong white highlights and deep black shadows will never show a cast in its true colors, or will a patch of fully saturated color (bottom), but if you are lucky to have a midtone gray in your image, you'll get a much better idea about the extent of your problem. If no such gray is present, use a skintone area to base your corrections on.

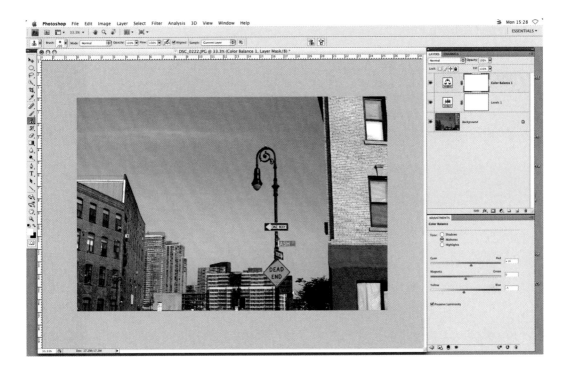

Using Color Balance Controls

More advanced control can be achieved using the less user-friendly color balance sliders common to most imaging applications. The success of the command relies entirely on your ability to spot which color is causing the cast. Corrections are made by increasing the amount of the opposite color and this change becomes instantly visible in the image window. For removing casts from artificial light, apply your corrections with the Highlight option selected first, then apply another correction in the Midtones.

Correcting Brightness First

Muddy color is often created when the original image is underexposed. By changing the brightness of the image with your Levels controls, print colors will start to look more saturated and free from casts. It's essential to correct image brightness before attempting to correct any color issues.

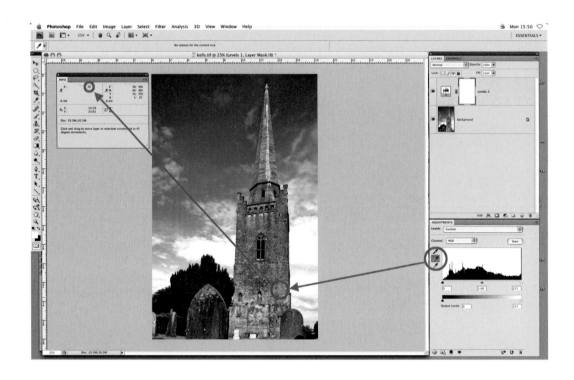

Quick Color Correction

You can also correct color by using the Levels dialog controls and the midtone dropper. This technique provides a near-objective method of correcting images that cannot be otherwise corrected in Camera Raw or in the Color Balance dialog.

Start by selecting Window > Info and position the floating palette on your desktop, so that it doesn't overlap your project image. Next, in the Info palette, click on the tiny triangle under the dropper tool next to the RGB readout. When the pop-out menu appears, choose the Grayscale option. Now, the K symbol will appear in the top left quadrant of the palette, together with a real-time 0–100% readout alongside. Next, make a Levels Adjustment Layer and then click the tiny midtone dropper tool from the Levels dialog, as shown on previous below. However, this dropper is over the image until the K readout in the Info palette reads 50%. It's important to place the dropper over a neutral gray area if possible. Once you have found a 50% region, click the dropper and watch the image change color. Compare the corrected version, above, to the starting point, right, with a magenta cast.

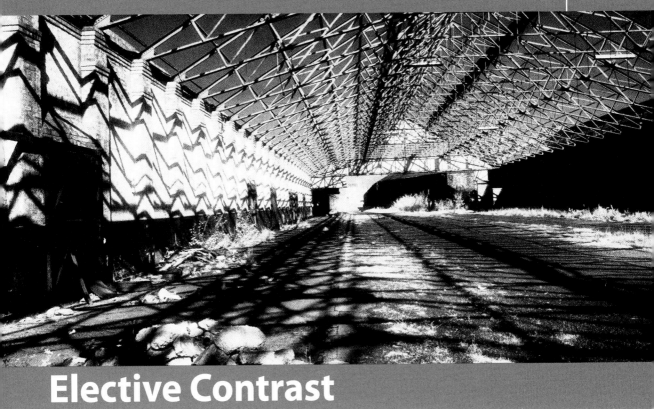

Elective Contrast

Contrast Essentials

What Is Contrast?

The different shades of gray arranged between the black shadow and white highlight point is called contrast in traditional photography and referred to as brightness in digital imaging. Pixel brightness can be made darker and lighter very simply and this allows the skillful user to separate and enhance different areas of the image to create a totally different visual balance. Unlike straight color photography where little tonal manipulation can occur without looking invented, black-and-white interpretation can be highly individualistic. With a good mixture of pure black and white and a full range of grays in between, the subtle contrast image presents a seamless jump from highlights to shadows. Software controls such as Levels and Curves are ideal for putting proper black-and-white points into a low-contrast image and can also be used to shift the balance of the midtone grays. In addition to correcting low- and high-contrast images, software tools can also give the user an opportunity to express their own creative ideas through the printed end product.

Pixel Brightness

Arranged along the base of the histogram's horizontal axis is the brightness scale. At far left is the white point, at far right is the black point, and neutral gray is found in the center. In an RGB image, Levels editing is best done on the composite RGB channel.

Understanding Levels

The Levels dialog box is without doubt one of the core functions of both Adobe Photoshop and Photoshop Elements and has remained unaltered through different versions of the programs. The Levels dialog box, found under Enhance > Adjust Brightness/Contrast > Levels, is the most sophisticated tool for adjusting both contrast and brightness of your digital photographs. Compared to other tools such found under the Quick Fix menu, Levels offers a more exacting range of controls. In a digital image, both contrast and brightness are entirely measurable by objective methods rather than in an arbitrary visual way, and the results can help you solve the most complex of problems. Once measured, this important information is displayed in a kind of graph found within the Levels dialog called a histogram. Once you've really got to grips with the histogram, you can carefully process and prepare images for perfect printout and with two scales for changing contrast and brightness, you'll never suffer from muddy prints again.

In a 24-bit image, color is created by the mixing of three separate color channels, red, green, and blue. Within these channels, color is placed within a 0–255 scale, where 0 is black and 255 is the color at its maximum saturation. The histogram graph found in the Levels dialog shows the spread of pixels

across this scale together with their quantity in each tonal area. All digital images are different, and, therefore, the levels histogram will be a different shape for each image. Yet for common photo mistakes such as underexposure and overexposure, or high contrast and low contrast, the histogram shape becomes recognizable. Looking inside the dialog, CS4 offers you tools for remapping pixel brightness from its original state to a new and more appealing end result. Whether your image lacks true blacks and whites or it's too murky or muddy, you can easily remap a section of pixels without needing to make a complicated selection. In addition to correcting scanning or shooting faults, Levels can also be used to make very creative decisions and really take control.

Quantity of Pixels
Arranged along the left-hand side of the histogram's vertical axis is the quantity scale. At the base of the scale is zero denoting no pixels, but at the top of the scale denotes many. Quantities displayed do not indicate a high- or low-resolution image but are proportional to overall pixel count.

White, Black, and Gray Points

Two scales are present in the dialog: the Input scale for adjusting brightness and increasing contrast, and the Output scale for reducing contrast. At the base of the histogram are three movable triangular Input sliders, white at far right, gray in the center, and black at far left. The Output scale has only two sliders, white and black.

Fixing Low Contrast

Identifying the Problem

In a low-contrast image, pixels are arranged in the center of the histogram, typically in a narrow band, as this example shows. There are no black or white pixels, which make the image look muddy, flat, and completely uninspiring. The same histogram shape occurs in both grayscale and RGB image modes.

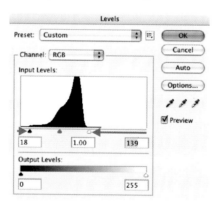

Once edited, your corrected image will now look punchier and will produce a better printout.

Fixing the Problem

Ensure that there's no selection on your image, then gradually drag the Input triangular highlight slider until it reaches the foot of the central black mountain shape. Move the black slider inwards in the same way until it too reaches the base. Even a tiny movement makes a huge difference to your image.

Creating Low Contrast

Choosing the Low-Contrast Style

With no black or white, the low-contrast image is derived from an expanded range of grays and can also be an expressive and atmospheric way to interpret a subject. With a softness associated with vintage photographic processes such as platinum and carbon tissue, the low-contrast image can be very effective on portraits and flower subjects. Spotting potential images for a vintage treatment can be tricky at first but keep a close eye on background details, as telegraph poles, street signage, and even parked cars will ultimately give the game away.

 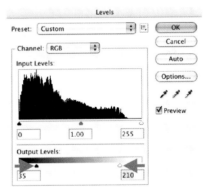

Creating a Low-Contrast Image

When shooting standard RGB color mode images with your digital camera, you'll need to change the tonal range of your image after uploading to your computer by using the Output scale in your Levels dialog box. By pulling both highlight and shadow points towards the center, you are making the darkest areas of the image dark gray instead of black and changing any white highlights into a flatter light gray.

Fixing High Contrast

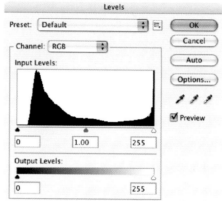

Identifying the Problem

In a high-contrast image, pixels are usually arranged in two separate peaks towards the opposite end of the histogram. Showing lots of white and lots of black and not much else in between, a high-contrast image is difficult to edit and even harder to print out properly.

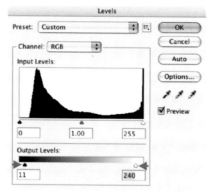

The image now has a much softer contrast range and will be much easier to print out.

Fixing the Problem

Using the Output scale at the bottom of your Levels dialog box, gradually slide the highlight and shadow triangles towards the center of the scale. This has the effect of mapping original blacks to dark gray and original white to light gray. You'll only need to move these points slightly as shown.

Creating High Contrast

Choosing the High-Contrast Style

When strong whites and blacks are present with very few accompanying gray tones, the result is said to be high contrast. Best suited to strong-shaped subjects, high-contrast effects will enhance lines, edges, and textures, and is the way to get a bit of realism into your work. The end result of a high-contrast print is usually a strong graphic image that attracts attention due its stark difference from the way we normally see the world. As a by-product of the process, finer details found in midtone gray areas will disappear, so this kind of style is best used when delicacy is not desirable. High-contrast subjects are usually found under bright sunlight but excessively high contrast can be very challenging to print out on a desktop inkjet, with darker gray areas filling in and reproducing as black. This style is a good way to shoot a photo story out on location, particularly if it's based around a strong issue or theme. It also an excellent way to shoot natural light portraits.

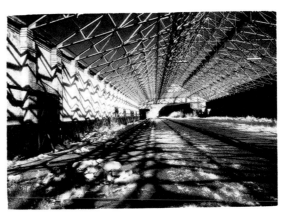

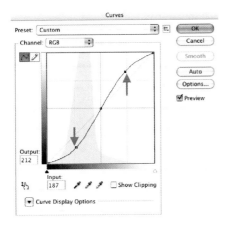

Curves is the easiest tool to use to introduce contrast. Simply open the Curve dialog and reposition the straight line as shown at the left. For a slight contrast increase, create a gentle, italic style sloping "s" shape. For more increased contrast, push the two points further up and down, as indicated by the red arrows shown at the left.

Correcting Exposure Errors

Making Dark Images Lighter

Open your Levels dialog and work on the Input sliders found at the base of the histogram shape. Drag the central gray midtone slider to the left until your image becomes brighter. This will not change your highlight and shadow points.

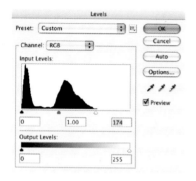

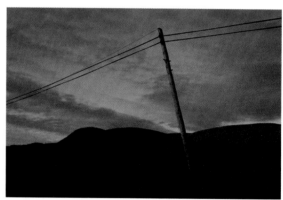

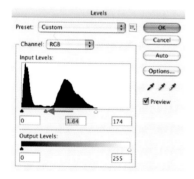

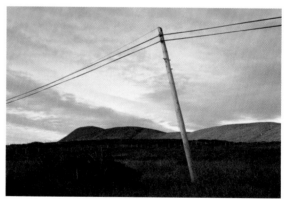

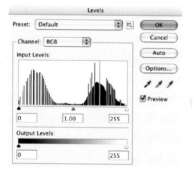

Avoid Posterization

Vertical gaps in your Levels histogram indicate posterization or color banding. When excessive corrections are made from very poor quality originals, there simply isn't enough information to create a smooth tonal range. Any subsequent image editing on a posterized image will only make it look worse and more artificial. If you can reshoot or rescan a bad quality image, it's well worth the effort.

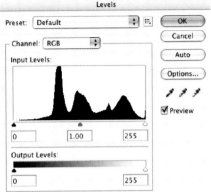

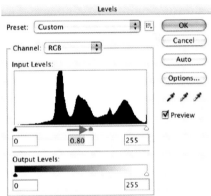

Making Darker

When faced with images that are lighter than you want them to be, use the Input sliders to make your corrections. Drag the central gray midtone slider to the right until your image becomes darker and loses its washed-out look. Avoid going too far or your printouts will look dark and heavy.

Advanced Controls

The three tiny dropper tools found underneath the buttons allow the more experienced user to click select highlight, midtone, and shadow points from within the image itself. If this makes the image worse rather than better, click on the Alt and Reset to revert back to your original settings without quitting the dialog.

Correcting Flat JPEGs

Precise control of tone as practiced by many film-based photographers is gleaned by experimenting with a specially devised papers, chemicals, and processes. For the digital user, however, there's often too many software tools to choose between. Which is best? Levels or Curves? For most of us shooting digital, the best way to approach the editing process is to first visualize the final print, then drive your software to deliver the goods. Never be "driven" by your application and always work in a nondestructive manner to allow for maximum flexibility. In this feature, we are going to use three simple techniques to alter three typically flat, original image files, with the aim of creating three different end results: exercising grade-like control over your printing paper; mimicking split-grade printing, and, finally, devising a digital method of prefogging. Like all digital images taken straight from the memory card, the three starting points exhibited a characteristic flatness. This is caused by a combination of the camera's antialiasing filter and the inevitable by-products of compression.

Starting Point

Shot and saved as a high-quality JPEG, the unprocessed file looks dismal and almost fogged, with no rich shadows. The purpose of the following edit is to put back some of the original lighting quality, to draw out the lost texture of the brick wall, and to make the final print as interesting as the subject.

Preparing the Curve

An S-shaped curve is a classic method for rescuing flat-contrast images and works every time with both monochrome and color originals. Open your Curves dialog and ensure that the shadows are set to the bottom left-hand corner of the graph, as described by the vertical and horizontal tonal bands meeting in the bottom left-hand corner. If not, click on the tiny white/black triangle icon, circled as red, to reset the scale in the correct place. Next, click a marker dot on the very middle of the diagonal Curves line and two other marker dots, as shown. These markers effectively determine which tones you will alter in the next step. The center of the three defines the midtone, top right near-highlight, and bottom left controls near-shadow.

Manipulating the Curve

To create the S-shape, it's not necessary to move the center marker dot, as this acts as an anchor, to stop the line from moving during the following two steps. First, click on the near-highlight marker dot in the upper right-hand quarter and move this gradually upwards, as shown. This will cause the highlight areas of the image to become brighter. Next, click on the near-shadow marker dot in the bottom left-hand quarter of the dialog box and move this slowly downwards, as shown. This edit causes the darkest tones in the image to get darker, thereby creating a little more punch.

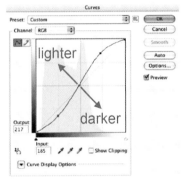

The Final Result

The more extreme the slope of the S-shape, the more contrast is created; flatter, italic-like S shapes create less contrast.

Creating Split Grade

Step 1

Starting Point

This technique allows you to mix high-contrast and low-contrast versions of the same image into a final printout and helps to avoid burning-in complex shapes. Resourcefulness is the term to remember when looking back to the methods devised by master darkroom printers for manipulating image contrast with very basic silver-based materials. Faced with complex shapes too tricky to burn in, a special method was developed using multicontrast printing paper. Variable contrast paper was first exposed with low-contrast filters to register the highlights, and then a second exposure using high-contrast filters was made to deepen the shadow areas. The result was the most perfect blend. Faced with similar circumstances, a much simpler method can be used in Adobe Photoshop using layer blends and duplicate layers. To retain maximum control over contrast in this edit, use Levels adjustment layers for both the high-contrast background layer and the low-contrast duplicate layer, so that you can return and edit until ready for printout.

Step 2

Prepare the Low-Contrast Layer

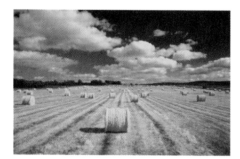

Open the high-contrast original, then duplicate the background layer, so that you have two identical versions of your file lying above each other in the Layers palette. Next, do Image > Adjustments > Levels to bring the Levels dialog up on your desktop. The purpose of the next step is to lower the contrast of the uppermost layer creating grayish, rather than bright white, highlights. Drag the two triangular sliders in the Output Levels scale towards the center, as shown in the dialog box on the next page. This will determine the new bright and dark values.

Step 3

Blend Together

Once your soft and hard layers have been created, the Layers palette should look like the example shown. Next, to create the blending recipe, click and hold on the pop-up menu found at the top left-hand corner of the Layers dialog, which by default will display the word Normal. Choose Multiply as the blending option and watch how low- and high-contrast layers start to merge. A further control can be made using the Opacity slider, so that you can alter the transparency of the uppermost layer.

Step 4

Final Print

This final example was prepared with a 50% Opacity value.

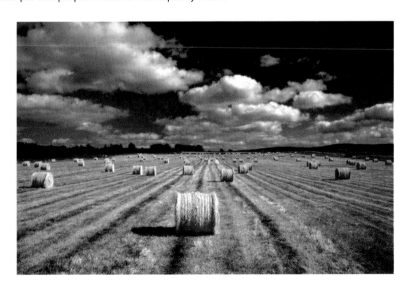

Creative Emphasis

Localized Emphasis

Adopted from the time-honored skills of the traditional darkroom printer, burning-in and dodging helps to emphasize the main subjects in your image.

The image was shot with a manual Olympus 35-mm SLR, using Fuji Neopan 400 and was grabbed within a split second. The quality of light at the time of capture was flat and overcast, and the negative was further reduced in contrast by developing in Agfa Rodinal to produce a low-contrast but versatile starting point and to minimize the granularity of the film. Except for the main subject of the child, the outer parts of the image were of a very similar tone and did nothing to contribute to the overall emphasis that I wanted to achieve. The task was to darken down the unimportant areas and target all the attention on the main subject. To start with, I created a scan using Silverfast software to make a low-contrast original with enough

information to make a legal print. Once captured, the aim was to apply a digital burning-in technique using CS4 that had been adapted from my experience of conventional darkroom printing. This method enables me to darken down precise parts of the image and to do it gradually in stages to create the look and feel of a handmade digital print.

What Emphasis Means

The best conventional photographic prints undergo an extra stage in the darkroom when individual areas of the print are darkened down and lightened up to create a much more sophisticated image. Natural and artificial light will never fully draw out each individual part of an image, so this emphasis is added at a later stage. Just like the moody dark and light effect used by great painters such as Rembrandt, photographic burning and dodging can help to make an image look more three-dimensional and more inviting to look at. In addition to these tricks, small but offending image areas can be darkened down and made less noticeable, placing more of the viewer's attention on your main subject. For minor problems caused by shadows or camera underexposure, dodging will restore brightness to an area in the same way.

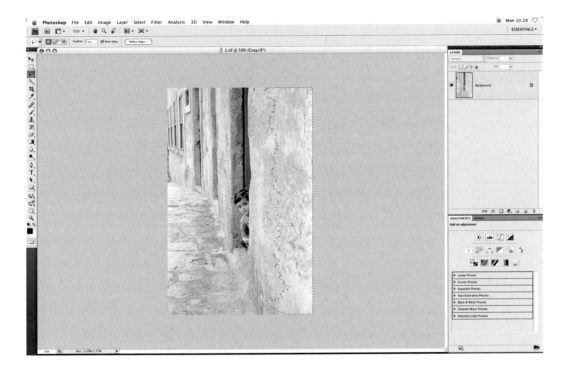

Step 1

Define the Burning-In Area

Rather than using the default brush-shaped burning tools in CS4, this method uses the Lasso selection tool. Check that the Feather value is set to zero on the contextual menu bar before you start, then resize the view of your image using the Navigator tool, so that there is plenty of gray desktop space surrounding the image edges. Next, draw a simple enclosed selection shape, as shown, in an area of the image that you want to darken, placing the Lasso in the gray desktop areas as you draw around the edges to ensure you capture the peripheral pixels. This selection now becomes the area that you will add extra "exposure" to, but it first must be softened before the next step using the Select > Modify > Feather command. Set this value to 5% of the maximum pixel dimensions of your image, e.g., 2000 divided by 5% is 100 pixels.

Press P to toggle the preview of the edge refinements. Press F to cycle through the preview modes, and X to temporarily view the image.

Step 2

Setting Up the Adjustment Layers

Before darkening down the soft shape that you have created, it's important to get rid of the visually distracting selection edges that define the border between selection and protected image. Do View > Extras to switch them off or Ctrl/Command +H. Only the edge is turned off at this stage and the selection remains in place, albeit invisible. Next do Image > Adjustments > Levels and drag your dialog box to one side, so that you can see the entire image. To darken down the selected area, move the gray midtone triangle to the right (as shown) but avoid trying to complete the effect in a single command. The area will now have turned darker but with a soft edge that mimics the kind of gradual change created by using a moving sheet of card under your enlarger lens.

Step 3

Repeat the Burning in a Smaller Area

After the first effort, repeat the command again, but this time in a scaled down selection area. Like burning in a conventional photographic print with a third period of "exposure," this stage enables you to further darken down the area while maintaining a hand-printed feel. Using the lasso tool again, make an irregular-shaped selection that sits inside your first attempt but avoid being too perfect or your dark shapes will start to look obvious. Shown here side-by-side are the before (left) and after (right) states compiled into a single screenshot. The most convincing example of this technique can be produced when several different-shaped increases in print "exposure" are built up in a single area rather than in one direct hit.

Step 4

Drawing Emphasis Shapes

After gaining confidence with the first attempt, you can now create more complex selection shapes to break up large areas of similar tone. In this example, the paving area of the image was a single shade of gray from foreground background, so the aim was to break this up with an invented shape that better caught your attention. This area of the image was darkened down using one large selection, followed by six smaller selection edits to ensure the paving varied in tone, shape, and interest. With this technique, you can really start to amplify any tonal area you choose to create a very sophisticated hand-printed feel.

Final Print

The finished example was the result of many selections and burning-in using the Levels midtone slider. By using this part of the Levels tool, only the midtones are altered each time you create a burning-in effect, minimizing the risk of making burned-out highlights or blocked-up shadows. With so many small and overlapping selection shapes, it's impossible to see where the editing has taken place, mimicking the skill of an expert darkroom printer who knows how to keep the card mask moving during exposure! I'm pleased with the final result, as it really helps to introduce drama to an otherwise flat and featureless negative.

High Dynamic Range

What Is High Dynamic Range?

If you've not heard of the latest buzzword to hit digital photography, then now is the time to experiment with high dynamic range processing, or HDR, as it has become known. High dynamic range processing is the latest technique for extracting the perfect tones from several bracketed exposures of a single subject. For landscape photographers, this will revolutionize the way you shoot for ever. High dynamic range processing offers the photographer a hands-on technique for mixing the perfect tonal blend across shadows, highlights, and midtone areas and all without the use of Selections, Masks, or Layers. In fact, there's even no need to use Levels or Curves to organize the image ready for printing.

Very rarely does perfect lighting exist on location and on the occasions when your camera exposure captures the details in a bright sky but not in the darker landscape; HDR processing can be used to get the best out of this situation. CS4 offers an HDR processing function through its Automated actions menu, and much better results are obtained when using a specialist software application such as PhotoMatix Pro.

PhotoMatix Pro works by mixing and merging together individual files that have been exposed under different conditions in a shooting technique called bracketing. Instead of hoping to capture all tones and detail within one single file, three or more different files are created at the scene, each exposed differently to get the best out of highlight, midtone, and shadow areas. These are then combined together into one perfectly balanced file for output.

Shooting for HDR

PhotoMatix Pro recommends that you shoot at least three individual files for later combining and suggests that they are bracketed as follows: one at normal 0.0 exposure value; one at –2.0 exposure value, and one at +2.0 exposure value. When shooting on location, these exact bracketing differences are best set on your camera's ± EV dial, or if available, as part of an autobracketing program that fire off three shots with one pop of your shutter release. Within this range, all possible tones are captured as the example here illustrates. The only drawback to using this technique on location is that you need to have your camera tethered on a sturdy tripod between brackets, as any change of position will result in ghosting or misregistration when the three images are combined in PhotoMatix Pro. The big problem in capturing three identically positioned originals is, of course, the limitation imposed on your subject matter. Moving subjects are out of the question and even shooting static landscapes in a wind will result in some parts of your image misaligning.

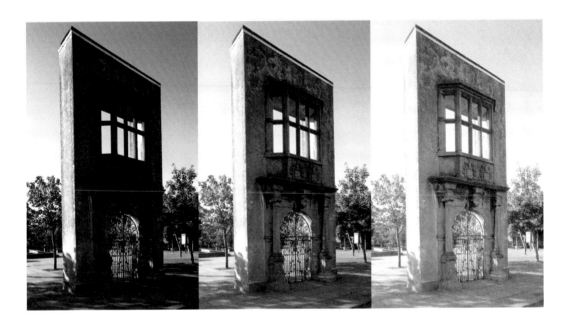

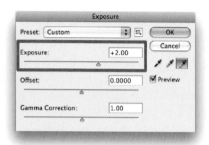

Making Your Own Brackets

An alternative to this method is to extract two extra "exposures" from a single existing file by using Photoshop's Image > Adjustments > Exposure function. This tool allows you to set the same rate of change on the universal ± exposure value scale, rather than the 0–255 digital scale. This method is less ideal and relies on your original file being pretty close to a perfect exposure to work. This final result, shown here, was generated from a single original file that was processed with Photoshop's Exposure tool to create three different versions.

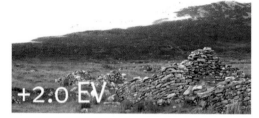

These three were then combined in PhotoMatix Pro to create a single image that merges together the best bits of all three, without any obvious edges, noise, or posterization. Like the perfect amount of fill-flash, HDR processing can offer you the chance to retrospectively reclaim detail in shadow areas that would be tricky to manipulate without masking.

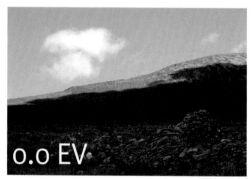

A typical example of ghosting is presented here, where the software was unable to reconcile the differences between source files.

Once your images have been combined, the initial result look very disappointing and dark. This is because the HDR can't be fully represented without additional processing. At this stage, you can save the initial version and treat it in much the same way as a RAW file available for processing and reinterpretation later on.

The second stage is the truly creative one: choose the Tone Mapping option from the HDR menu. Once the dialog appears, you are faced with a choice of three different resolution previews, so choose the largest that your monitor can accommodate. The dialog offers two ways of interpreting your HDR file: either using the Details Enhancer method or using the Tone Compressor. These two options offer slightly different tools for adjusting your file, but the Details Enhancer give by far the most dramatic results.

Once selected, the Details Enhancer dialog creates the first preview of your combined file, with its surprising combination of detail in both shadow and highlight area. This effect is best described as applying a gigantic fill-flash retrospectively to your shot. The tools in this dialog offer you the ability to moderate contrast, color saturation, and lightness, with no fixed rules or guidelines. For this example, see how different the results from a Strength edit makes: 0 looks washed out and 100 looks rich and intense.

CS4 has an improved HDR function, available through File > Automate > Merge to HDR.

You are first prompted to identify the source files, as above.

Next, you can ensure that CS4 has judged the correct exposure values for your three source files HDR in CS4.

The preview allows you to see the combination of your source files. Choose the 32 Bit/Channel option to preserve all the HDR data.

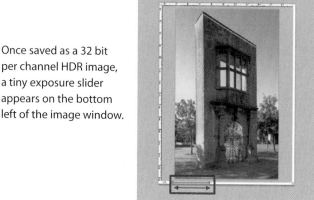

Once saved as a 32 bit per channel HDR image, a tiny exposure slider appears on the bottom left of the image window.

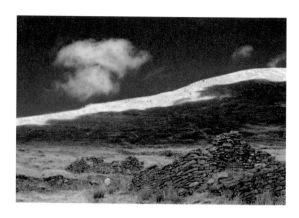

Great for rescuing disappointing exposures, but even better for encouraging you to now shoot the kind of contrasty lighting scenes that you would have otherwise walked away from. Shown left is a further toned variation.

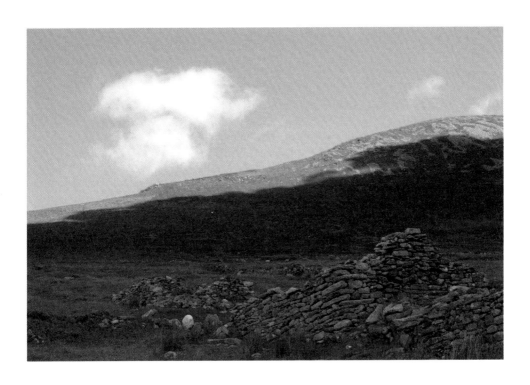

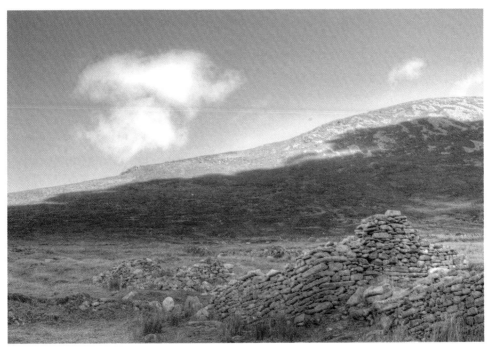

Working in Monochrome

Mono Essentials

Shooting with black-and-white film has long been established as the all-time favorite with traditional photographers; yet, in the digital era, monochrome photography has got even more potential. Conventional black-and-white photography has developed over the last century and a half as a craft skill rather than just a technical picture-taking process. With as much influence possible on the final end result at the secondary darkroom stage, photographers could reinterpret the original negative in many different styles. Contrast, tone, and color tints can all be applied to the image to enhance flat lighting and bring out lurking textures not revealed in a machine-processed print. Yet, apart from the real skill in the postproduction of stylish black-and-white photography, you've got to be able to spot potential monochrome images when strong colors are largely absent. When natural light is dull and your subject colors don't exactly sing out loud, a monochrome interpretation can add warmth and punchy contrast to the most mundane situations. Although many digital SLRs offer an additional sepia mode shooting option, this is really just a crude RGB image with a brown tint attached. A much better

option is to shoot using normal RGB color mode and follow this with one of the many different conversion processes in your image editing application. With a comprehensive assortment of tools for converting color to black-and-white, there's simply no advantage in starting with a monochrome original. Even if you're shooting conventional film and using a film scanner to convert negatives into digital files, it's much better to shoot color negative film stock rather than panchromatic black-and-white. In addition to having the option of printing color or monochrome, starting with a color film or digital original gives you the valuable asset of original color values, which you can remix and rebalance before conversion takes place.

The Channel Mixer in CS4 is a straightforward tool for remixing original color before monochrome conversion. As a general rule, the total of the three text boxes must add up to +100. Unlike previous Channel Mixer versions, there are several useful preset recipes in CS4, including Black-and-White, Infrared, or Deep Red filter.

CS4 allows you the flexibility to redefine the tonal values of your original image. Above is an example of a RGB image where the original dark green has been lightened before converting to monochrome.

Any color present in your original image can be lightened or darkened during the process of monochrome conversion to generate a more interesting end result. Colors that are too similar in the RGB image can be made to stand apart, like the blue sky and clouds in the example below.

Mono Conversion

Film and Tonal Reproduction

The idea of editing the relationship between original tones in a subject in the shooting or printing phase was around long before the dramatic landscapes of Ansel Adams. Early photographic emulsions were so far from panchromatic (the ability to respond to the entire visible spectrum) that studio photographers used to counter these imbalances by dabbing bizarrely colored makeup on their unsuspecting sitters. Pre-1900 emulsions were horrifically oversensitive to the blue end of the spectrum, rendering greens and reds much darker than in real life and blues much lighter or mostly white. When emulsions were refined to allow subject colors to record across the spectrum, there were still many photographers who developed their own customized approach to tone conversion. A great favorite for black-and-white film photographers was the yellow screw-on filter, which was used to prevent pale blue skies printing even paler. Orange and deep red filters were also essential parts of the kit bag, allowing even more dramatic tonal change in the final print.

The principle of using physical filters is pretty straightforward and easier to grasp if the screw-on device is visualized like a kind of sieve. A filter works by letting certain wavelengths of light pass through the mesh to the film and traps other unwanted colors. All red light in the subject is allowed though the sieve-like filter, recording white or pale on monochrome film. Green light such as the color of the football pitch will be trapped by the filter and will record dark gray or even black, as an absence of light. Although it was possible to radically enhance the tonal appearance of a subject using such deep colored filters with mono film, it was never possible to redefine the reproduction of more than one color at a time. So, in practice, you could make a blue sky reproduce black for dramatic effect, but you couldn't also alter any other tonal values at the same time by screwing on another filter.

Original color images with muted or little color to start with look much more effective in monochrome.

Conversion Principles

Nowadays, with the introduction of the universal three channel RGB image, it's possible to remix the original balance of an images entire color palette and tonal relationships. What's even better is that the conversion techniques can be reapplied retrospectively to any digitized color image from your library, even if it was shot on ancient film stock. Only after a shoot do many photographers realize that a monochrome version of the image would have made a better end result, but now it's possible to remix the tonal values until you get precise separation between tones, or a more visually pleasing end result. Pixel color in a digital image is based on a recipe using varying quantities of three ingredients: red, green, and blue. It's entirely predictable, measurable and therefore able to be altered by a precise amount, too. When making a conversion, pixel color is remapped to another value, but the key to doing this properly is to avoid destroying smooth tonal transitions with excessive filtering, editing, or hesitancy.

Noise Avoidance

Like many software enhancement techniques, converting to black-and-white can be fraught with danger. Although most of the tools and processes offer a dazzling and seemingly unlimited scope, if used in excess, they will introduce the biggest of all gremlins into your image—noise. Before we discuss this in detail, it's important to realize that the very way that you shoot and save your digital file will have a huge bearing on its ability to be converted to exhibition standard output. Lowest quality and most noisy results will be created if

The Desaturate command in CS4 offers the least creative conversion tool in the box. Results are always flat and lifeless and retain little of the original tonal values.

Dramatic conversions, although visually effective, will start to stretch original tone until visible bands start to appear in the Level's histogram. Little more processing can be applied to an extreme conversion.

The simplest way of turning an image into black-and-white is converting an RGB file to Grayscale. However, the results can look a bit lifeless and flat.

you edit highly compressed JPEG files shot at a high ISO (800+). Before any editing takes place, this kind of file will be chock full of compression artifacts and grain-like noise that will magnify throughout a very shortened editing process.

Highest-quality output is created when using RAW format files shot on the lowest ISO sensitivities; this kind of starting point will allow you the greatest freedom to stretch the color of your file before noise becomes visibly apparent. However, the more steps that you introduce in your editing sequence, the greater likelihood of noise appearing, whatever format it was created in; so always use a nondestructive editing technique. Don't forget, nondestructive doesn't mean that noise isn't created along the way, only that you've got the chance to intervene to minimize its visual effects. Noise is caused by excessive stretching, as shown in the Levels dialog above left.

Conversion in CS4

For die-hard users of Adobe Photoshop, the Channel Mixer was the first real tool of choice, as it was the only accurate way to mimic deep color contrast filter effects on film. However, since the introduction of the Black-and-White adjustment layer function in CS3 and its subsequent refinement in CS4, there's no real reason to stick with the Channel Mixer tool anymore. Photoshop CS3 users who are skeptical about the benefits of upgrading to CS4 should look away now, as the latest version of the popular imaging software offers a much more intuitive workspace and greater nondestructive controls. Stuck to the right-hand edge of your desktop, the Adjustment menu offers all the familiar adjustment layer content but with the added advantage of automatically adding an adjustment layer as you edit. With this level of convenience, there's no need to choose separate dialogs from the drop-down Image > Adjustments menu anymore, and, best of all, it promotes a nondestructive work flow. The best way to make a conversion in CS4 is to use a Black-and-White adjustment layer to draw out the difference between tones in your original. In this example, the brand new on-image adjustment tool (like Lightroom's excellent targeted adjustment tool) allows you to grab hold of the tone you want to change in your image. Click onto the area, then move left to darken or right to lighten, it's really that simple. Unlike previous incarnations of the adjustment layer, CS4 displays your settings permanently alongside your image, so there's no need to keep clicking on the adjustment layer icon to change your commands.

The converted example above was created with the Black-and-White controls.
Compare this result to the Grayscale conversion on the opposite page.

In CS4, the very useful Adjustments menu now provides a Lightroom-like control panel so that you can edit your images without the need for a floating dialog box.

Although the Black-and-White controls offer an interesting range of preset recipes, as shown above, excessive contrast conversions, as shown, can be difficult to print properly.

This image was edited to reveal more texture in the brick wall, more contrast in the sky, and a darker green road sign to make the white lettering stand out.

CS4 also provides a much better Color Balance dialog/adjustment panel with the three colored pairs awaiting your command. This image was toned with the color balance controls applying a small amount of yellow in the highlights followed by a small amount of red in the shadow areas. What was largely a monochrome image to start with is enhanced by removing all original colors and replacing with similar but more luxurious tones.

Using Silver Efex Pro Plug-In

For additional control over your conversions, the sophisticated Silver Efex Pro Photoshop plug-in is worth consideration. Designed with the same control point interaction as its sister application, the nondestructive color enhancer Viveza, Color Efex Pro provides a wealth of tools and film look-alike effects. The application works best when run as a Photoshop plug-in and edited files opened as nondestructive Smart Filters. There's the usual contrast flavor, as you'd expect, but there's also an intriguing Holga look-alike preset and a pinhole camera preset, both with mandatory vignetting and crusty grain effects. In use, Silver Efex Pro is very straightforward, providing editable color filters that pop tone back and forth with a reassuring clarity and the very flexible control points. Like Lightroom 2's new nondestructive brush tools, Silver Efex Pro's control points float edits over the areas of your choice, allowing maximum flexibility of movement, size of image area, and of course, settings change. They are effectively like mini-adjustment layers that sit within an invisible selection area. In addition to altering brightness, contrast, and color conversion, the application also provides a wonderful film type simulator. If you are one of the many who have tried the always-disappointing grain simulators for introducing gritty film-like texture into your image, then Silver Efex Pro is really worth a go. Equipped with a simulation of every great monochrome film, including APX100, HP5, and the terrifying Delta 3200, the application not only recreates the grain effects but simulates the film's typical panchromatic response to your subject. Unlike most other black-and-white film effects, each film preset in Silver Efex can be edited with grain, sensitivity, and tone curve adjusters. To complete the edit, there's also an effective Stylizing palette, which provides toning presets (editable, of course), various vignettes, and the highly pleasing Burn Edges commands, where you can darken down each of the four edges independently like using a pen-sized torch in the darkroom.

Once opened, the application provides a useful Styles palette along the left-hand edge, so that you can see your image under a number of different presets.

This example changed a washed-out color image of the now-famous Obama poster into a punchy black-and-white inspired by an Ilford XP2 film type and some deliberate darkening down of the outer edges.

Making Digital Lith Prints

All conventional chemical printing effects rely on a manipulation of tone, color, and contrast, usually with developing, bleaching, or reducing agents. Chemical styles such as lith printing, when done to a high standard, impart an alternative feel to a finished print, elevating it above the mechanical printed product, feeling closer to a one-off hand-finished artist's print. With lith printing, both contrast and toning effects provide an extra "bite" to otherwise flat and mundane images, making them look more arresting. Lith printing is a curious combination of both high-contrast and low-contrast areas in the same print, combined with a base color ranging from pink to orange. In the darkroom, image contrast is controlled by enlarger exposure and print development, both far in excess of a typical print. Developing prints can pose problems too, and after an unnerving delay of five minutes or so, the image appears suddenly with increasing activity in the shadow areas. Infectious development spreads like wildfire and it can be difficult to know when to pull the print out of the tray. The purpose of this technique is to recreate the lith look but without the unpredictable nature of silver-based materials. In this project, we will use a range of Photoshop tools including Curves, Hue/Saturation, and Layer Blends, all applied as Adjustment Layers for maximum nondestructive flexibility.

Step 1

Starting Point

A good example to use for this technique is a plain monochrome image, which has a good range of textures and tonal variation. If you are starting with a color original, first make an Image > Adjustments > Desaturate command to drain away the color but leave in the RGB mode. For Grayscale images, perhaps scanned from black-and-white negatives, you'll need to convert to RGB mode first. The following process, like the conventional darkroom version, works best with low-contrast originals such as this example image.

Step 2

Duplicate the Layers

Once you are satisfied with your starting point, duplicate the background layer by doing a Layer > Duplicate Layer command. Do not be concerned at this stage if it looks flat and uninteresting. You will now have two identical layers floating above each other in your Layers palette, as shown.

Step 3

Colorize

Start by globally toning the image with an allover wash using the Colorize command and the Saturation slider, as found in the Image > Adjustments > Hue/Saturation dialog box. For this example, a very low value of saturation was used to keep the overall intensity down rather than overblown. Use the Hue slider to introduce a pinky-orange color.

Step 4

Make the Low-Contrast Layer

Switch off the Duplicate Layer by clicking on its tiny eye icon. Select the Background Layer and then do Layer > New Adjustment Layer > Curves. Now you need to adjust the curve into shape as shown, by dropping the highlight point a full quarter box and raising the shadow point a full quarter box. The

image will now look flat. This low-contrast reduction will serve to create the lith-type flat highlights in the final image.

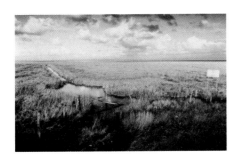

Step 5

Make the High-Contrast Layer

Next, switch the Duplicate Layer back on and select it. Apply a Curves Adjustment layer then create an "S" -shaped curve as shown. This will create a contrasty effect that will mimic the infectious development in the shadows. Press OK.

Step 6

Layer Blending

Once you have the two layers in place, each with a different contrast effect applied through individual adjustment layers, experiment with the different layer blending modes, as found within the pop-up menu on the top left of the Layers palette. By default, the blending mode is set to Normal, where no color reaction takes place between different layers. Yet, once this is altered away from the default, colors will start to react to each other in an unpredictable manner. Start by selecting the Duplicate Layer before changing the blending mode, as shown, to Soft Light.

The Final Result

By mixing the layers together, you can achieve this characteristic gritty appearance of a lith print. You can also try the Luminosity blending mode.

Changing the Tonal Balance

Lith prints can look really effective when combined with contrast filter effects, such as a deep red filter. Using Photoshop's innovative Black-and-White controls (available in both CS3 and CS4, but sadly not in earlier versions), it's possible to mimic the effects of filters and film, with the flexibility of adjustment layers. Open your image and do Layer > New Adjustment Layer > Black-and-White. Choose the High-Contrast Red Filter option from the drop-down dialog box. Next, resume the lith effect at Step 2.

The Final Result

By adding a red filter effect at the start, the original tones were flattened to produce this curious milky kind of effect.

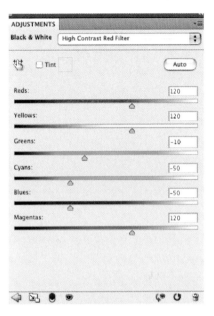

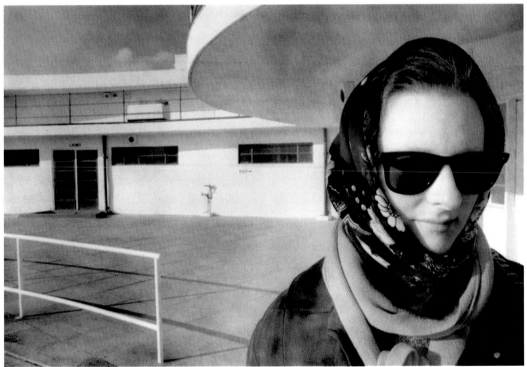

Preparing for Printout

Printer Software Basics

Preparing for Desktop Print

Like the tiny specks of grain in traditional photographic film, an inkjet printer uses tiny dots to create the illusion of color. Just like the commercial reproduction of photographs in magazines and books, an inkjet printer uses a variation of the halftone process using the same four Cyan, Magenta, Yellow, and Black ink colors. The resulting color print is built out of millions of tiny drops of color set at different distances from each other, and when viewed from a distance, these minute ink particles merge together to give the impression of continuous photographic color. Aimed at the professional photographer, better quality inkjets are designed to minimize fading and operate at high resolution. With pigment inks for greater stability but slightly less saturated colors, these devices cost more to buy and operate but give the highest-quality results. Printer software links with professional imaging applications provide useful color profiles to ensure a tight control over color management issues. Super high-resolution printers create ink droplets at different sizes to make a more photorealistic effect but when used with low-resolution settings will create

speckly results regardless of your images' resolution. Poor results will be made if the wrong media settings are chosen by mistake. The term resolution describes the actual number of ink droplets sprayed onto the receiving media and is expressed in dots per inch such as 2880 dpi or 1440 dpi. The bigger this number is, the finer and more photo-real your prints will be. Most printers can output to custom-sized sheets of paper in addition to standard letter and legal sizes. Better devices have roll paper feeders for printing panoramic images or a special pop-out tray for printing directly onto CDR disks. Never be tempted to use cheaper third-party ink sets, as this will cause both printer software and paper settings to underperform. For professional inkjets, special four- or six-tone monochrome cartridges can be bought for highest-quality black-and-white printing. Once you've made your image look good on-screen, the next stage is to prepare it at the right size and resolution for printout.

In printer software, preset controls decide printer resolution, paper type, and color balance and have a profound effect on the quality of your printout. The choice of media type will trigger a sequence of software adjustments, as shown on the right.

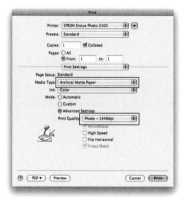
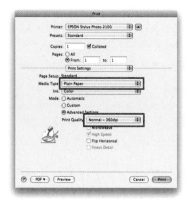

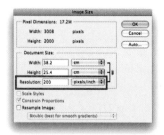

In Photoshop, open the Image Size dialog and first uncheck the Resample option. Next, change the Resolution to 200 pixels per inch (ppi); this will set the maximum print size available as shown in the Document Size readouts. It's not essential to prepare your images to match the 1440 ppi or 2880 ppi output resolution of your printer, as you won't see any increase in quality above 200 ppi. The most important controls for printing out at top quality are found within your printer software. After choosing the Print command, make sure that you pick the closest match to your print media from the Media drop-down menu, as this will have a huge influence on print quality. Next, set your print quality to its highest available option, sometimes referred to as High, Photo, or 2880 dpi.

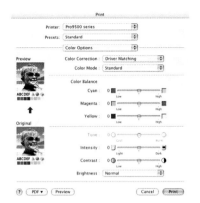

Always avoid selecting
any autocontrast,
color, and sharpening
controls, as these might
undo your carefully
corrected work.

Printer Driver Versions

All desktop printing devices have their own unique printer
software, which won't work with any other device. Printer driver
functions will depend on the specifications of the actual printer
itself. It's a good idea to check your printer manufacturers web
site for driver updates as these will contain refinements and new
profiles and are available free of charge.

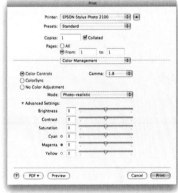

Image Resolution Essentials

Digital Camera Resolution

Surprisingly, pixels are not created with a fixed size, but the three
RGB ingredients in a pixel create the same color if the pixel is an
inch square or a meter square. You are responsible for setting the pixel size to
match the intended output. Using Photoshop's Image Size dialog box, pixel
size can be set at 72 per inch or 200 per inch. The number of pixels in the image
remains the same, but they can be made physically bigger or smaller. At an
inch square, pixels will look like tiles from a giant mosaic and would be a poor
photographic illusion. The smaller the pixels are, the more invisible they become
and the more realistic a printout will be. All digital cameras create images with
pixels set at 72 per inch, but if you made them smaller like 200 ppi, a printout
will become physically smaller, but the print will be much higher quality.

Scanner Resolution

Like the variously sized megapixel sensors found in digital cameras, flatbeds
are also sold on the basis of their resolution. Unlike digital cameras, scanner
quality is not described in megapixels or in pixel dimensions but by the ability
to capture pixels across one linear inch. In other words, a 600-ppi scanner will

create a 3600 × 2400 digital image from a 6 × 4 inch photo print. Even budget 1200-ppi scanners create more data than is really needed, and anything over 2400 ppi is overkill for desktop photo printing. Pound for pound, a flatbed scanner generates more digital data than a professional digital SLR and is a cost-effective route into digital photography.

Printer Resolution

Most printers can be operated in lower-quality or draft mode for making rough prints or layout proofs to keep your consumable costs down. A printer resolution of 360 dpi will drop fewer ink dots on the receiving paper even if your image is a high-resolution file. Best photo quality is made using 1440 or 2880 dpi, but expect each print to take a lot longer to print and more ink to be used. Never consider selecting High-Speed setting for photographic quality results. The choice of media may cause some printer resolutions to become unavailable as they are deemed inappropriate for the paper.

Preparing for Inkjet Print

Most inkjet printers' true Resolution, i.e., its capability to drop fine dots of ink on media, is somewhere between 200–240 droplets per inch, and there is very little visible difference in print quality between these two values.

Preparing for C-Type Output

When outputting to conventional color photographic paper, it's essential to prepare your images with a higher resolution such as 300 ppi. Digital C-type output is created when a laser light source "beams" data onto photographic paper in a lighttight environment. The laser is a high-resolution device, so your image file needs to be set accordingly.

Avoiding Resample Image

If the image resolution is altered with the Resample Image option selected, then new pixels will be added to your original file. On the example shown at the left, notice how the Pixel Dimensions have now increased, with the original starting point shown in brackets. Like enlarging small originals on a photocopier, resampling an image beyond 20% will indeed increase the document size, but the end result will be unsharp and of poor quality.

Aspect Ratio and Paper Shape

Paper Size and Sensor Shape

We are at an early stage in the development of universal shapes for digital data and there are many different standards in use. Many digital cameras now have sensors that produce images with slightly different dimensions, unlike the universally shaped 35 mm film, which always produced a 36 × 24 mm negative shape. Like the varying aspect ratio options found on a new television set such as 16:9 and 4:3, there are several different image shapes used in digital photography.

Aspect Ratio

Although there are now two common-sized image sensors used in SLR devices, the smaller DX and the full frame F, it's actually the aspect ratio of the image file that has a bearing on printout. Most digital SLR cameras capture images in the 4:3 or the traditional 35 mm–shaped 3:2 aspect ratio.

Multiaspect Ratio SLRs
The Panasonic Lumix SLR is a unique device that offers the chance to shoot in three different aspect ratios: 16:9, 4:3, and 3:2.

HDTV and Sensor Shape

Some recent digital cameras are designed to capture at the 16:9 aspect ratio, as used on high-definition television (HDTV) sets. With many consumers opting in to the HDTV revolution, camera manufacturers, such as Panasonic with their Lumix range, have seen an opportunity to link their product with a specific output shape. The 16:9 shaped images are obviously more panoramic in shape compared to the traditional 3:2 aspect ratio and can produce a visually pleasing result.

Paper Shape Considerations

Depending on the aspect ratio you are shooting with, you'll find the international paper shapes and sizes don't really fit. Shown right is the universal A4 paper shape compared with three common aspect ratios used in today's digital cameras.

3:2

4:3

16:9

A4

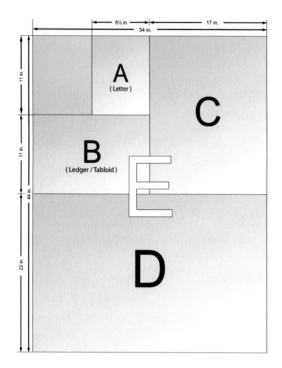
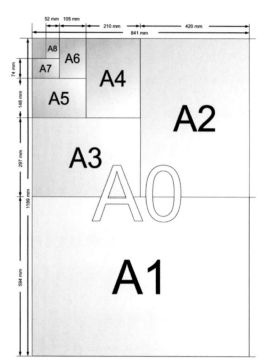

International Paper Sizes

In the United States, paper sizes are unified in the ANSI (American National Standards Institute) scale, as shown above. ANSI paper sizes are measured in inches.

In the rest of the world, however, a different system is employed using millimeters rather than inches. The A-size scale is in common use across the globe offering slightly shorter and narrower shapes compared to ANSI sizes.

Both systems follow the same scaling rules where paper sizes double or halve with each increment.

Oversize Shapes

Many paper manufacturers supply oversize paper shapes, so you can print an image to a full A-size with bleed. After the print has dried, you can trim the final print size to match. Super legal or legal+ are two commonly used sizes for use with desktop printers without an edge-to-edge printing function.

Print Dialog Basics

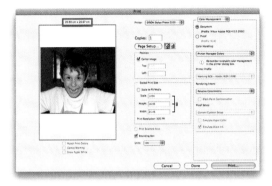

To preview how the image will appear on the current paper size, do File > Print. In the example shown above, the current letter paper size is too small, cropping the left and right edges off the image.

The original was prepared from a 3000 × 2000 file at 300 ppi.

Changing Paper Size

Click on the Page Setup button and change your paper size to a larger sheet. In this example, shown right, the paper size was changed from letter to legal, which enabled the entire image to be placed on the paper without changing the resolution.

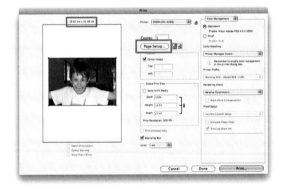

Changing Paper Orientation

Now, to flip the paper from upright (portrait) format to a more desirable horizontal (landscape) format, click on the tiny icon, as shown right. This will override any further orientation setting that you choose in the Page Setup dialog.

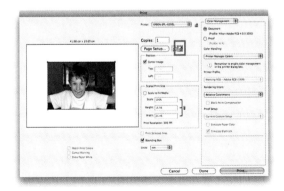

Drag and Drop Placement

You don't always have to position the image in the center of the paper, you can make an offset layout instead. To make this effect, deselect the Center Image option, as shown left, then click-drag the preview image to a new position on the paper.

Scaling Your Print Size

Photoshop allows you to enlarge or reduce the size of your image to fit your chosen paper size with the Bounding Box control. To use this command, deselect Center Image and Scale to Fit Media options, then select Bounding Box. Next, click-drag any of the four corner handles on the image to scale up or down. Notice how the Print Resolution value decreases if you enlarge or increases if you reduce. This 300 ppi example has shrunk to 217 ppi after enlarging, but the resize calculation is only temporary and is discarded once the file is sent to print.

Downside of Scaling in the Print Dialog

Although this is an effective method for visualizing the size of your printed image, the process uses the default image interpolation method to resample the image file, rather than a specific interpolation method for enlarging or reduction as found in CS4's Image Size dialog. In CS4's Preferences > General dialog, the default interpolation method can be set, as shown left, but you are always stuck with one method rather than the flexibility of choosing one of five different interpolation methods as found in the Image Size dialog, as shown at the left.

Canvas Size Adjustments

For certain print projects, it's essential to introduce an additional area of blank pixels surrounding your image file, and this is best made using CS4's Canvas Size dialog box. Canvas Size edits increase a documents dimensions without enlarging the image. Canvas adjustments are often used when you want to see your image reproduced on a nonstandard paper size, e.g., when preparing prints for a book layout or portfolio.

Using Canvas Size

From the Image menu, choose Canvas Size. In the New Size text boxes, enter in your desired size, as shown right. In this example, the image was arranged within a 29 × 21 cm canvas to match the exact size and aspect ratio of an letter sheet of paper.

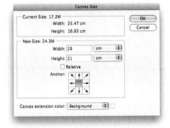

After the Canvas Size adjustment is made, the new pixels are displayed around the perimeter of your original image. Canvas Size pixels are always colored by default with the current background color, in this case white.

113

Canvas with the Crop Tool

If you prefer to visually judge the new Canvas Size as you edit, then you can use the Crop tool instead. Click-drag the crop until it surrounds the edge of your image, then pull any of the handles outward, as shown left, until a new perimeter space is created. For more accurate resizing, use the Info palette to provide an accurate readout of the documents new dimensions as you drag into place.

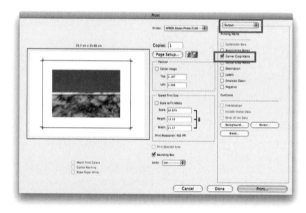

Marking the Edges of Your New Canvas on Oversize Paper

If you introduce a white canvas edge extension around your image, then this will be invisible when printed out onto paper. Instead, choose the Output option in the Print dialog, as shown left, followed by the Corner Crop Marks option. This will print four hairline crosses at the corners of your canvas to help when trimming the print with a blade.

Basic Multi-Image Layouts

Canvas Size adjustments can also be used for making multiple image layouts on a single sheet of paper. After increasing the size of your document, simply copy and paste additional images into the extra space, as shown left.

Test Printing

How to Make Test Strips with Your Inkjet Printer

If you've taken time to color calibrate your monitor and even worked out the best printer software settings for your paper, there's still no guarantee of perfect prints each and every time. Test strips help you to solve simple problems quickly and make better use of costly ink and paper consumables.

Central to the craft of conventional darkroom printing is the test strip. When thin pieces of photographic paper are painstakingly exposed to different amounts of light, the photographer generates a useful selection of variations to choose from. Yet, digital image-makers never printout variations and place too much trust in the self-correcting nature of printer software. When prints turn out wrong, most of us try another combination of printer software settings rather than modifying the image in Photoshop. With this straightforward technique, there's no need to copy and paste tiny image sections into a new document for proof printing. Instead, you can print a selection area onto a small sheet of paper from the very image you are working on. Any paper size can be used, but it's much more economical to set up a custom paper size in your printer software beforehand. Every printer has its limitations on minimum media size, but an letter sheet cut into four quarters will give you enough paper to test at least one image. It's rare that you'll need to make more than a couple of different test strips, but if you do, then it's a good idea to label them with any corrections that you have made. Never adjust image size or resolution between tests and final print, or you will need to start all over again. When test strips are ejected by the printer, its important to let them dry before making your decision, as some papers with sticky top coats can take a couple of minutes to absorb ink and dry. Always judge your results under natural daylight from a nearby window.

Filling-In

Inkjet printers are prone to filling in the near shadow areas of an image, unless careful adjustments are made before printing. Printer ink values are ranged on a 0–100% scale and can display little tonal separation above 90%. Dark and atmospheric images need careful preparation and if in doubt it's a good idea to prepare an overall lighter image or brighten your shadows with the Curves controls.

Step 1

Defining the Test Area

Make sure your selection includes both highlights and shadows. Once your image is ready to print, select the rectangular marquee tool. Make sure that the feather value has been set to 0, then click-drag a rectangular selection

115

that includes a cross-section of highlights, shadows, and midtones. On portraits, this should be based on a skintone area. Ensure that this selection area is smaller than your intended printing paper.

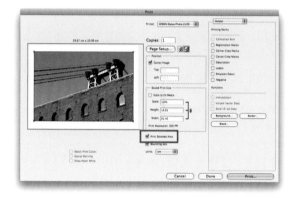

Step 2

Sending to Print

Make your printer software recognize your selection, choose Print from the File menu, and in the printer software dialog box, select the Print Selected Area option. This command will print your selection in the center of your chosen paper size. It's important to use the same paper for both test and final print or you'll get an inconsistency that you can never solve.

Analyzing the Results

Monochrome or toned images frequently print darker than expected due to the way RGB image colors are translated into printer ink color. Shadow areas can also start to fill in and prevent image detail from appearing. Color prints also become much less vivid when dark. To correct your image, cancel the selection, then use your Levels midtone slider controls to lighten up or darken down.

Correcting Problems with Levels

The Levels dialog is the easiest and most effective way to manipulate midtone brightness, the cause of most printing problems. Move the central triangular slider to the left to brighten the image or move it to the right to darken it. Be cautious with your adjustments and work in steps of no more than ten at a time.

Gridding up a Test Page

You can make further advanced test by copying and pasting several variations at a time into a new document, as shown below. Be cautious and ensure that the new document is created with the same profile and color space as your original file.

Plug-In Test Modules

Canon's innovative Easy PhotoPrint Pro plug-in print dialog provides a useful testing function, as shown at the left. Although the individual test image is printed out at thumbnail size, the test print provides useful information on color balance and brightness.

Sharpening

How Sharpening Works

Sharpening is nothing more than increasing the level of contrast between adjacent pixels. In a soft-focused photograph, colors are very gray overall and particularly muted at the edges of different shapes. In a pin-sharp example, however, colors are much more widespread and have inherently more contrast, particularly at the boundary edges of shapes. All digital camera images are captured with a slight soft-focus effect due to a hidden antialias filter fixed in front of the sensor to prevent the destructive effects of jaggy staircasing. No digital camera will produce images that can't be improved by software sharpening, which should be applied as the final processing stage just before printout. Despite the presence of in-camera sharpening settings and sharpening filters on film and flatbed scanners, its much better to capture an image unfiltered, as you can't remove the effects of a crude filter afterward. Sharpening, like many other processes, ultimately can be destructive if applied too early in an editing sequence causing visible artifacts, which become more noticeable with each successive color or tonal edit. If resizing upwards or downwards is your thing, then these resampled images should be sharpened too, as interpolation causes an inevitable loss of original image detail. CS4 is supplied with four sharpening filters, Sharpen, Sharpen More, Sharpen Edges, and the Unsharp Mask, all of which can be applied to the image overall or to a smaller selection area. Only the Unsharp Mask filter can be modified to address the precise problem posed by individual images.

The Unsharp Mask filter

Found under the Filter > Sharpen > Unsharp Mask command, the USM has three controls: Amount, Radius, and Threshold. Amount describes the extent of the change of pixel color contrast with high values suitable for more out of focus images. The Radius slider is used to determine the number of pixels surrounding an edge pixel, with low values defining a narrow band and high values creating a thicker edge. Radius is best slid towards the high end until edges are sharp, but not in relief. The final Threshold modifier is used

to determine how different a pixel is from its neighbors before sharpening is applied. At a zero threshold, all pixels in an image are sharpened equally resulting in a noisy and unsatisfactory result. Set at a higher value, less visible defects will occur overall.

Permanent Sharpening Flexibility

For many Photoshop users, playing with the sharpening functions were a high-risk activity: pushed too far and the results looked obvious and, even worse, if the command was saved by mistake, it was embedded permanently in the file. What often complicated matters was the need to print or prepare files at many different sizes and resolutions, so no single Unsharp Mask setting would ever suffice. In CS4, sharpening can be applied as a clever Smart Filter, floating over your image, either edge to edge or through a mask and permanently editable. This effectively means that you can now save a sharpening-based command with your file, without any danger of limiting your future editing. To clear up any confusion, the new Smart Sharpen filter does not as its name suggests, apply a nondestructive command straight out of the tin. It's merely called Smart, because, it's, well, smarter than the previous sharpening filters.

Always judge your final printout before considering any increase in USM sharpening. Paper surface, printer settings, and image resolution can all play their part in changing the sharp appearance of your image. If you do need to resharpen, return to the Smart Filter layer and adjust.

Printing with Profiles

Profile Essentials

Why Use Profiles?

There's simply no reason to use output profiles if you continue to use an Epson, Canon, or HP printer, along with the same brand of ink and paper types. When printer manufacturers design their unique printer driver applications, they include purpose-made profiles for each of their own type of media within the driver itself. In fact, by choosing one of the Media Type options from the printer software, as shown right, you are unconsciously linking your print to a hidden output profile.

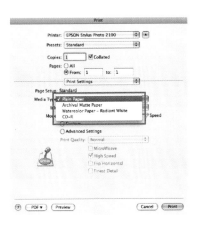

Using Third-Party Products

However, if you decide to use third-party papers and inks, printing with a profile is essential. Although most third-party papers are supplied with recommended printer driver settings, these rarely

produce adequate result when compared with prints made with their purpose-made profiles.

What Profiles Do

No Epson printer driver knows exactly how to convert the color of each pixel into the exact proportions of ink colors to get the best out of a third-party paper, such as Moab. Instead, the third-party paper manufacturer provides free profiles for you to bolt on to your work flow. The best way to visualize the function of a profile is to think of it like a language translation service. The bespoke profile converts English sentences to French, ensuring that the original values are carried over from the source.

What Profiles Look Like

In reality, profiles are tiny data files, often no bigger than 100Kb in size, which provide a service for translating pixel color into ink colors. Profile documents are identified by their file extension ending in either .icc or .icm.

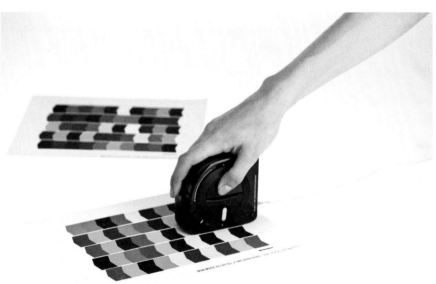

How Profiles Are Made

Output profiles work by linking three critical variables together: printer model, ink type, and paper type. Each profile document can only support one configuration of these three variables, so if one of these are changed, the profile is rendered useless. Most profiles are made by printing out a standard color test chart using the desired printer, ink, and paper combination, which is then scanned by a spectrophotometer, as shown on the previous page. This device is plugged into your PC and works within a profile creating application. Once each tiny color patch is scanned by the spectrophotometer, the software estimates the characteristics of the color, then makes a recommended ink recipe. In essence, the profile decides how to adjust the mix and quantity of printer ink, so that you get the very best results possible.

Profile Naming Protocol

All paper manufacturers supply their own profiles for free download and most of them follow a standard naming protocol for the filename, which includes each of the three identifying variables. As shown at the right, the profile name starts with the printer model (Pro 9900_7900) followed by the paper name (Archival MattePaper), then ink type (MK or PK). You can't rename profile documents unless you edit them in a profiling editing application.

- Pro9900_7900 ArchivalMattePaper_MK.icc
- Pro9900_7900 ArchivalMattePaper_PK.icc
- Pro9900_7900 Canvas_MK.icc
- Pro9900_7900 Canvas_PK.icc
- Pro9900_7900 DoubleweightMattePaper.icc
- Pro9900_7900 EnhancedAdhesiveSyntheticPaper.icc
- Pro9900_7900 EnhancedMattePaper_MK.icc
- Pro9900_7900 EnhancedMattePaper_PK.icc
- Pro9900_7900 EnhancedMattePosterBoard_MK.icc

Installing Profiles

Where to Get Them

All third-party paper manufacturers provide free profiles for download from their company web sites. Shown right is the Epson section of the Innova web site, where profiles can be downloaded for a number of different printer models.

What Printers Are Supported

All the bigger paper companies provide support for the latest Epson photo-quality printers but not necessarily for office desktop printers or discontinued models. If you are considering buying a printer, it is a good idea to check if your favorite paper manufacturer supports your desired device. Fewer paper manufacturers support Canon and HP inkjets.

How to Get Hold of Profiles

After finding the correct section on the web site for your printer and ink type, each of the paper profiles can simply be downloaded to your desktop.

How to Load the Profiles into Your System

Profile documents need to be placed in the correct folder or they simply won't be available for use. On an Apple OSX system, drag the profile into Library > Color Sync > Profiles, as shown left.

On Windows Vista systems, it's even simpler. Once the profile appears on your desktop, right click on its icon and choose the Install Profile option, as shown left. After this, the profiles can be found in Windows\system32\spool\drivers\color folder.

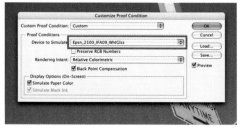

Checking if They Have Loaded Correctly

To see if your profiles are recognized by CS4, open an image file and then do View > Proof Setup > Custom. Click on the Device to Simulate pop-up menu, shown below, and hunt for your desired profile.

Managing Your Profiles

Many profiles are already loaded into your system as part of the basic software pack, and even more are added when you install printer software. This can result in a giant long list of output profiles to choose from each time you decide to print. A good way of managing this situation is to create a new folder called "unused profiles," where you can store unused or unlikely to be used documents.

Printing with Profiles

Step 1

After editing your image, choose your target printer, as shown below.

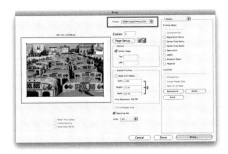

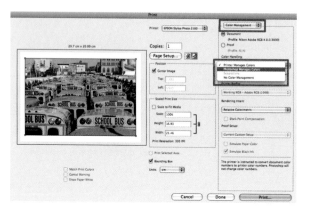

Step 2

Click in the Output drop-down menu, then choose the Color Management option. Next, choose Deselect Printer Manages Colors and choose Photoshop Manages Colors option from the Color Handling pop-out menu.

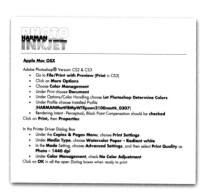

Step 3

Now, refer back to the instruction sheet that accompanied the downloaded profile, as shown left. The instructions will tell you which of the rendering intents to choose.

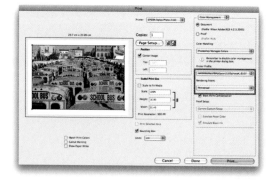

Step 4

For this example, Perceptual is the recommended option. Then press Print.

Step 5

After entering the Printer software dialog, the next step is to match the Media Type to the profile's instruction sheet. For this paper, Watercolor Paper-Radiant White is the recommended option, together with the 1440 dpi print quality.

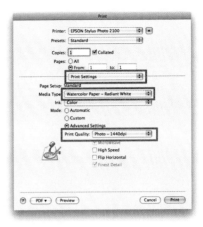

Step 6

The final step is to switch off the Printer software's own color management functions so that Photoshop and the profile translate pixel color into ink. Choose the No Color Adjustment option, then press Print.

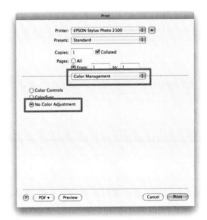

Saving Printer Settings

Why Save Printer Settings?

If you plan to print with profiles, it's very easy to forget to set the correct media type and resolution and switch off the color management functions in your printer software. However, it is possible to save a configuration of settings, so you only have to define the settings for a profile once.

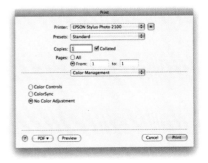

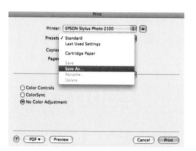

Step 1

Making a New Preset

Set the printer driver to match the instructions provided with your printer profile. Next, click on the Presets pop-up menu and choose Save As, as shown at the left.

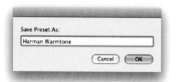

Step 2

Naming Your Preset

In the text box, type in a recognizable description of your paper type. Press OK.

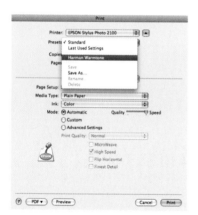

Step 3

Quick Check

Check that it's been created, click the Preset pop-up menu, and see if the saved setting is present.

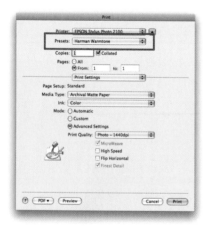

Step 4

Using the Preset

Next time you use the profile, simply pick the paper preset from the pop-up menu, as shown left. All options connected to the preset will now be set automatically, so that you don't have to do it manually.

Making Your Own Profiles

When to Make Your Own Profiles

If your printer model isn't supported with free downloadable profiles, or if you choose to use three unconnected brands of printer, ink, and paper, then you'll need to make your own bespoke profile. Many photographers also prefer to make their own profiles to match the subtle idiosyncrasies of their own workstations and media, even though off-the-shelf profiles are available. If you decide to print on to nonstandard paper, such as artists cotton papers or watercolor paper, you can really improve their performance with a profile.

What You Need

To make your own profile, you need a spectrophotometer like the EyeOne device from X-Rite, as shown right and below right. This kind of gadget is available for about the same price as a professional inkjet printer but also can be rented from a prophotography outlet. At this price, the sensing unit is handheld, but if you double your budget, you can buy a fully automated model.

Printing the Test Chart

The first step to making a profile is to select the appropriate IT8 test chart, as shown at the right. Supplied with the profiling device as a digital file, the text chart is opened within the profiling application (rather than Photoshop) and printed out onto your desired paper material.

Keep a Note of Your Test Settings

If you are profiling nonstandard media, you will need to experiment with different printer software settings to see which combination of Media Type and resolution produces the best results. Don't accept the first print; try different media settings. For uncoated media such as cartridge paper, you'll get the best results with low-resolution printer settings such as 720 dpi or even 360 dpi. Make sure that you keep a record of your settings, as these will need to be replicated each time the profile is used.

Commissioning Bespoke Profiles

If you don't fancy investing your capital in a profiling device, you can get profiles made from independent providers. The process kicks off online where you download a sample test chart, then this is printed out and sent to the service provider through the post. Once the test chart is scanned, your provider will e-mail the bespoke profile to you as an attachment. Prices for this service start at about $25/$30 per paper type.

Colormunki Test Charts

The Colormunki device is a low-cost, high-quality unit for calibrating monitors and making printer profiles. The Colormunki uses smaller color test charts with fewer sample colors compared to the EyeOne device, but results are impressive.

How the Profiler Works

Once the test print is placed in a special holder, as shown below, the spectrophotometer is plugged into your PC and tracked across the dry test print line by line. After scanning 20–30 lines, the profiling software makes the recommended color translation values and saves it in a single document.

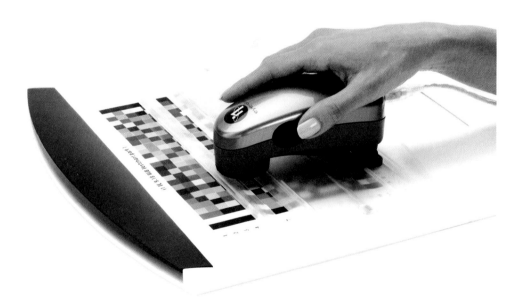

Using Profiles for a Remote Printing Service

When to Use Them

If you are sending digital files through a network to a remote printing unit, it's best to embed the output profile into your file before sending it off.

Many photographers prefer to output onto conventional color photographic paper, such as the C-type, which offers exceptional color saturation, high resolution, and of course, the benefits of chemical permanence.

C-type prints are produced using a laser imaging device that "beams" light onto photographic paper, much like an old-fashioned enlarger projected light on sensitive materials. After the photographic paper is exposed, it is then fed into a chemical color print processor where it emerges dry after 8–10 minutes.

C-Type Paper Profiles

Just like inkjet paper profiles, chemically processed color paper can be profiled, too. Like CMYK press profiles, C-type paper profiles are not generic but are provided by each professional lab, calibrated to their own individual equipment and conditions.

The PrintSpace

The PrintSpace is a professional lab, providing high-quality inkjet and C-type output for photographers. Prints are available as a walk-up service or via a handy online ordering service. The PrintSpace provides profiles for all their paper types, so you can fully manage color from your own desktop.

www.theprintspace.co.uk

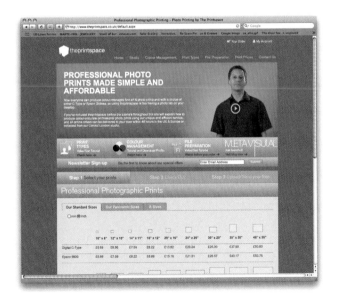

Internet Photolab versus Professional C-Type Output

Although there are many Internet-based photolabs offering cheap C-type prints from your JPEG files, they rarely provide profiles to the end user. Many photolabs also apply an unknown amount of autoprocessing to your submitted files, such as auto contrast and sharpening, so the results can look very different to your expectations. Better prolabs avoid processing your images, so you can determine the final look of your print.

Preparation Tips

Flatten your files if they are layered.
Convert back to 8-bit per channel.
If you are asked to send JPEGs only, ensure that they are high quality.

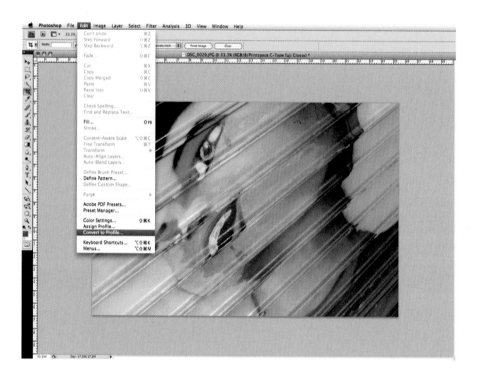

Packaging an Image for Remote Printing

Once you have chosen your professional service provider, download the profile pack for their C-type or large format Media Types. After installing the profiles, edit your file using the paper profile as the soft-proof. When complete, do Edit > Convert to Profile, as shown above. Next, choose

your paper profile in the Destination Space and match the recommended rendering intent as per profile instructions. These settings will be identical to the setting used in your soft proofing view.

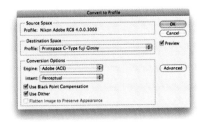

Finally, do File > Save As and rename your file, so that you don't overwrite your original source file. It's now ready to send. When it arrives at the other end, the color is already translated to the correct "language" so no unexpected adjustments take place.

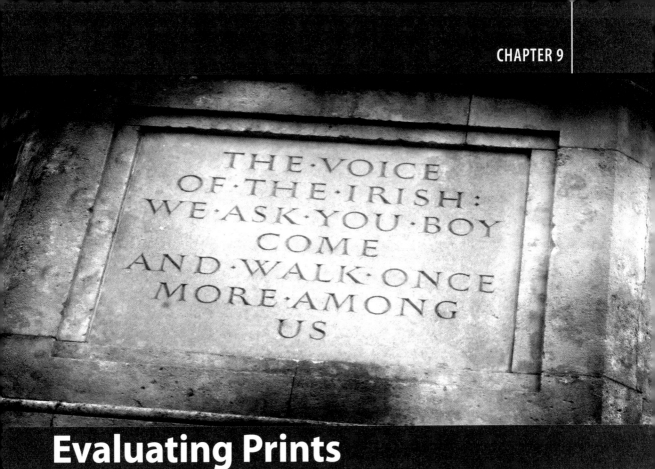

Evaluating Prints

What Makes a Good Print?

Taking a stunning digital photograph is only one half of the task; making a print that does it justice is far more time-consuming and never happens by accident. The definition of a good photographic print is identical for both digital and silver-based photographs. Good prints exhibit a rich tonal range between small areas of full black shadows and clean white highlights; fine details are present and visible without needing to scrutinize at close distance. Finally, the principle subject should be clearly emphasized using variations in light and dark to direct the viewer's attention away from any irrelevant details. Poor prints have a compressed tonal range, lack any emphasis, and hide image detail under a shroud.

Desktop printing is fraught with technical hurdles, principally the creeping increase in shadow areas when an image is translated from the monitor to the printed page.

Testing Paper

A good way to confirm that your paper profile is working correctly is to print out a test print first, like the useful example shown at the left. Many test images are available as shareware on the Internet and the better ones provide a composite of tone steps, color charts, and a full range of extremes, so you can see if the paper is reacting properly. This excellent example is available as a free download from www.billatkinson.com.

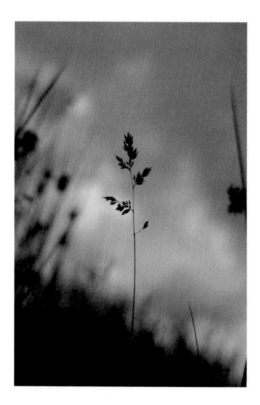

This finished print was prepared with a lower than normal contrast, combined with a subtle toning effect.

Viewing Conditions

Ideal Illumination Conditions

Like the D65 (or 6500K) used to set a universal white point for computer displays, there is also a standard for artificial illumination. The D50 lighting standard is fast developing as the recommended conditions for viewing color prints for critical color evaluation. Although we perceive daylight and artificial light as colorless, they are in fact both hugely variable and unreliable. To make matters worse, color digital prints will absorb and reflect different colors depending on the type of illumination they are evaluated under. There's no sense spending time, money, and effort on calibrating your workstation if your working environment is lit by orange domestic lights or green fluorescent tubes. Correct color evaluation in these circumstances will be impossible.

If you are planning to redesign your workspace, try and limit the amount of variable light entering the space such as strong sunlight and avoid using brightly colored paint or wallpaper, as these will reflect color back onto your carefully prepared prints. If you are prepared to go the distance, opt for a gray wall paint, which corresponds to the Munsell 8 reference color with 60% reflectance.

Viewing Booths

For a fully professional workspace, a color-corrected print viewing booth, such as this example shown below from Just Normlicht, provides an accurate colorless-controlled viewing environment. These booths are available in most professional photolabs and are manufactured in a variety of sizes to accommodate big prints.

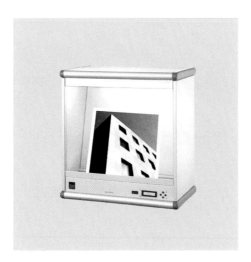

Room Lighting

An alternative to an expensive viewing booth is to replace overhead lighting fixtures with purpose-built lighting. Designed specifically for graphics studios, these lighting banks provide a diffused color-corrected light.

Budget Fluorescent Tubes

An even cheaper option is to replace fluorescent tubes with color-corrected D50 tubes. Be very careful in your choice of product, as many products branded "daylight" do not conform to the universal D50 color temperature.

Correcting Color

Solving Cyan Casts

When prints emerge with an overall cold appearance, they are likely to be suffering from a Cyan cast. Any reds in the image will look duller than expected and skies will look vivid. To solve this issue, open the Color Balance dialog and move the top slider towards the Red end. This example below on the left needed a +20 correction.

Solving Blue Casts

Blue casts are very different to cyan and are characterized by an absence of yellow. Other indicators are strong sky colors and grass that looks weaker than expected. To correct a blue cast, open the Color Balance dialog and move the bottom slider towards the Yellow end. This example below in the middle required a –20 correction.

Solving Green Casts

Green casts are easy to spot but mustn't get confused with yellow color casts. A good indicator of a heavy green cast is ultravivid grass and sallow skin tones. Green casts also can be caused by a combination of a fluorescent light source and an incorrect white balance setting. To remove green, move the middle slider towards the Magenta end. This example below on the right required a –25 adjustment.

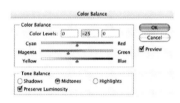

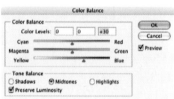

Solving Yellow Casts

Yellow casts are difficult to see because they can add a pleasing warmth to the image, just like sunlight. You can spot excessive yellow in sky areas, which turn almost monochromatic. Green colors also look warmer than they ought to. To remove excessive yellow, move the bottom slider towards the Blue end. This example above on the left required a +30 adjustment.

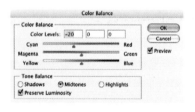

Solving Red Casts

Differentiating between red and magenta can be tricky for a novice eye. However, red casts are characterized by turning greens slightly muddy but warm. Overall, image colors are warmer than those affected by a magenta cast. To correct red, move the top slider towards the Cyan end. This example above in the middle required a −20 adjustment.

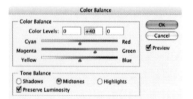

Solving Magenta Casts

Like red, magenta drains green colors of their intensity. However, magenta casts impose an overall pinkish tone to the image, which is clearly colder than red. To remove magenta, simply move the middle slider towards the Green end. This example above on the right required a +40 adjustment.

The corrected image

Correcting Light Prints

Checklist Before Changing

Check that you're using the correct profile.
Check if the rendering intent matches the profile's instructions.

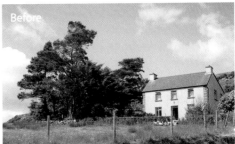

Fixing Light Prints

Light prints are characterized by weaker color saturation and some loss of detail in bright highlight areas.

This example to the right shows how color saturation is improved with the correction applied using a slight Levels adjustment.

The midtone slider was dropped from 1.00 to 0.72 and the resulting print looked punchier.

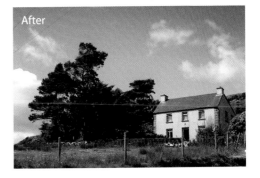

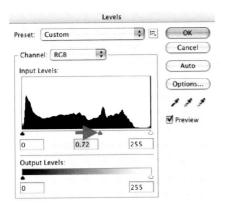

Saturation and Brightness

Light prints will always lose color saturation and may even appear "bluer" than expected.

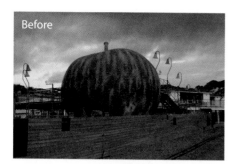

Correcting Dark Prints

Fixing Dark Prints

Dark prints can sometimes appear more dramatic and eye-catching but will always squash image detail.

This example to the left shows two prints from the same image file. Notice how much better the giant red apple looks after a very small adjustment in the Levels dialog.

To brighten images, increase the midtone value from 1.00 to 1.20.

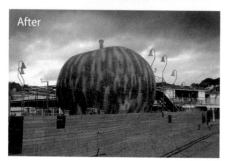

Checklist Before Changing

Check that you're not using Printer Manages Color.

Check that you're proofing to the correct profile View > Custom Proof.

Check that your monitor profile is the most recent.

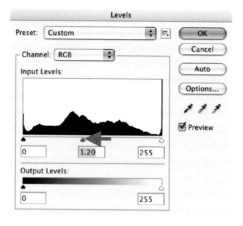

Casts Caused by the Wrong Profile

Using a profile designed for a different printer caused this original image below on the left to reproduce in an entirely different way.

Protecting Your Prints

Working in the same way as varnish applied to an old master painting, UV protective print coatings can increase the life span of your work. Available from all good ink and media manufacturers, these products are applied to your prints after they have dried sufficiently and effectively encapsulate the unstable ink within a sandwich of paper and coating. However, despite the fact that research has shown that longevity is increased by using these products, a similar rise in life span is gained when prints are mounted within a sealed frame. It is atmospheric pollutants that cause printing ink to deteriorate, not just excessive exposure to sunlight.

Coatings are used by many professional photographic printmakers to provide an extra guarantee for potential purchasers, so that they can sell work with the same assurance of a silver-based photographic print. For smaller pieces of work, print coatings can be applied by brush, a technique that will raise the color saturation of the print, just like a transparent varnish would do to an artists paint on canvas. Larger pieces are best sprayed with coating, using an air compressor within a booth with forced extraction. For large prints, it is best to apply sprayed coating in a sweeping motion, ensuring that the print is evenly coated across the surface.

Lyson Print Guard

One of the first products to offer additional protection from UV light and other airborne contaminants, Print Guard is available as an aerosol spray. It's designed to work with most water-based inks and watercolor and provides a protective shield from the damaging effects of water. A typical application of Print Guard would be to spray your print two or three times, allowing it to dry in between applications. In addition to providing this kind of protection, Print Guard can also ward off excessive color shift, due to prolonged exposure to light. A typical example of this occurs with nonlightfast inks, which frequently faded in less than three months. Made from dye rather than pigment, these inks were so unstable, each color would fade at a different rate, resulting in prints that would turn into entirely green or cyan versions of the original.

Life Span

Nowadays, the life span of digital prints is compared favorably with silver-based media. Get into the habit of using the very best inks that you can afford, as they will ensure that your print lasts the distance over time. Inks such as Epson's Ultrachrome offer exceptional lightfast properties and, when used with archival paper, are projected to last longer than a silver-based color print. Never choose the option of cheaper third-party inks, as these will have been

prepared using unstable dyes and are available at a cheap cost because they were made from cheap ingredients in the first place. It's much better to print less with very good media and good pigment inks.

Display Considerations

To ensure maximum protection from contaminants and to extend the life span of your print, it's essential to provide careful storage conditions to support any coatings that you apply. Avoid chemicals at all cost, such as adhesives or cheap cardboard, as these will likely contain harmful bleaches and dyes that could harm the delicate surface and color balance of your print.

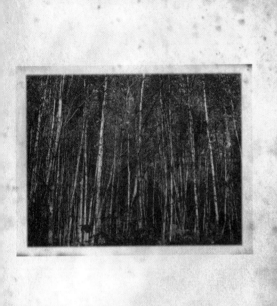

Creative Print Styles

Toning

Historically, photographic print toning has used chemical toners like sepia and selenium to make prints with fairly limited colors ranging from brown to purple-reds. With the digital process, however, there are many more color options available together with a near Zone System level of control. For the fainthearted, this digital route is also reversible, so there's no danger of ruining your perfectly good image file. Subtlety, if you want it, is there in bundles, with no need to produce intimidating Colorvir-like prints, unless hallucinogenic effects are your thing. Digital coloring in CS4 means you can have infinite control over the toning process adding color across the whole image or dropping it in up to ten different tonal sectors. Following is a number of different routes to image toning, starting with the easiest and ending with the more interesting Duotone techniques.

Starting Points

Unlike the darkroom process, you can begin with three different types of image modes, Grayscale, RGB, or CMYK, but you must convert to a desaturated RGB image before you start. If you have a full color image, such as a scan from a color tranny and want to apply an all-over digital tone effect, like selenium, drain the color away by Image > Adjust > Desaturate. This is useful, because the result stays in the RGB color mode.

Using CS4's Variations Dialog Box

Found under Image > Adjust > Variations, the Variations preview window promptly displays your image surrounded by a range of colored options. In the center box is your image in its current state, surrounded by six color variations, with a lighter and darker version on the right-hand side. At the top right is a slider for increasing or decreasing the increments of change, but best is to start at the Fine end rather than at the Coarse end. Click on any color variation that looks good and watch it affect the center image. You can apply as many adjustments as you like and if you go too far, click on the "original" box (top left) to revert back to your starting point.

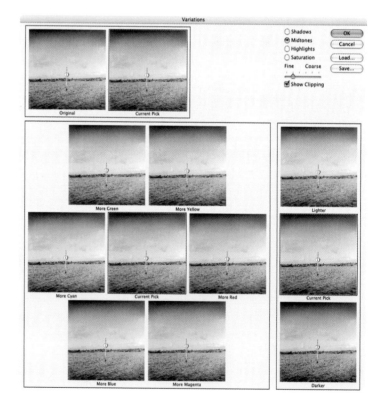

Once you are happy with the result, press OK to see the full-sized image. This is by far the easiest way to add image tone, but any subtle changes may be invisible at such a small scale. The final example was created by clicking magenta and cyan.

A weak color image can be transformed radically into a better type of print by toning. This example, shown at the left, started off as a scan from a color negative (top), which was then desaturated before being toned with CS4's Duotone functions.

Toning

Using the Color Balance Control

Much more sophisticated results can be gained by using CS4's Color Balance controls. In darkroom terms, this is like printing a black-and-white negative on to color paper using the enlarger's color filters. Make sure that you have a desaturated RGB image first, then go to Image > Adjust > Color Balance. Here you are faced with familiar Cyan to Red, Magenta to Green, and Yellow to Blue opposites. Move any sliders until you achieve the desired tone effect, but keep the Midtones and Preserve Luminosity buttons checked for best result. You can apply a different color to the highlight and shadow areas, too, by checking their respective buttons and then moving the sliders making a more subtle mix. The example had −22 yellow, with −19 magenta and +27 red applied to the midtones. Avoid saturated colors and be careful about making the image too heavy, as midtones and shadows will clog up during printing.

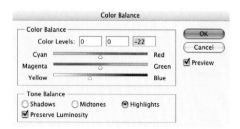 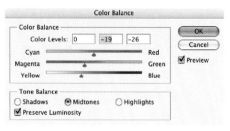

Using Hue and Saturation

This command gives you the chance to tone with a similar range of colors, having additional control over its saturation or color intensity. Like split-toning photographic prints, using Hue/Saturation can add delicate washes of color to your images. You can start from a full color RGB image, then do an Image > Adjust > Hue/Saturation (6). First, check the Colorize button (bottom right) and observe the dialog box split into three sliders. Your image will have already taken on the default tone. The Hue scale is a linear representation of the color wheel and by sliding along, you can change the overall color. The Saturation slider dictates the color intensity and is best left on 10–15. The final scale

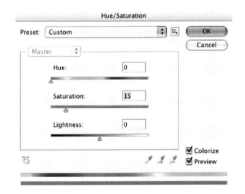

is Lightness, working a bit like a primitive "exposure" adjuster, and is best altered in tiny increments or left alone altogether. Very delicate tones can be applied to your images with this process by moving the Saturation levels lower, allowing you to mimic toners such as selenium. The examples above show three different color variations using the Colorize command.

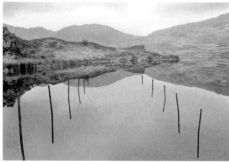

Using Duotones

Duotones

By far, the most sophisticated way to digitally tone an image is to work in the Duotone mode. Duotones are traditionally used in the lithographic printing industry to reproduce high-quality monochrome images, such as those found in Aperture photography books. To mimic the look of an original photographic print, perhaps printed on a warm tone paper or finished with toners, book designers call for additional litho inks to be used. In basic lithographic reproduction, such as a black-ink-only newspaper, grayscale images are printed with one color: standard black ink. Despite 256 levels of gray present in the digital image file, the litho process reduces this down to about 50. The effects of this are disastrous and look very crude. As each additional ink color needs a separate printing plate, adding to the overall cost, quality comes but only at a premium. However, with the introduction of each new color, a further 50 tonal steps are added, edging ever closer to faithfully reproducing that original photographic print. In many Aperture monographs, additional warm brown and light tan inks are often used to retain the "feel" of the photographers' work, and part of the book's higher than average cost can be due to tritone (three ink colors) or quadtone (four ink colors) printing and the complex film separations that need to be made.

Surprisingly, Duotone mode (and tritone and quadtone) digital images can be printed out by most desktop inkjet printers, so the process need not only be restricted to litho output. The most interesting aspect of toning in this way is that you can work with a personal swatch of colors, manipulating each in up to ten different tonal sectors.

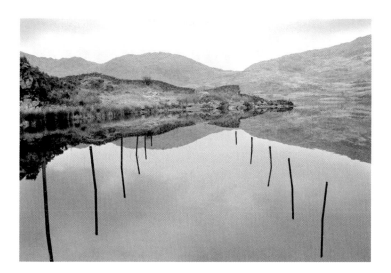

Making a Simple Blue Duotone

Start with a grayscale image, then do Image > Image Mode > Duotone. In the
Duotone dialog box, black is set as the default first ink color and there will be a
blank box next to Ink 2. Clicking this blank box reveals the Color Picker, where
you can choose the second color or click on Custom and select a Pantone color,
such as blue 279 C. Photoshop immediately updates your image window,
(behind the dialog), showing the effect the blue creates. Next, click on the
small curve graph to the left of the ink color square. Like the Curves controls,
pulling or pushing the straight line will darken or lighten the blue color.

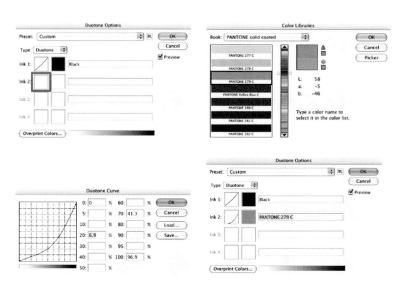

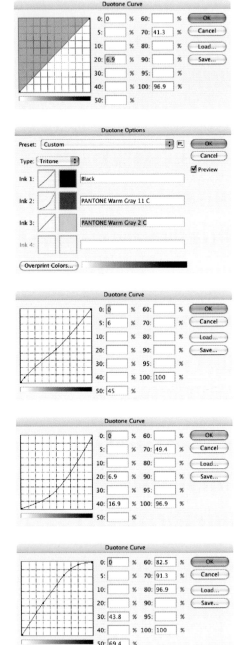

Using the Duotone Curves Dialog Box

If the concept of curves still eludes you, using Duotone curves can make things much clearer. Printing ink is usually expressed in percentage terms, and in the curves dialog, the normal grayscale range of 0–255 is converted to a 0–100% scale. The graph is divided into ten sectors, with each square representing a 10% step in tone. The line is a straight diagonal by default, meaning each original grayscale value is substituted with the same percentage of new color with highlight bottom left and shadow top right. You can manipulate the color by clicking anchor points on the curve and moving them. By pushing the curve into the pink zone, this will darken the color and pulling into the white zone will lighten it. To make things even clearer, there's a text box to the right, which corresponds to your anchor point, giving a readout of the new color value as you move the curve. If you want to remove an anchor point, just press the delete key. You can leave the curve alone all together, and just type new values in the text box, watch the curve change shape and your image changing color. If you think of these 0–100% values representing ten tonal zones from highlight to shadow, you can see the huge creative scope for manipulation.

Fine Tuning

Most problems using this method occur if you let all inks (colors) run into the shadow areas, giving heavy prints with spreading blacks. The tritone example (opposite) was created with three ink colors: black, brown, and tan. Both black and brown inks were pulled in the midtones to lessen their effect, shown left, but the tan color was pushed further into the highlights, shown left bottom, to make it more evident. The final result (left bottom) shows a finer distribution of tone than previous methods. If you want to stop the new color reaching the shadow areas, type 60 in the 100% box, watch the curve change shape and that color drop out of the shadows altogether. To make the midtones lighter, type 10 in the 50% box. This way, you decide which tonal sector the color sits in and how bright it is in that area.

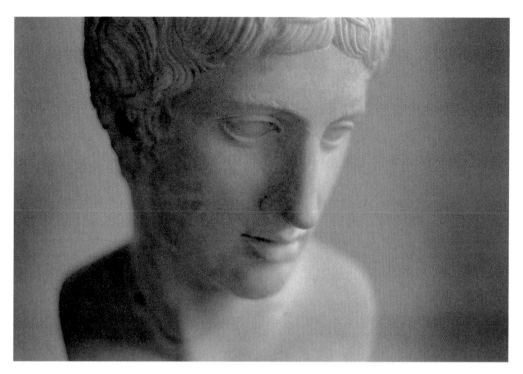

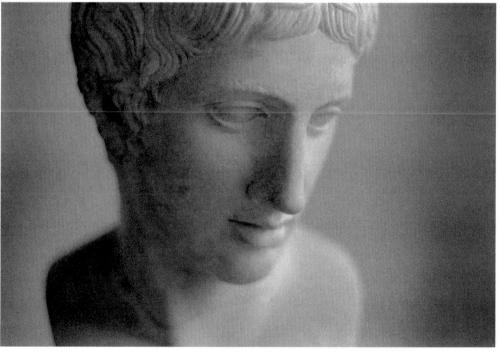

Using the Duotone Presets

Photoshop comes with a set of ready-made duo, tritone, and quadtone "recipe" files, which can be loaded for use on your grayscale images. To apply one of these "recipes" to your image, click on the Custom pop-up menu in the Duotones dialog box and select any of the premixed color recipes. There are some excellent examples that can be used to mimic warm, cold, or vintage photographic papers. Most important, the unusual curve shapes in the ready-mades give you a very good idea of how to control color distribution. This example above was created using a vivid orange for the third color, although you'd never believe it in the final result.

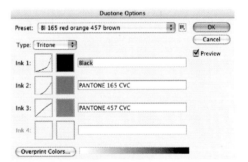

Saving Duotone Recipes

When you arrive at a combination and blend of colors that you like, you can save the recipe as a Duotone settings file. This tiny data file can be saved and stored away for use on future images, and like the hard-won chemical toning techniques, you can preserve your findings and swap them with other users. There are many Duotone recipe files available over the Internet, developed by enthusiasts and posted as shareware.

Making a Cyanotype

You can reproduce this technique by starting with a grayscale image scanned from a negative, print, or object. The example shows a group of fabric and leaves scanned together with a sheet of writing paper, avoiding the need for cutting out. After correcting, do an Image > Adjust > Invert to recreate the negative effect of contact printing. Change the image mode to Duotone, and make a tritone with three blue values.

Vintage Print Effects

The pigment print process shares many of the advantages of today's innovative digital printing techniques by using tactile papers and a wider range of image tones permitted by conventional photographic toners. In fact, apart from completely dissimilar processes involved, the end results can appear very closely matched.

Sudek's prints were made using carbon tissue, a process that transferred the image onto a receiving sheet of cotton paper. Like lifting off the emulsion of a peel-apart Polaroid and placing on paper, the carbon tissue process brought with it four fabulously delicate edges of unexposed tissue surrounding the final image. These edges accompanied the image like a signature and defined the print as a handmade entity in its own right.

Making a Carbon Tissue Print

By using a digital process to mimic these vintage results, there's absolutely no reason to be purist about any part of the process whatsoever. All elements of the process and the final print can be manufactured in Photoshop rather than sourced in the real world through hard-won research. Illogically, it's important to plan the final steps of the process before the first and decide on the kind of paper you'd like to printout on. Sudek liked to print out onto cream or ivory cotton papers, some of which over time have acquired a creased and mottled appearance. There's no point in searching out a top-quality cotton inkjet paper that has the right kind of cream base coat, because it's easy enough to invent it yourself. What you will need to find, however, is a top-quality inkjet paper that has a tactile finish and good weight for the task, such as Somerset Velvet Enhanced. Leave the paper to one side.

Texture and Aging

With any inkjet print, the last thing you want to do is to dye or stain your printing paper and toss another chemical variable into an already crowded ring. Instead, artificially age your paper by scanning in an already existing sheet of suitable material. Good things to look for are old sheets of good-quality writing paper, or if you want to introduce an element of aging, some old and preferably damp books that have unprinted endpapers or blank pages to scan. Even if there's more than a bit of unwanted matter on the page, such as text or illustrations, you can still remove it with CS4's Clone Stamp tool after scanning.

Capture in RGB mode and to make a large original, set your scanner input resolution to 300 dpi. If your paper is monochrome, like writing paper, change the mode to Grayscale and save and store as a TIFF file, as you can always change to RGB and colorize later on. A good idea is to build up a library of paper textures, colors, and finishes, and make high-resolution scans and store them on a CDR for future use. When you are ready to start, mix a desirable base color using your Color Balance command and use Levels to alter the paper contrast. Avoid making this color and contrast too intense, as the background paper only needs to show the slightest tone and texture and not pull attention away from your main image.

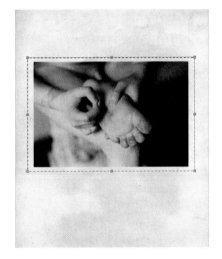

Making the Tissue

Use an image that would benefit from the process, either color or black-and-white originals will do, but you'll need to convert to RGB before you experiment with tone colors. Use the colorize option in the Hue Saturation dialog to create a warm gold brown tone. Next, you want to open the scanned paper image on your desktop and have both images side by side for easier working. Check that both images are the same resolution, then Edit > Select All, Edit > Copy the photographic image, then Edit > Paste in into the paper image. If your originals were different dimensions, before starting the process you'll need to resize one or the other so that they acquire the proportions you want. You can now close down the photographic image, as its no longer required.

Next, you'll need to select the photographic image that has been pasted into its own layer, so make sure that this layer is active. You can use a variety of selection tools to make this happen, but there is a much easier way to do this kind of operation. Place your cursor over the layer thumbnail (the tiny image icon in the layer palette), press and hold down the Command/Ctrl key, then click once with your mouse. This immediately makes a selection of the layer content, regardless of its complexity or shape.

Once you've made a selection around the photographic image, you'll need to stretch it outwards so it becomes bigger. From the Select menu, choose Transform Selection and with your fingers held on the Shift+Alt keys, drag one of the corner handles outward until you make it bigger. Using these keys allows you to transform from the center outwards. Now click on the paper layer and notice how the selection still remains. Do a simple Edit > Copy, Edit > Paste and watch how a third layer is created with an exact copy of a portion of the paper texture. Name this layer "tissue" to make things easier.

Drag this tissue layer in between the photographic layer and the paper layer, at this stage it should still be invisibly merging with the paper underneath. Now, to recreate the tissue edge, open your Levels dialog and drag the midtone slider a little to the right. This will have the effect of darkening the tissue layer and visibly separating it from the underlying layer, without looking false. Don't overdo it at this point as a slight darkening is all that's needed.

Finishing Touches

No carbon tissue print was ever produced without some blemishes or has survived without some discoloration to edges, so this is the next step to take. Working on the tissue layer, quick select it, then pick the burning-in tool from your toolbox. Set it up with a small soft-edged brush and reduce its Exposure to around 30, so that its effects are gradual rather than full on. The purpose of using this tool is to try and introduce some fake fogging or coloration to the edge, so apply the tool in areas that are traditionally fogged, i.e., edges and corners. To finish off, use the Airbrush set with the darkest color sampled from your photographic image to intensify these fogged patches. Finally, you may want to modify the all-too-perfect rectangular shape of your tissue by using the eraser tool. Take a few chunks out of the sides and corners and roughen it up a bit, so it doesn't look too perfect. If you take off too much, use your History palette to retrace your steps.

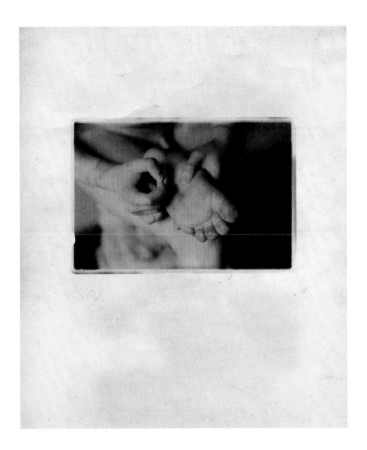

Soft Edges

Now, you'll notice that your image will be looking too rectangular with razor sharp sides and edges, so you'll need to soften these down a touch. The effect to aim for is the kind of soft edge created in the darkroom when enlarging a negative without masking off diffused edges with an easel. Return to your photographic image layer and quick select it. Now, from your Select menu, make a Select > Modify > Contract command with about 8 pixels. This has the effect of pulling in your selection by an equal amount from each edge. Next, you want to soften this edge by applying a 4-pixel Feather to it. Finally, do a Select > Inverse, then Edit > Cut and this will cut away the excess edge to create a softer and more convincing look.

Tweaking the Image

After all the processing has been completed, the only steps left are to adjust image contrast and tone. At this stage, the photographic image layer will still have its original contrast intact and will look as if it's floating over the paper rather than embedded within it. You can't have an image that has highlights brighter than the base color of your paper, so click on the photographic image layer in your layer palette. Next, from the Blending modes drop-down menu (top left and usually set on Normal), choose the Multiply option. Immediately, you'll notice that all the white highlights are dropped from the photographic image layer, becoming as bright as the underlying paper layer. This will introduce an unexpected contrast change, which you'll next need to address using your Levels dialog. Most images will appear darker and muddier after a Blending mode change, so to increase image brightness, move your midtone slider to the left. Don't overdo it, as you don't want your image to look too light.

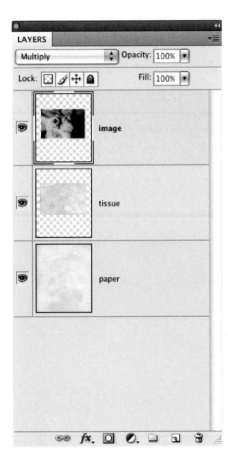

Low-Contrast Alternative

Many carbon tissue prints were made purposely to look very pale and delicate, a bit like deliberately underexposed low-contrast photographic prints. You can further modify the digital process by adjusting the image contrast at the final stage by manipulating the little used Levels Output sliders. Found at the base of the Levels dialog box and with only two sliders for highlight and shadow, these two markers effectively determine the starting points of both contrast extremes. Unless you decide otherwise, all digital images will be ranged in brightness from white 255 to black 0, but by modifying the Output values, you can have your highlights starting at a light gray 200 and your shadows ending at a weak gray 30. By far, the easiest way to change your image to a low-contrast version is to drag the sliders towards the center until you've achieved the desired effect.

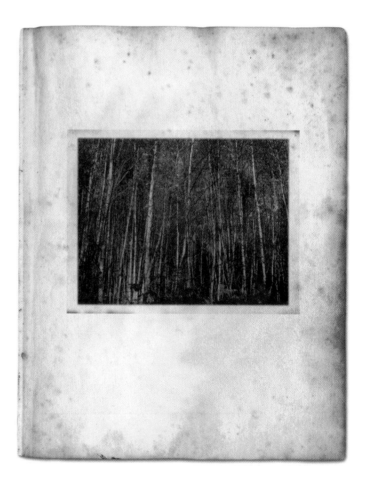

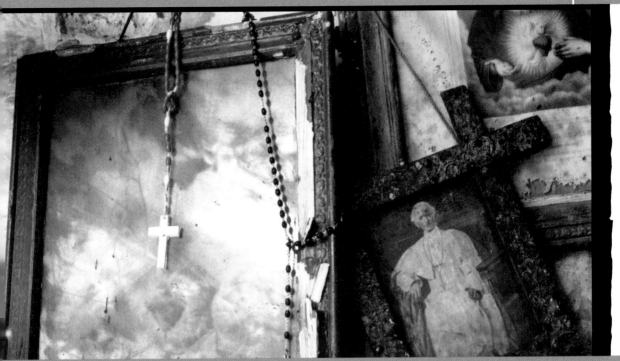

Creative Print Edges

Polaroid Peel-Apart

Step 1

Acquire an Edge File

Most peel-apart instant material is pretty hard to come by these days, so it's much easier to buy a high-resolution edge file to use. Many microstock agencies, such as iStockphoto, shown right, trade film rebate edges for just a few dollars each. Download the file and open in CS4.

Step 2

Tidy Up the Edge File

Use the rectangular marquee tool to remove any stray pixels from the center of the edge frame, so they don't appear in your composite print. Rotate and resize if necessary.

Step 3

Merge the Two Images

Open your photographic image and prepare this for output as normal. When complete, do Edit > Copy and Edit > Paste until the images merge. Use the Transform tool to scale the image file fit into the shape of the Type 55 edge. If the aspect ratios don't match, then you will need to crop off some of your image.

Liquid Emulsion Edges

The technique of liquid emulsion is much favored by photographers keen to create a halfway house between a painting and photograph. Yet the traditional process is not straightforward, needing special equipment and a degree of patience and when things don't go as planned. Emulsion-type edges are great for making watercolor effect printouts, or for giving your photographs a hand-drawn feel.

Step 1

If you've painted your own edge, place it on a flatbed scanner and scan at 300 dpi in grayscale. As there's a lot of fine brushmarks, you will need to scan at 300 dpi to capture them all. Don't scan the whole sheet; instead, drag your marquee as tightly around your black shape as you can, as it will make your file leaner.

Step 2

Now convert your Grayscale to RGB mode. Notice that the file size of your image will triple after this point. Even if your original black ink painting was far from perfect or if you want to fill in any streaky areas, do this step next. Only the black areas will contain your overlaid landscape image, and any white lines will appear white in your final printout. To remove them, use the Airbrush tool, set with a hard-edged brush at size 100 and pressure 100%. Save your results. Next, open your photographic image and make any corrections or manipulations you need to.

Step 3

Keep both images open on your desktop at the same time. Next make the black emulsion image the active image window, then select the Magic Wand tool. The Magic Wand works like a magnet and attracts pixels of a similar color into a selection area. Its pulling power, or tolerance, can be set low to attract only similar colors or high to attract a broader range. If white areas are included in your selection, do Select > Deselect, then reduce the Wand's tolerance to 10 and try again.

Step 4

Now you'll notice that any black areas lying outside the central shape aren't included in your selection, so to remedy this, do Select > Similar. Now every black pixel in your emulsion image will be selected ready for the next step.

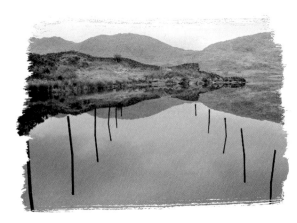

Step 5

Next, without closing your emulsion image, make your image the active window. Then do Select > All, then Edit > Copy. This sends a copy of your image to the clipboard. Close down the image, as you don't need it any longer. Next, make the emulsion image the active image window, then do Edit > Paste Into. Once the image has been pasted in, pick the Move tool and click-drag it on your image until it's in the right place. Your former selection now works like a stencil, allowing your image to appear inside the brushy edged shape.

Step 6

If the image you've pasted in is too big or too small, resize it by Edit > Transform > Scale. If you can't see the Scale handles (at each edge and the center of each side), zoom out using Space Bar+Alt until you can see them. Don't distort your image at this stage; either hold down the Shift key and drag a corner handle or even better hold down Alt+Shift together and watch your image resize from the center. Pulling inwards reduces your image and pulling outwards will enlarge your image.

Final Prints

Another variation is to omit filling in the white streaks, in Step 3, leaving the brushy marks showing through.

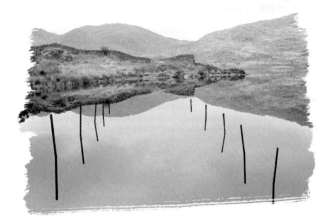

A good variation on the final result is to use Edit > Transform > Scale to pull the image inside the brushy edges, so it looks as if it is printed full frame.

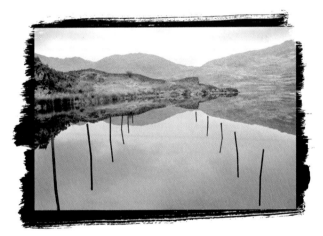

To change the color of your emulsion from black, click on the Background layer, then select a new Foreground color. Rather than picking one at random from the Color Picker dialog box, pick the Dropper tool and click in a dark area of your image to select a new Foreground color. Use your Paint Bucket to drop this new color in.

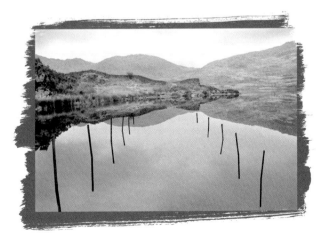

Scanned Paper Backgrounds

You can further modify the appearance of the end result by using a scanned paper texture as your background layer. This image was created using a mottled sheet of paper from an old sketchbook.

Make Your Own Edges

If you want to make your own emulsion edges, get a sheet of white letter copier paper and a pot of black Quink fountain pen ink or a tube of black acrylic paint. Get a bristly half-inch paintbrush from your local home improvement store and drag your brush across the page for a scratchy edge effect.

Negative Carrier Edge

Step 1

Start with an edited image, which is ready to print. This example, shown right, has been split-toned.

Step 2

Find a Rough Edge

Unlike premade edge designs or those created in Photoshop, find and scan a shape with a rough edge. This example was a piece of cardboard with ripped edges. Scan at 300 ppi and open in CS4. Don't worry if it isn't exactly the right shape initially.

Use an oversized film holder if you are feeling creative, you can also enlarge your film scanner's filmstrip holder with a metal file. This enables the scanner to capture some of the film rebate area, as shown by the thin black edges above.

Step 3

Merge the Two Source Files Together

Open both images, then Edit > Copy, Edit. Paste the photographic image onto the black background shape, as shown above.

Step 4

Fit the edge around the image. Working on the black edge layer, do Select > Transform and pull the shape inwards until it's close to the edge of the image.

Erased Edge

The example above uses the same technique and the Eraser tool to cut away some of the black edges.

Think Outside the Box

This screenshot left shows a collection of slate roof tiles, captured for later use as rough edges. Irregular shapes such as these can be cut out precisely with the Pen tool.

Step 5

The finished print. With careful transforming, the black, rough edge shape was positioned around the toned image to create this result.

PhotoFrame Pro Plug-In

Step 1

There's no law that states that all images must have sharp edges. PhotoFrame Pro is a well-established Photoshop plug-in, which offers a range of easy to apply edge effects. Start by making all essential edits to the file before loading it in the plug-in. Next, do OnOne > PhotoFrame Pro to launch the plug-in.

Step 2

When the full-screen dialog appears, select View > Frame Grid, so that you can preview your image with a range of different effects in place. This is much easier than choosing a random filename from a dialog box.

Step 3

To change the properties of the edge, do Window > Show Background. In this viewing mode, you can change border width, color, shape, and even sharpness. The new border acts like a further cropping edge to your original.

www.ononesoftware.com

Step 4

Fine Tuning

Around the outside of the image on each edge are four tiny handle icons, similar to Photoshop's cropping tool. Pull and push these until the new border is positioned in the correctly place. When complete, press the Apply to New Layer button. This final command commits the edge into a new Photoshop layer, so that it remains separate from the original at all times.

Final Result

The print looks much more eye-catching compared to the starting point and was created using PhotoFrame Pro's Film Edge border colored white.

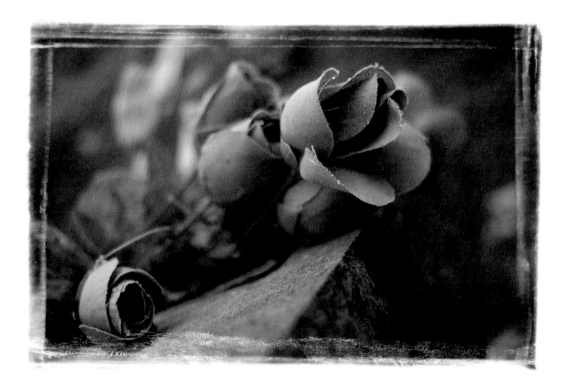

Mountboard Edges

Like conventional photographic prints, digital inkjet prints can look washed out if there's a bright area at the edge of your image. When your eye is drawn to an empty space, especially one that is as bright as the surrounding paper border, it does feel as if the image is slipping off the page. Not all digital photos are meant to be darkened down at the edges, so a good compromise is to add a thin border that acts as a container and frames the image inside the paper print. Just like a conventional picture frame, the border defines the edge and bounces your eye back into the all-important images. Surprisingly, border color can be determined by the Canvas Size control, as this effectively surrounds your image with new pixels of a color that you can determine by sampling color from the image or choosing a new value from the Color Picker dialog box. With each Canvas Size adjustment, you can effectively build up a different border and create a kind of tiered mountboard effect. Just like cutting out a series of colored window mounts to house your photographic print, the Canvas Size adjustment can do this without the aggravation of cutting straight lines.

Sampling Color

Use the Navigator to maintain the space around your image, then click the eyedropper tool onto a neutral midtone color in your image. Set it as the background color, then repeat the Crop tool command to produce a slightly bigger border this time. Press Return.

Expert Tip

Always surround your image with a white border first, as this will prevent any unwanted color casts from appearing. If you surround your image with strong and vivid colors, then the center of the print will start to be visibly affected. Entirely an optical illusion which you can't ignore, the strong color will start to dominate your attention. Look for a neutral midtone color as your outer surrounding. If you can't tell a 50% tone from an 80%, then use the Info palette as a visual aid. Hover the dropper tool over the image and watch for the Info percentage readout to change.

To add a second darker outer edge, return to the image and sample the darkest tone with the dropper tool and make this the current background color. Next, increase the canvas size at double the width of the first adjustment, as shown left. The resulting image, below, will now look balanced.

Photoshop CS4 and Bridge CS4 Print Functions

Printing from Bridge CS4

CS4 Redesign

Surprisingly, in the struggle to expand the functionality of CS4, Adobe has not included the printing-based tools Contact Print and Picture Package in the first releases of CS4, so they are not where you'd expect to find them under the Automate menu. Instead you have the choice to download these former tools as part of an optional (but free) plug-in package or to use the newly devised Output module in Bridge CS4, which also is provided freely with both versions of Photoshop CS4.

Using Bridge CS4

The Output module in Bridge CS4 is a cross between the panelized interface of Photoshop Elements and the convenience of Lightroom's superior

Disadvantages of Bridge CS4
Output as PDF only.

Another color-managed application to synchronize.

Advantages of Bridge CS4

Lightroom-like interface ensures that you can see your content as you work.

one-stop-shop Print module. Essentially, it's not a bad way of making thumbnail, contact, or picture package prints, but it does have a significant limitation by outputting only in PDF format, unlike the Photoshop Contact Sheet II and Picture Package plug-ins that generate standard documents free from format restrictions. Indeed, using the PDF contact sheet, you have the choice between high- and low-quality PDFs, which equate to Suitable for Printed Output (High) or Only Good for Onscreen Use (Low).

Watermarking

Although not as clever as the watermarking option in Picture Package (there's no positioning control in Bridge CS4), this is a useful function.

Using Bridge for Contact Prints or Proof Sheets

Left shows a good use of Bridge CS4 for making high-quality contact prints. Simply Shift+Click the images on the bottom filmstrip that you want to include in the print. Next, set the paper size, then Columns and Rows, until it all fits together.

Using Bridge for Making PDF Proofs of Single Images

Click a single image from the filmstrip, then set the Columns and Rows as shown.

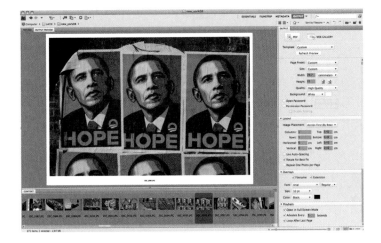

Contact Print II

If you get baffled trying to track down your digital files on numerous DVD disks, then a contact-sheet cover makes much more sense. Surprisingly, you can print about 36 recognizable thumbnail images on a custom-sized sheet of paper designed to fit on the rear cover of your DVD case. CS4 has an autocommand that will do this without the need to do a layout manually.

Step 1

Arrange your images inside one folder on your hard drive or open the DVD disk window. Count the number of thumbnail images, and make sure that they are labeled properly. In Photoshop, choose File > Automate > Contact Sheet II. Choose the source folder, and set the paper size to fit your DVD case. Try 13.5 × 11.5 cm for starters, and set your image resolution to 200 ppi. You can also determine the number of rows and columns for your layout. Finally, click on Use Filename as caption, so you have a precise reference filename for each image.

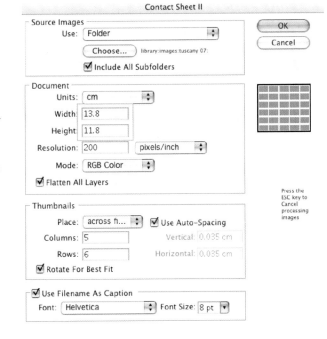

Installation Note
Contact Sheet II is an optional plug-in for CS4, available from www.adobe.com.

Step 2

Press OK and watch Photoshop assemble your custom-sized contact for you. Once finished, flatten the image, then go to your Printer software and make sure the Corner Crop Marks is selected in the Page Set Up dialog box. This makes it easier to cut the contact out when printed on a larger sheet of paper.

Contact Print Sizes

The flexibility of this automated printing function allows you to determine the overall document size (to match the printing paper) and the size that each image appears within that layout.

Don't be tempted to cram too many thumbnail-sized images on your sheet, or they will become too difficult to view. The Rotate for Best Fit option reorients images into the correct position, as shown below, but this creates an invisible white square around each image.

Step 3

Finally, cut and fit the contact into the rear of your jewel case. A great idea is to produce an additional front cover for your DVD case with the best image out of the set and a clear descriptive title, so that you'll spend less time searching for that elusive file.

Picture Package

Back in the predigital days of mail-order photo processing, ordering multiple copies of your most popular photo prints was both a pain and expensive. Nowadays, with the advent of photo manipulation software, you can easily print out the same image more than once on a single piece of paper. Without needing to create a DTP layout together with fiddly and time-consuming copying and pasting, CS4 offers a simple command that does it all for you. Found under the File > Automate menu, the Picture Package command offers all of the tools you need within a single dialog box. The command works on either a folder of images or a single image file and creates a brand new document, ready to print or save and store for another day. There are over 16 different packages to choose from for making just a couple of prints per page or up to 20 smaller ones. Multiple printouts are a great way to make invitations, business cards, or mini-postcards without having to stand over your printer as they emerge on single sheets. For adding a caption, date, or message to your printouts, the Picture Package allows you to call up any text previously created in the File Info or enter a simple caption. The positioning of your caption can only occur within the image itself rather than in a border, but

Installation Note
Picture Package is an optional plug-in for CS4, available from www.adobe.com.

Including Watermarks
Picture Package also enables you to add your own security mark as an overlay, too.

there are five positions to choose from. In this example, below, diagonal text was chosen as it interfered the least with the overall composition. Text style is restricted to four or five system fonts, but these may be used at a range of different sizes and most useful colors, too. Finally, essential for any wedding photographer producing proof or inspection prints in this way, the useful Opacity scale can be used at 20% to make your name and copyright symbol

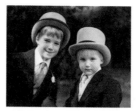

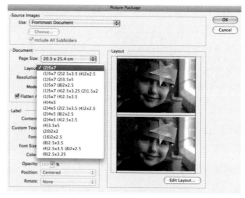

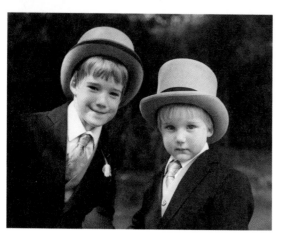

appear faintly across your images to prevent any unauthorized copying. Although there are only three document sizes available within the dialog, with 8 × 10 inches rather than much more user-friendly letter, it's very simple to design your own layouts based on your own personal paper sizes.

Step 1

Picking the Package and Defining Text

Make all the normal adjustments to your image before printing, then do File > Automate > Picture Package. Choose the 8 × 10 inch page size for printing out to letter, then from the Layout menu choose one of the multiple print options. Once chosen, your layout will preview in the dialog. Set the resolution to 300 ppi and enter your text option as described previously.

Step 2

Checking Print Size

Click on OK and let the Automated sequence run its course until the new document is complete. Next, do a File > Print command and double check that your image won't print too close to the edge. Deselect the Center image option, then click on the Show Bounding Box and drag your layout away from the edge of your print paper.

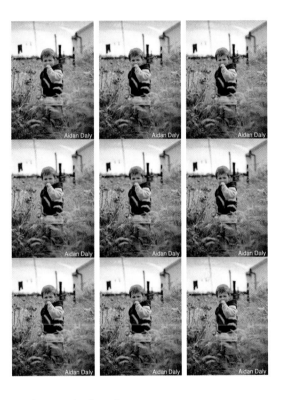

Step 3

Print and Cut Out

Choose a stiff paper to print on if your individual images will be cut into smaller sizes. The heavier Epson Photo Glossy paper is ideal for this project and will prevent tearing. Once dried, cut your sheets using a rotary paper cutter rather than scissors or a scalpel, as this will give you a clean edge without any risks.

Creating Your Own Layouts

Photoshop allows you to create your own custom layouts by entering new measurements into a text document created in any basic text editor. Detailed instructions can be found in the Help > Photoshop Help command, under Saving and Exporting Images > Customizing Picture Package Layouts. Once you've created your own layouts, save the text file in the Adobe Photoshop > Presets > Layouts folder and then it'll appear in the Picture Package dialog box.

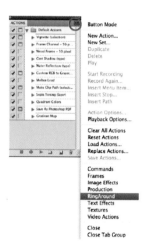

Print Actions

Using Actions in CS4

Like many previous versions of Photoshop, Actions are well and truly embedded into CS4 to aid speedy workflow. In addition to the default set of Photoshop actions that hasn't really developed since version 5.5, you can also install custom-made actions to help improve print quality.

The RingAround Action

I've devised a simple and really effective action file that creates a full sheet of 28 different color and brightness variations, shown on the next page, so you can chose which one looks best. Above all, each modified sample has a text description underneath, so you can easily add the suggested correction to your working file. Here's how it works.

Loading the Action into CS4

Go to the Photoshop > Presets folder and place the action file, denoted by its .atn file extension in there. Next, open CS4 and then do Window > Actions. The actions palette won't show the new addition yet, as you have to load it in manually. Click on the tiny pop-up menu at the top right of the actions palette and select the new action, in this example RingAround.atn. The action will now become visible in the palette and ready to use.

Using the RingAround Action

Step 1
Open your image and edit as usual. Make sure that black and white are the foreground and background colors by pressing D on your keypad.

Step 2
Select the Rectangular Marquee tool with Fixed Size style. If you are printing at 200 ppi, set the Fixed Size to W180 × H440. For printing at 300 ppi, set the Fixed Size to W260 × H680.

Step 3
Place the fixed size rectangle on an important area of the image, then do Edit > Copy.

Step 4
Choose either 200 RGB or 300 RGB action, then press the Play button on the base of the Action palette. Wait 20 seconds until the action is complete, then print your test sheet as normal.

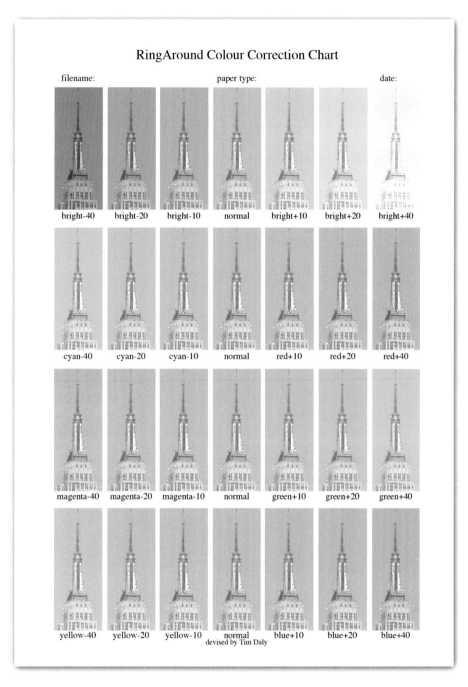

RingAround for all versions of Photoshop is available from www.timdaly.com

Canon Print Plug-In

The standard printer software for many recent Canon printers is accessible from your imaging application but offers little in the way of configuration tools such as print resolution and fine color balancing. Instead, basic color correction functions are presented alongside a straightforward media selection menu. Canon has developed a Photoshop plug-in called Easy-PhotoPrint Pro. The latest versions of the plug-in work with Photoshop CS4 and are selected through Photoshop's File > Automate > menu. The plug-in provides a large preview window, with access to your profiles, media settings, and print quality. The fine-tuning controls are hidden under the small Color Adjustment button but offer the chance to specify color balance, brightness, and contrast.

Test Pattern Printing

The plug-in also contains the innovative Pattern printing function. Like a conventional color darkroom test for color balance, the Pattern function provides a printed ringaround page showing 30 or so thumbnail variations of your image, with the all-important adjustment setting values printed out as text shown beneath each one. Like Photoshop's Variations dialog but as a printout, this is one of the better tools to help you achieve color accuracy. To avoid further confusion, Easy-PhotoPrint Pro grays out all normal options in the Print menus when you are ready to print so that you can't override decisions that you've already taken in the plug-in; this is a very clever move!

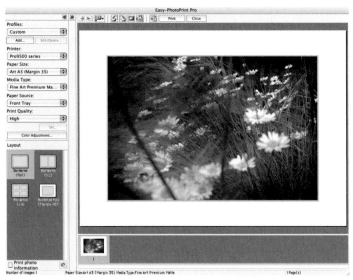

Cropping and Composition Feature

In addition to additional layout templates (duplicating the functions offered in Photoshop's Print Package menu, but with fewer controls), Easy-PhotoPrint Pro provides a very innovative cropping tool based on the rule of thirds. Designed to help you recompose your shots under the overlay of the historic nine-block grid, this can help take the guesswork away from composition, if you are ever in doubt.

Test Results

It goes without saying that print sharpness from this professional printer is exceptional, with no perceptible ink dots on any area of the print, either near white highlight or elsewhere. The Pixma makes a very good job of rendering detail in dark shadow areas and offers exceptional results when printing contrasty scenes. Using the highest quality output setting available, all prints required no further manual color or contrast adjustments, and the results were very good indeed. When printing the test image, it was clear that the device made a fine job of separating out very dark tones, especially in the 90–100% blacks. After accepting the different nature of art papers compared with glossy or matt inkjet media, both sets of tests were excellent.

Preview and Soft Proofing

Soft-Proofing Essentials

If you're constantly disappointed by inkjet prints that don't look anything like the image on your monitor, you should use CS4's soft-proofing functions.

In digital photography, one of the hardest issues to resolve is the difference between the image displayed on your monitor and the same image printed out from your desktop inkjet. Although created from exactly the same data, they are presented via two very different kinds of device: the transmitted light of a monitor and the reflected light of a print. In short, never the two shall meet.

If you'd rather not gaze into a crystal ball to foretell your printed outcomes, there is a much more sensible way of keeping sight of the end, but you need to remember the golden rule of accurate printing: proofing and preview

This example shows a vivid color image (top), which printed out with much less color saturation (bottom). Using Photoshop's soft-proofing tools can really help you to predict unexpected changes before wasting expensive ink and paper.

equals prediction. So, if you are confident that your monitor calibration technique is presenting a neutral colored work surface, you'll be pleased to know that Photoshop can be used as an accurate tool to predict how your print will emerge. Developed from the cost-conscious world of lithographic printing, the method of soft proofing allows you to see into the future and save the waste of ink, paper, and valuable time. Before the advent of soft proofing, the only way that lithographic colors could be tested was by making a handful of test prints called wet proofs.

As you edit your way through a complex creative imaging project, your visual senses are fully aware at all times of the job that needs to be done. Yet, although your imaging application can tell what kind of printer it's targeting, how can it best prepare your file if it doesn't know the kind of ink or paper combination that you are intending to use? With such a wide range of print media now available, giving very different end results from the same image file, it's essential that you and your application can package your file for best performance.

Most reproduction shortfalls occur in the blue/purple parts of the spectrum, as CMYK inks can't match the vivid values of RGB.

Called a soft proof, this innovative feature in Photoshop creates a virtual or simulated prediction of the final paper print that is displayed on your screen for the ultimate convenience. Found in recent versions of Photoshop 7 and CS, the function is an enhancement of the much more basic CMYK preview mode, which has been present in the application over the last 10 years. To say that working in the RGB color mode is like saying ignorance is bliss might be looking too simplistic, but it can give you a false sense of security to think that all your color work in RGB will effortlessly translate to your printers available color palette, because it won't.

In CS4, the Proof Colors view enables you to have the best of both worlds: you can still work unhindered in full color palette RGB mode, but your visual results on-screen will be adjusted to predict the likely outcome on your chosen printer, paper, and ink combination. In short, if the rich purple filter effect that you've added to a sky won't print out on the kind of paper you are using, your monitor image under Proof Colors view won't let you see what you're not going to get.

With most input and output devices sold with their own unique color profiles to help manage the accurate translation of color from one to the next, you'll be surprised to know that there are profiles available for specific printer, ink,

and paper combinations. Even more amazing is the news is that you probably already have a few loaded into your imaging application without knowing it.

With printer manufacturers keen to facilitate the use of their brands of paper and ink, so output profiles are provided as part of any standard printer software. Loaded invisibly into Photoshop each time a new bit of printer software is installed on your machine, these profiles are there to provide extra help as you work. Providing that you keep within the range of media combinations supported by the profiles, you can always get an accurate monitor simulation of the likely end result. For third-party media manufacturers whose profiles are not carried with printer software, such as Lyson or Hahnemuhle, many offer free profiles to accompany your printing from their Web sites as tiny downloads for your convenience.

In use, you'll detect very little color change if you are working with a soft proof for shiny bright white papers and standard inksets, but this changes dramatically when pigment inks and no shiny media profiles are used. Best of all, if you enjoy experimenting with print on very absorbent media such as archival cotton surfaces, you can prepare your file with the right tonal range to suit the media by doing all your editing with the Proof Colors setting left switched on. Preparing your files with lighter midtones and much less dense shadows can really help to make your final print display more detail and more atmosphere.

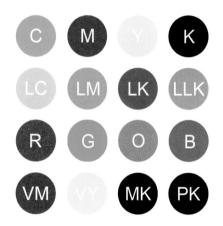

Proofing and Ink Type

The more inks you have in your printer, the more colors you are able to mix on your chosen printing paper. The new High Dynamic Range inks from Epson provide a super-wide range where very little colors are "lost" through the soft proof.

Basic inkjets with three or five colors will display significant differences between the nonproofed RGB image and the same image under soft-proofed conditions.

Setting Up the Soft-Proof Function

Open your image and do View > Proof Setup and then choose the Custom option. You'll notice other options below, based on CMYK litho, but these are intended for use only by commercial printers.

Choose Your Profile

Click and hold the Profile Pop-up menu until the entire list pops up on your desktop. Scroll down and opt for the printer and paper profile combos. This example was set to an Epson 9900 printer with Velvet Fine Art paper.

Output Profile Location

Many output profiles are loaded automatically when a new printer driver is installed. On an Apple OSX system, the profiles are loaded into the Library > ColorSync > Profiles folder, as shown right. Unfortunately, there are also a whole load of other profiles in there, too, including generic color spaces and monitor profiles.

Choose Your Settings

Make your dialog box look like this. Deselect Preserve Color Numbers option if checked and set the Intent to Relative Colorimetric, the most commonly used method for photographs. Finally, choose Paper White and Black Point Compensation.

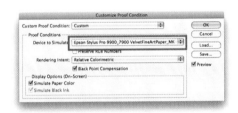

Viewing the Soft Proof

Once completed, press OK and your dialog will disappear, leaving you with the proof visible on-screen. These two examples below show the same image under different proofing conditions. Below left is is without the Proof Colors options and below right shows it switched on. The difference is enormous.

Switching the Soft-Proof Option On and Off

With the View > Proof Colors function not set up, the desktop image is now shown with a completely different color balance and much reduced white highlight. The highlight change has accounted for the softer white of the target paper rather than the full-on white of your monitor screen. To view your soft proof, do a Ctrl/Command + Y to turn it on and the same to turn it off again, perhaps when working on a different project aimed at different paper. If you forget if it's switched on or off, then take a look at the top of the image window. Once selected, the name of the profile will be shown next to your document name following a forward slash.

Match Print Colors Option in the Print Dialog

In CS4, you can also view the same soft proof in the Print dialog, by choosing the Match Print Colors option, as shown below.

Proofing in Working CMYK View

If you need to work in the true CMYK mode, you'll notice that many of Photoshop's functions and features become unavailable. Yet, there's a simple way around editing files for CMYK output: simply use the CMYK Proof mode. In this way of working, your image file remains in the RGB color space throughout but is constantly previewed as the likely results of final CMYK conversion. Document sizes remain unaltered and you have all the access to Photoshop's editing tools from creatively processing your image files. CMYK files are drawn from a much smaller color palette compared to RGB, and this frequently causes disappointing repro results. With the proof function in use, your image won't display a color or saturation value that can't be matched in the CMYK color mode.

To set this soft-proof view up, choose View > Proof Setup > Working CMYK. The image will now be displayed as a soft proof tied to the CMYK variant that you have set up in CS4's Color Settings, in this example US Web Uncoated, as shown right.

Like desktop printer profiles, colors under the Working CMYK will appear more muted.

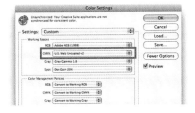

Gamut

If your printouts never look as good as they do on the monitor, its probably because you are trying to achieve the impossible.

A computer monitor displays color in a fundamentally different way to the way a printer outputs colored ink on paper. The monitor transmits richly saturated colored light via RGB phosphors, but printouts reflect less vivid colors. Each station in the capture, processing, and output of a digital photo has its own unique range of colors called a gamut, better imagined as a palette. When an image is transferred from one stage to another, colors can reproduce with less saturation than expected or even translated into different color altogether. If you've frequently been disappointed by the difference between printout and display, it's because you are trying to exceed the range or gamut of your ink and paper combination. Yet, by using Photoshop's Gamut warning functions, you can make a better prediction of potential mistakes before you waste paper and ink. Photoshop allows you to increase the color saturation of an image very simply, but this will never translate to your printouts with the same intensity. These overambitious colors are detected by switching on the Gamut Warning option found in the View menu. Once switched on, the Gamut Warning option is left on for the duration of your work in progress and works by tagging all colors unlikely to print as they appear, a drab gray color. This gray is not embedded in your image file but acts purely as a marker and won't print out. As you work steadily throughout your project, the Gamut Warning will show up only when you try and stretch color saturation or use special color palettes such as the Pantone ranges, which frequently can't be reproduced by inkjet printers. It's a much better idea to have the Gamut Warning selected from the outset, because smaller problems can be dealt with on the spot rather than trying to tackle an insurmountable problem at the very end of your work. In addition to marking problem colors, Photoshop also offers several methods of changing these colors into values that will print out properly. For this project, we will use the Replace Color dialog found under the Image > Adjustments menu.

Switching the Warning On

Open your image and before making any color balance corrections or color enhancements, turn on the Gamut Warning, found under the View menu.

Remember What You Are Proofing To

The Gamut warning tags out-of-range colors, but this is always linked to your current choice in the Proof Setup menu. In this case, the Device to Simulate is a Canon Pro9500 with Canson Canvas.

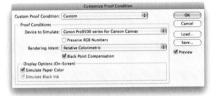

View the Out-of-Range Colors

When the Gamut Warning is switched on, every color that lies outside the range of your chosen printer/paper/ink combination will be tagged with a gray color, as shown right.

Curing the Problem

Open the Replace Color dialog and move it to one side of your desktop, so that you can see the tagged colors.

Use the dropper tool and click into the gray area of your image, and then push the Fuzziness slider until all of the gray has been selected.

Next, move the Saturation slider to the left and watch the gray marker disappear. Click OK. If you haven't managed to remove all the gray, return to the Replace Color dialog and repeat the process, but this time sampling a different gray area. To remove the marker from the reds, Hue, Saturation, and Lightness sliders were moved slightly until the warning disappeared. Once removed, what you see is what will print.

Choosing Safer Colors from the Picker

If you want to work with printer safe colors at the end of a brush, you can use another of Photoshop's Gamut functions found in the Color Picker dialog box. When searching for colors that will print as you see them on-screen, make a normal selection by clicking into the color box. If a tiny red triangle appears, shown here inside a blue circle, this means your selection is out of gamut.

Modifying Your Choice to Fit in Gamut

You can change this into the nearest printable value by clicking on the tiny triangle itself. This shoots your selection circle into a new position.

Gamut Warning in the Print Dialog

In CS4, you can now view the same gamut warning in the Print dialog but without the facility to edit out your differences.

Print Output Functions

Image Placement

Previewing in Bridge

A much bigger style preview is available when using Bridge CS4. In the Output module, a single image can be displayed in proportion to the currently selected paper size, so you can get a better feel for the end result. Better than the tiny Print dialog window of Photoshop CS4, but still not as professional as Lightroom's Fine Art Mat view, Bridge offers a good compromise. When changing any controls in the Output dialog, it's essential to press the Refresh Preview button, or your edits won't show up. Surely, this will become a live preview in CS5?

Arranging Print Placement in CS4

Descended from the Print Preview window in previous versions of Photoshop, CS4's Print window is really too small to see how tiny adjustments to print placement make a difference. Although the useful Bounding Box command allows you to drag and drop the image into any position on the paper, this is hardly a precise way of measuring white borders.

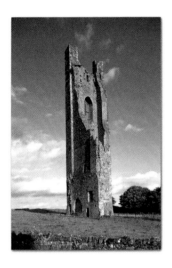
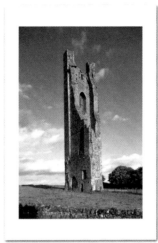

Is Big Best?

Sometimes it's not necessary to fill the entire sheet of printing paper with image. In these three examples, the most pleasing result is the print with the smallest image. Above typical examples of a print where edge to edge (or full-bleed) doesn't really enhance the look. In the second example, above, the uneven white borders echoes a cheap print from an office inkjet, while the example above is a classical layout with a deeper bottom border.

Framed Positions

The proximity of frame edge and mountboard color can also have a profound effect on the final result. Shown on the right is a good example of how a portrait image can fit into a square frame.

Background Color

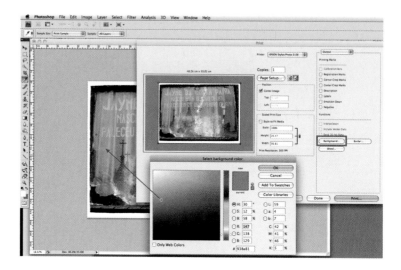

Using the Background Option

CS4 has a useful extra print function called Background, so you can print a colored ink in the areas of the paper that would ordinarily be blank.

The Background option immediately brings up the Color Picker dialog, as shown above, so that you can set a precise color of your choice.

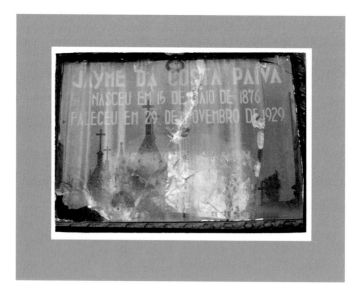

This example shows how a midtone color can be sampled from the actual image window (not the preview image in the Print dialog), so that you can use a color that has some connection to your central image.

Unfortunately, you have to press OK in the Color Picker to see the background color appear in the Print preview dialog, so there's no way of scrolling through a range of possibilities first.

Borders and Bleed

Making a Border

For certain print jobs, it's desirable to have a printed black border around your image. Rather than apply this permanently around your image, instead you can use the Output Border command to place a temporary border up to a maximum of 3.5-mm wide around your image. Black is the only color available, however.

Using Bleed

Many designers and photographers used CS4 to create press-ready artwork rather than use a DTP application like InDesign. The Bleed function is used for specifying a corner crop mark inside the boundaries of your oversized image file. When a guillotine cut is involved in any print product, always extend your artwork a extra few millimeters bigger than you really need to prevent distracting white hairlines surrounding your print if the cut isn't accurate. This photobook cover artwork, shown below, was printed with a 3-mm bleed, indicated by corner crops, so I could preview any likely errors caused by the guillotine.

Printing Captions

Deep inside the hidden organs of CS4 is the essential File Info dialog box where you can enter your own captions, copyright statements, and other text information such as date, location, and shooting details.

Connemara, West Ireland, 2001. Photograph by Tim Daly

This text information is saved with your image file but always remains hidden, never appearing on your monitor display or in the printed result, unless you decide otherwise. File Info can be constantly altered and updated, and with the exception of the EXIF shooting data created by your digital camera, which is not editable, remains a useful way of adding comments to your work. The information stored within File Info is compatible with all image file formats when saved on the Mac OS platform, but only with PSD, TIFF, JPEG, EPS, and PDF formats on Windows PCs. Adding captions to your work is a great way of keeping track of important details such as shooting date and location, especially if you intend to market your images at a later date. When faced with hundreds or thousands of images to label and catalog, captions are an essential way to manage your work.

Used by press and public relations photographers for adding a simple byline to their work to inform the newspaper's picture editor, the printed caption is a much quicker alternative to making a layout in InDesign or other DTP packages. To add a caption to the File Info, you can type directly into the dialog or copy and paste text from a word-processing document. Up to 300 words can be added to each image, which allows more than enough space to record your essential information. You can also use the File Info function as a way of communicating with other users of your image rather than adding instructions on a separate sheet of paper. When sending images to a print bureau or repro house, the File Info is a great way of ensuring that your precise instructions remain attached to your image. When output, there's no choice between different fonts or point size, and text will be printed using 9 pt Helvetica and aligned centrally under the bottom edge of your image.

Printing Text at Higher Resolution

Although an image file set with a resolution of 200 ppi is perfectly acceptable when printed out on a desktop inkjet, this does not follow for text. If you want your captions to look ultrapin sharp, then consider preparing your image at 300 ppi for printout. Curved type shapes will look crude when printed out at too low a resolution.

Step 1

Adding File Information

Open your image and do a File > File Info command. Select the Description option from the General drop-down menu and type in your information. Keep it simple and direct and avoid using hard returns when coming to the end of a line, as this will show up on your printout.

Step 2

Adjusting Print Size

Once complete, close the File Info dialog and then save your image. Next, go to the Print dialog and make sure that there's free white space around your image. If it's going to print edge to edge, then the caption won't have any space to print. Resize your image by deselecting the Center Image option and then pull the image corners inward.

Step 3

Making the Caption Print

Although still in the Print dialog, select the Output option from the pop-up menu. Select on the Description option and watch how the line of type is shown underneath your image in the Print Preview dialog box. This is how it will look when printed out.

Save as PDF Options

Making a Quick PDF on Mac OSX

PDF files have become the universal currency for sending artwork for review and feedback. Created by many applications and transported easily across networks, PDFs are often required by clients who want to see a low-resolution preview to check that things are okay.

You can make a lightning-fast PDF from any image file using a standard Epson printer driver on Mac OSX. First, edit and lay out your image as shown right.

Next, press Print and when taken from CS4 into the printer driver dialog, choose the Preview option, as shown right. This automatically creates a fast PDF with a resolution of 150 ppi, which is ideal for e-mailing to your client.

Preview's Soft-Proof Function

For Mac OSX users, the PDF automatically appears in the generic viewer application, Preview, which has a useful soft-proofing function, shown right. When clicked, this option will soft proof the image with its own embedded color profile against the characteristics of the target printing device.

DSC_0017.JPG

Annotating PDFs in Preview

You don't need Adobe Acrobat to add useful annotations to your PDFs; you can do the same in Preview. Do Tools > Annotate to bring up a basic text box for adding your comment for review. The text is never embedded into your original image file.

DSC_0017.JPG DSC_0018.JPG DSC_0019.JPG

DSC_0020.JPG DSC_0021.JPG DSC_0022.JPG

DSC_0023.JPG DSC_0024.JPG DSC_0025.JPG

DSC_0026.JPG DSC_0027.JPG DSC_0028.JPG

Making High-Quality PDFs

Like other Adobe CS4 applications, you can export your image file in a specific PDF format from within Photoshop. Edit your file to completion, then choose File > Save As, picking PDF as the Format.

Once this option has been selected, you are faced with the standard Adobe PDF options dialog, where you can specify the type of PDF, compression, and other packaging indicators for your file's target use.

Crop Marks and Film Output

Crop Marks

Like all previous incarnations of Photoshop, CS4 provides a handful of very useful output functions for preparing your work for specific devices. Found under the Output menu, there are two crop mark options: corner (as shown above) and center. Corner crop marks are placed at the very edges of your image file as a black hairline to assist later cutting. Although intended as a prepress tool, the crop marks are an excellent guide for cutting images on a rotary trimmer or handheld craft knife. Crop marks will only print if there's enough blank space around the image on your paper. For this reason, many designers and photographers print on oversize papers such as oversize 11x17, which permits the printing of a full size 11x17 image, but has a little extra around the edge for crop marks.

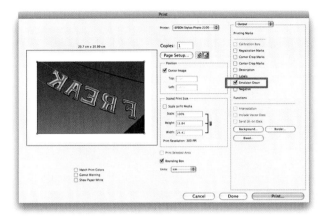

Emulsion Down

For some prepress jobs, it will be essential to prepare your images slightly differently for submission. Where a special kind of printing process is used, this command flips the image, so that it will print the correct way around. Emulsion Down doesn't reorient your original image file and is discarded after sending to Print.

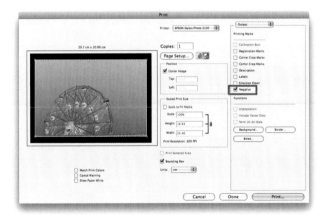

Negative Option

This output command is used by many photographers who are preparing images for film output. Once the image has been reversed and printed on an imagesetter or onto high-quality inkjet film, the new original can be enlarged or contact-printed onto conventional photographic paper.

Paper and Media Characteristics

Paper Essentials

Like a master darkroom craftsman, it's essential to understand the nature of your materials, so that your choices and decisions are informed by fact as well as feeling.

Paper technology is an expanding and developing subject, and despite the concerns over deforestation, there's more paper manufactured nowadays than ever before. With many paper manufacturers keen to benefit from the new market in desktop inkjet printing, there are many products and just as many claims. Yet it's important to know how these products have been manufactured, how long they are likely to last, and if they are worth using. Surprisingly, many of the first inkjet papers were nearly impossible to use, a result of overeager manufacturers adapting existing stock, rather than redesigning a necessary new material.

Bright white papers will give you very few adjustments to cope with the change from image brightness on-screen to print contrast.

Machine-Made Papers

At the bottom of the quality scale are the machine-made papers designed for office use and commercial litho printing. Made with pounded wood pulp and a certain amount of recycled paper, alkali agents are used to chemically break down the raw materials. Mass-produced artist's papers contain a more favorable ratio of cotton materials. Techniques in processing pulp are varied, but all use force, heat, and chemicals to help separate the fibers. The finished pulp is funneled through a narrow slot and drawn out across a rolling belt, which ensures a continuous web or roll of paper with all of the fibers lying in the same direction.

Recycled Papers

Despite the politically correct origins of these materials, recycled papers can be a challenging material to use if consistency of result is your aim. Recycled papers often have an irregular thickness and little or no grain direction, making them feel "floppier" and less suitable for large-scale prints. Yet, for low-key results with deliberately muted colors, they are an exciting prospect.

Coatings

For a smoother surface finish, called coated or matt, better papers are impregnated with finely powdered china clay. Matt inkjet paper has a china-clay coating, which cracks if you try to fold it. In addition to this, most good artist's papers are produced with an invisible coating called size, which aids the rigidity of paper and lessens its absorbency. In unsized materials such as blotting paper and copier paper, applied ink bleeds severely into adjoining areas. Sized paper stops this spread occurring and retains sharp detail. For specialist inkjet papers designed to look like photographic paper, an invisible high-gloss coating is applied that lets ink pass through. Most archival materials use no or only specially devised coatings to extend the life span of a print.

Any colored paper beyond a midtone won't show highlight areas very well and will play havoc with color balancing but will add a subtle dimensions to monochrome prints.

Finishes

The surface texture of paper can also be modified in the manufacturing process. Smoothness is achieved by pressing between hot or cold metal rollers, offering a surface capable of holding the maximum amount of detail. Machine-made artist's watercolor papers and commercial litho papers, with a variety of effects such as leather, are generated by running sheets between textured metal rollers to impart a variety of surfaces mimicking the look of handmade papers. Genuine handmade papers derive their texture from the metal mesh used in the sieve, a process also used to make watermarks.

Color

To cater for the modern-day obsession with brilliant white, bleaching agents are used in the manufacture of cheaper papers, creating unknown reactions with ink. Many papers are dyed to achieve an alternative base color, such as cream or yellows. Of course, a colored paper base will demand a different approach to image preparation where a much brighter on-screen starting point is required.

Weight and Thickness

One of the last remaining battles between imperial and metric measuring systems reigns with paper weight and thickness. Paper weight is measured either in grams per meter squared (g/m^2) as in Fabriano 5 250 g or imperially as in Bockingford 250 lb. The greater the numbers, the heavier the material will be. Photocopy paper is usually around 80 g. Many inkjet printers will have maximum (and minimum) media thickness guidelines. Yet, if you are adventurous, media up to 350 g, fairly rigid card, can be fed through most devices.

Inkjet Paper Characteristics

The biggest revolution in digital printing may not be the convenience of printing from your desktop or even the endless possibilities afforded by digital manipulation software; it is the ability to print onto more exciting surfaces than gloss, luster, and matt. Quite simply, digital prints can now be as tactile as an artist's lithograph or etching as more quality paper types become available. Print sharpness, color saturation, and contrast are all dictated by your printing media, even before you start enhancing your image in Photoshop or fiddling with the printer software. These restrictions are worth understanding before you start work, saving you effort, time, and wasted consumables.

Image Sharpness

Regardless of the resolution of your image document and the halftone settings on your inkjet printer, some papers just can't cope with fine detail. Like cheap newsprint, poor-quality papers do not have the surface coating to hold individual ink dots without spreading. Copier papers, writing papers, and machine-made artist's papers all react like blotting paper: ink dots are merged into each other and sharpness will decline. In fact, these materials work much better if you use low-resolution images and low-quality printer settings. Maximum sharpness is achieved using plastic film media, designed to hold each ink dot in its rightful place. If printing sharp-edged graphics is your thing, then only coated materials will reproduce crisp lettering.

Contrast

Perhaps the greatest challenge is connected with the control of image contrast. For photographers experienced in darkroom printing, the careful balance between exposure and contrast dictates a successful print. Like photographic paper, greater tonal range is achieved using glossy papers, less with luster surfaces, less still with matt, and even less with uncoated. With colored materials such as cream or off-white papers, the paper base color will become the maximum highlight brightness of your image, regardless of its appearance on your monitor. Yet, with most commercial photographs ending their lives as glossy, pin-sharp, and heavily saturated illustrations, uncoated media opens an interesting avenue of experimentation. Precise contrast control will only come after a thorough study of Photoshop's Levels and Curves functions.

Brightness

Getting the print "exposure" right first time round may not be as easy as the printer software makes out. Different papers react differently to inks resulting in muddy prints. It's essential to get your brightness correct before looking at color casts.

Purpose-made high-gloss inkjet paper will reproduce the highest level of color saturation and rich black shadows. This type of media is the easiest to work with and requires little testing.

Coatings and Color Balance

Surprisingly, ink reacts with the various paper coatings and chemicals to produce color casts. Just like color photographic printing, a pack of new paper might need an additional color correction to get the best results. A print made with two different glossy papers, but under identical settings, will produce different outcomes. It's important to use quality papers made by reputable brands such as Epson, Somerset, and Lyson. Budget papers will give you low-quality results.

Surfaces

Textures such as laid, vellum, or bond can allude to a precious or vintage print with a delicacy that doesn't take emphasis away from your image. Heavier textures such as canvas or linen impart a much more severe pattern and can look as gimmicky as an effects filter. Textures will obviously take away some of your image sharpness, but perhaps the days of minute recognizable detail have passed.

Matt or coated papers offer a smoother "feel" but with a lower color saturation than glossy. Many third-party papers, not designed around a specific inkset, will impart a color cast on your prints.

Professional Inkjet Paper

Color Saturation

Like glossy photographic paper, glossy inkjet papers and films give you the highest color saturation. With a shiny topcoat enhancing the depth of a print's blacks and shadow areas, most light is reflected from this kind of media. Matt or coated surfaces, however, give a less intense result and certainly a weaker black. Under the microscope, a finely pitted china-clay coating reflects light in many different directions and uncoated materials such as art papers have a fibrous surface, which creates less saturation and a restricted tonal range. Colored papers such as cream add an extra color into the ink mix and may destroy delicate color effects in your image. Off-whites can be very effective for monochrome or toned prints, and uncoated papers can give the impression of an artist's print.

All manufacturers provide free profiles for their professional paper, so you can achieve the best possible results from your media. When a profile is set up correctly, you will make far less printing mistakes and therefore spend less on materials in the long run.

Keeping Your Costs Down

Rather than buying cheaper brands of paper to minimize your outgoings, a better idea is to buy your media on a roll. Better 11x17 printers have a roll paper feeding mechanism, together with all large format devices. Roll paper is not only cheaper to buy but can be used with RIP software for tiling different print jobs side by side, so every square inch of paper is used to good effect.

Contract Proofs

Proofing paper media is a common type of media, usually with a matt finish, and is used for producing proof prints for artwork before sending to lithographic or digital press production.

Trying Different Papers

A good way to experiment with third-party professional papers is to buy a sample pack, like this one from Moab. Containing a couple of sheets each from their entire range, a sample pack lets you try out colors, weights, and surfaces before you buy in bulk.

C-Type Photographic Paper

What C-Type Is

Before digital sensors and inkjet printers were invented, all professional and amateur photographers outputted onto the same kind of sensitive material. C-type photographic paper is sensitive to light and constructed out of color coupler dye layers embedded into each sheet. After exposing under an enlarger (or laser diode light beam), the paper is developed in a standard chemical process called RA4, within an automated roller transport machine. All color photographic prints follow the same processing sequence: development, bleach-fix, wash, then air drying to produce a dry print in around 10 minutes. Despite the introduction of permanent pigment inks, most photographic prints sold at galleries or exhibited at art museums are C-types.

C-Type Minilabs
The Fuji Frontier 390 is a wet minilab using standard RA4 chemistry and C-type paper. Minilabs are usually restricted to a limited paper width, unlike prolab processors that can output to around 30" wide.

Longevity

Better C-type paper materials such as the commonly used Fuji Crystal Archive brand is reliably resistant to fading, provided it is processed in fresh chemicals and washed according to manufacturers' guidelines. Crystal Archive has an estimated life span of around 50–60 years before noticeable color change takes place and considerably longer for prints stored in albums or away from atmospheric pollutants. In independent studies using accelerated exposure tests, C-type paper performed well below top quality pigment printing systems, such as Epson's Ultrachrome K3, but the common misconception remains that C-type chemical prints last longer than inkjets.

Access to C-Type Service

Better C-type paper product such as Fuji Crystal Archive provides downloadable profiles for use in soft proofing and convert to profile commands. Although the cost of C-type paper material is comparable to inkjet media, paper processing units are expensive to buy and keep replenished with fresh chemicals. Unless you are printing on a daily basis, it's more economical to send your files to a C-type processing lab.

Baryta Paper

Branded as a professional fiber-based inkjet medium, a Baryta-based media such as Harman's Photo Matt FB Mp Warmtone promises to lure black-and-white digital photographers frustrated with generic inkjet media. The paper feels luxurious and weighty, manufactured at 310 gsm, close to a double weight conventional photographic paper and has been designed with a clever baryta layer within. Helping to keep the paper rigid and improve the brightness of the image overlay, the use of baryta makes an exciting link between this new material and some of our old darkroom favorites.

The paper is designed with an off-white tone, similar to Somerset Velvet Enhanced, and as such provides a warmtone base for images to sit upon. The most impressive feature of the paper was its ability to render a neutral black-and-white print created from my color inkset, which is no mean feat for any photographer struggling to eliminate unexpected color casts. In this respect, the profile did a very good job of keeping the final piece strictly mono. I prefer to print my mono images using the full color inkset, as the print resolution is greatly enhanced by the use of six or more colors. Each of the test prints I made using the Harman Warmtone demonstrated a crisp sharpness, showing the finest detail in my images. The paper was also very capable at dealing with excessive black shadow areas, too, even the deliberately darkened test images printed very well without clumping together difficult to print tones. These characteristics make the paper positioned well to receive very good reviews from the black-and-white photography fraternity. The results bear out very well the claims made for the advantages of the baryta sub-base. Not only does this special layer create an ideal environment for printer ink, helping to maximize sharpness and tonal range, but it also contributes to extended archival qualities. Each print emerged from my inkjet curl-free and without any visible wet ink; indeed, the paper makes a very good job of drying quickly compared with other brands. Despite the tag of warmtone, the paper will not provide the same kind of brownish tone as Record Rapid or Portriga using the straight profile, but you can easily extend the use of the paper by digitally toning your files first in Photoshop.

Feels Like Fiber-Based Paper

Harman's excellent baryta-based inkjet paper does feel like traditional silver-based photographic paper because the same paper base is used in its manufacture.

The same paper base is a common component at Harman's coating factory in Cheshire, receiving either light sensitive emulsion or china-clay inkjet coating.

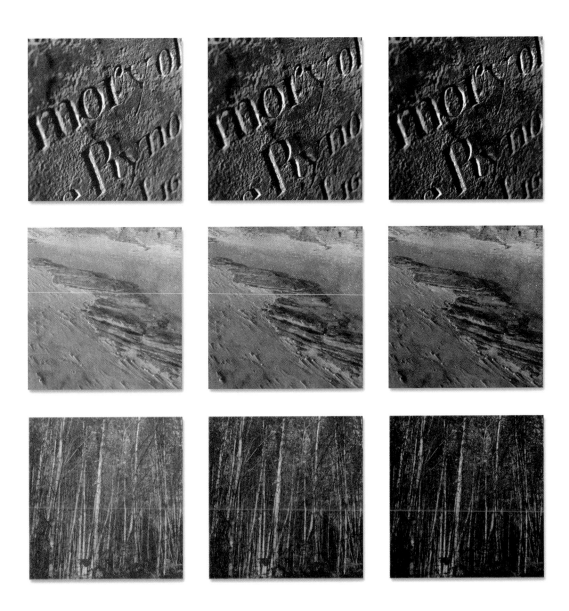

Cotton Papers

Handmade Papers

Greater permanence can be gained from handmade papers, which by their very nature use less chemical agents in their preparation. These papers are generally made from virgin materials including linen rags and cotton and made one sheet at a time. The vatman, as he is known, dips a rectangular sieve (the deckle) into the vat and pulls out a quantity of watery pulp, shaking to mesh the fibers together and drain excess water off. Edges can be modified too with deckled or untrimmed finishes. Both Somerset Velvet Enhanced and Lyson Fine Art share the quality and feel of a handmade material but with the added advantage of a specially designed surface coating to improve image sharpness.

Inkjet Art Papers
Inkjet art media offer a more tactile finish like traditional artists watercolor paper. Good brands to try are Somerset and Innova, and both have been carefully designed to reproduce fine detail and high color saturation with an alluring texture. Very heavy weights up to 300 gsm can be used for exhibition printing.

Archival Properties

Archival cotton rag paper is made without the use of any chemical agents likely to contribute to the deterioration of an art image, a prerequisite for images sold through galleries.

Giclee Editions

Archival cotton papers are often used for making editions of high-quality inkjet prints, otherwise known as Giclee (French for inkjet). Well-established artist paper manufacturers such as Somerset, Bockingford, and Canson all make inkjet versions of their most famous brands, suitably coated for use with digital inks.

Soft-Proofing Cotton Papers

The best coated cotton papers reproduce saturated colors really well and only alter in appearance slightly during soft proofing, as shown above. The only difference between cotton paper and glossy inkjet media is a compressed dynamic range, most obviously in a slightly weaker black point.

Printable Cards

Moab makes a range of cotton paper products to complement their inkjet paper range, including these prefolded cards. Prepared with the same coatings as inkjet paper, these cards can also be used with profiles.

Vintage Printing

Just like ancient photographic processes such as platinum and gum bichromate printing, art papers can take digital photography into another era. Many of the early photographic processes were produced on cotton papers rather than the shiny and mass produced papers we know and use today. If you're prepared to forego a slight sacrifice in pin-sharp image quality, then you can add a totally unique look to your printouts.

225

Watercolor Papers

Paper Types and Limitations

It's essential to realize at the earliest stage that cotton or wood pulp watercolor papers designed for artists use will react very differently to glossy inkjet paper. Art papers are much more absorbent than conventional inkjet media and as a consequence are much less reflective, too. After making your initial test prints, you'll notice that your results will look oddly dark and have a much less saturated range of colors compared with a monitor image. Because of the open weave and texture of many paper materials, high-resolution files with pin-sharp detail will not reproduce well and contrast will be flat and muddy, too. Bought in a single sheet or part of a sketch block, watercolor papers can be unpredictable but produce a wonderful textured result that is a perfect crossover between painting and photograph. Each kind of art paper has its own base color ranging from ivory, off-white through to cream, yellow, and even salmon pinks. Inkjet printers are never equipped with white printing ink, so it is important to recognize that this base color of your watercolor paper will become the maximum highlight color and value in your final printout. Most heavyweight art papers are made too thick and well beyond a typical inkjet printer's maximum media thickness limit of around 300 gsm. If you've got an Epson Photo printer, move the tension lever (found under the printer lid) from "0" to "+" to accommodate thicker material, but check your instruction guide before attempting anything close to the limit. Paper misfeeds are a common problem with art paper but can be prevented by using the printer's Form Feed command that pull your sheet of paper into position before you send the printer heads into a run.

The challenge of using unconventional media, such as these litho papers, will test all your problem-solving skills to get the best results. Composite and recycled papers offer the chance to investigate more exciting surfaces than glossy, matt, and luster.

File Preparation

The inherent limitations of this kind of paper will also determine exactly how each individual file is prepared. As so much fine detail will be lost in the print, it's not essential to have ultrahigh-resolution image files to print from. When ink dots hit the paper, they start to spread out like writing ink

Art papers can't really cope with anything more than 720 per dots of ink per inch and many will look better printed with the draft quality or fast speed setting, sometimes referred to as 360 pi mode.

on blotting paper, so there's little advantage in preparing images with a resolution above 150 ppi. With fewer pixels and fewer ink dots, the print stands much less chance of turning out waterlogged.

Brightness and Color

Ignoring your carefully balanced monitor, you'll need to make your image much brighter than normal to counteract the merging together of midtones. Make this adjustment in CS4 by moving the Levels midtone slider to the left until the image looks much brighter than you normally expect. This command should be further increased if you intend to print on cream papers. To head off the likely loss of color saturation, use the Hue/Saturation dialog to bump up the colors and move the Saturation slider by +20.

Judging Results

Most likely results will look muddy and dull, but this is easily corrected by returning to Photoshop and making a brighter Levels adjustment. Very thin papers such as Conqueror writing papers will only accept a small-scale print before buckling under the weight of the fluid.

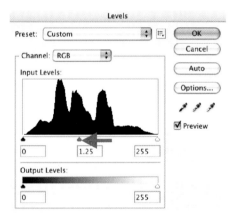

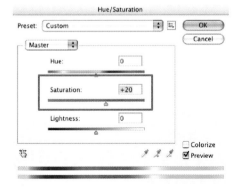

Alternative Papers

It's not just the convenience factor that makes inkjet printing such an exciting prospect for photographers; rather, it's the chance to print on a huge variety of unusual materials. You can print on to most absorbent media whether it's designed for inkjet printing or not to produce unique one off pieces. Yet, experimenting with unconventional media demands that you veer away from all autocontrast and auto everything commands. It's not tremendously difficult, but you've got to take hold of the manual reins. But if you've already spent more time than you'd care to remember in the darkroom or maybe had a bit of experience with litho printing, you are already well equipped to start off.

Setting Up Your Printer

Many litho papers are manufactured beyond your printers maximum media thickness of 300 gsm. If you've got an Epson printer, make sure that you move the tension lever (found under the printer lid) from "0" to "+" to accommodate these thicker materials. Paper misfeeds are a common but annoying problem with using nonstandard media. Avoid using paper that does not have a clean and sharp leading edge as it will prove tricky to load. If you are anxious about your paper misfeeds, preposition it in the print rollers before you send your image file by pressing the Form Feed button. This pulls it into place and waits for you to send your image.

Techniques

It is essential to recognize that this type of material will react very differently to standard bright white inkjet media. First, it is more absorbent and less reflective, so your first test prints will be disappointingly dark and have a muted color range. It will also be impossible to reproduce pin-sharp detail, so only use on those images that have a healthy degree of creative defocusing.

Contrast, too, can seem problematic as the base color of the litho paper will become the highlight color of your image, so an image printed on cream paper will have cream-colored highlights. Don't expect your inkjet to print white!

This shows the same image printed onto three different colored papers. Left is a standard bright white inkjet paper, which reproduces the image as a well-adjusted photographic print. The middle swatch is a piece of Conqueror writing paper, yellowish in tone, which takes the highlights down. Far right is a sandy-colored Gmund Bark lithographic paper, which takes the highlights down even more. Even after fully correcting the brightness of each image, the highlights will only be as bright as the paper's base color. Color balance, too, will be influenced by paper base, so you might want to make Color Balance adjustment before sending to print. With these three examples, the yellowish Conqueror adds a bit of "age" to the image.

Preparing Your Image Files

It's not essential to have extremely high-resolution image files to print from, as litho paper can't cope with 1440 dots of ink per inch. As ink dots spread slightly once they've hit the paper, like ink on a piece of blotting paper, you won't see any advantage using images above 150 ppi. If you reduce your image resolution from 300 dpi to 150 dpi, they'll be leaner to store and take less time to process and print, too.

Stationery

Good-quality writing paper such as Conqueror and Svecia Antiqua Rare make good-quality printing material. Without a coating of size, to stop ink and paint marks bleeding into each other, this material holds finer detail better than most artists' watercolor paper. Stationery is a great material for making individual sections of your own handmade book. This example

was printed on a lightweight paper called Gmund Straw, which, as its name suggests, is made with bits of straw and fiber showing through the surface. There's a random and unexpected nature to using this kind of material, but that's part of its attraction. For this image, finely detailed leaves and fabric were scanned in on a flatbed and then printed out.

Lithographic Papers

Perhaps the easiest to start with are lithographic papers. Designed and manufactured for the commercial printing industry, these papers can be bought cheaply but rarely in small quantities. They are best sourced directly from paper agents, who will send you a swatch book and sell you a sample pack once you've decided on a material to try. Most interesting types include those with textured surfaces or made with composite fibers, which add a totally different look to your images. Litho paper is designed to be used with spirit-based inks rather than the water-based inks of an inkjet printer. However, despite a slight loss of image sharpness, due to the spreading of inkjet droplets, very good results can be achieved.

Canvas

Using Canvas Media

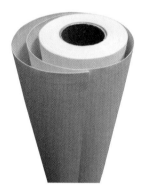

Both Epson and Canon provide purpose-made canvas media for their inkjet printers, but more exciting media is available from specialist manufacturers like Breathing Color. Coated canvas for inkjet is specially prepared to accept fine dots of ink and is flexible enough to withstand rolling and stretching without cracking. With such a fine coating, printed results are very colorful, sharp, and tonally rich. Uncoated canvas, like the material for painting on, won't accept inkjet ink, but it can be used if coated first in a brush-on medium such as InkAid.

It's cheaper to buy canvas on a roll, which you can cut down to size or load straight into your printer. Only large format printers will have a built-in blade capable of cutting the thicker and fibrous canvas, so you must ensure that your autocut option is switched off before using. Many canvas are produced with optical brighteners, so it's essential to use them with a recommended profile or you will get unpredictable results.

Drying and Curing

Although most canvas media dry instantly and is smear-free on ejection from the printing device, it's best if individual prints are left to "cure" before being stretched on a wooden support or framed. To assist in this process, lay the canvas print flat and cover with a sheet of plain paper and leave overnight.

Guarantees

Better canvas manufactures such as Breathing Color provide supporting documentation for certifying the archival properties of their media, which can increase the confidence of potential print purchasers.

Canvas Stretchers

A low-cost alternative to outsourcing canvas mounting is the excellent Gallery Wrap system from Hahnemuehle, shown left. Needing no specialized tools or equipment, oversized canvas prints are stretched around a wooden frame and kept in place with double sided tape. The system is available in lots of different sizes and is an effective way to present canvas prints.

Printer Types

Printer Quality Essentials

If you're about to upgrade your printer or invest in a digital workstation for the first time, it's definitely a buyer's market. With a wider range of print devices now available than ever before, you can achieve photo quality output from a very limited budget. In addition to different hardware options, there's an increasing variety of special papers, media, and third party inks to consider, too. Yet, with such an increasing selection of materials to ponder, how do you make an informed choice without multiplying technical problems or breaking your bank balance?

Variable-sized dots define a top quality printer, as this additional function aids the reproduction of fine detail and sophisticated color gradients without visible signs of banding.

Print Quality Essentials

With many home office inkjets still designed with a four-color ink cartridge, you'll need a better type of device to get photo quality results. Most photo inkjet printers use a six-color pack: the four standard colors of cyan, magenta, yellow, black, plus two additionals, light cyan and light magenta. These extra

Close-up, bigger dots are more evident in highlight areas, but this is much less noticeable in higher resolution devices.

two colors really help provide better skin tones and smoother color gradients found in photographic images. Four-color inkjets are really only suitable for printing solid graphics such as charts and line art for office reports and newsletters. The term *resolution* when applied to a printer should not be confused with the resolution of an image file; they are two separate issues. In a modest quality inkjet printer, the printer heads will be able to emit ink as a single-sized droplet, but in better models, droplet size can vary to include a micro fine option. The higher the resolution of the device, the finer print it can make, but any inkjet working at 1440 dpi will still produce photo quality output providing the right media is used. Responding to the first wave of anxiety about the permanence of digital printing, ink manufacturers have now developed colors based on pigments rather than dyes. Dye-based ink is found in all nonphoto quality inkjet cartridges and all budget third party refills. Cheaper to make, but quick to fade, dye ink should never be used to print an image for resale or exhibition. Pigment inks are made from lightfast pigments and are more expensive to buy. Pigment ink prints will last longer than conventional silver-based color photographic prints, tested by independent laboratories like Wilhelm Research. The downside to pigment inks is a lower color saturation, hardly noticeable when printing images drawn from a muted color palette.

Newly devised vivid ink colors and high-dynamic range inksets will enable color rich images, such as this shown above, to be printed with nearly the same intensity as viewed on-screen.

Dynamic Dot Distribution

It can be difficult to see the difference in quality between prints made with 1440 and 2880 dpi. Prints made with the finest possible ink droplets, such as 2880 dpi , take much longer to print than 1440-dpi examples and with little visible benefit. Many better printers including Epson's recent professional inkjets work in a smarter way by distributing the finest 2880-dpi drops when printing with the speed of 1440 dpi. The printer software drops fine dots in fine detail, followed by coarser dots in continuous color regions. The effect is a real optical illusion, as your eye doesn't see the difference.

Prosumer Printer

Basic inkjet printers have come a long way in the last five years, and long gone are the crude dots and bands. With better technology and the recent boom in digital cameras, a good inkjet can now make prints that are indistinguishable from conventional prints.

Two main factors determine the quality of an inkjet printer: resolution and color cartridge type. Resolution describes the number of tiny ink drops sprayed onto the paper and is measured in dots per inch, such as 1440 dpi. The bigger this number is, the finer results your results will be. Ink cartridges are made with a varying number of colors, such as three, four, and five. The more colors the cartridge has, the more subtle your prints will appear. Starting at the bottom of the range, a general purpose inkjet is designed primarily for home use. With a maximum print size of letter, this kind of printer uses a three-color combined ink cartridge and prints with yellow, magenta, and cyan inks at 720 dpi or higher.

Much better results can be achieved from a photo quality inkjet, typically with a five or more color cartridge and a resolution of 1440 dpi or higher. Two extra colors of light cyan and light magenta make a much better job of mixing flesh tones and other delicate colors, and your printouts are much less "dotty," looking like real photos.

The only downside to making inkjet prints with a budget device is fading. Most low-price printers use cheaper dye-based inks, which are naturally unstable in daylight. With some prints fading to a greeny blue in as little as two months, results can be very disappointing and worse still if you use third-party ink cartridges. If you want to make more permanent prints, a much better option is to spend a little more on a printer, which uses lightfast ink cartridges, such as the Epson Ultrachrome system, and always use the manufacturer's recommended ink.

Why You Should
Cheap entry point to digital printing

Small footprint and easy to achieve good results

Can work as a direct printer, too

Why You Shouldn't
Maximum letter size

Limited ink colors

Will not be supported by third party paper profiles

Multipurpose Devices

Why You Should
Low cost dye–based inks for lower running costs

Ideal for nondisplay and reference prints

Why You Shouldn't
There's very few third-party profiles available for these types of printers

Multipurpose devices are designed to clear away the clutter of your desktop and area a jack of all trades. Most can print up to letter (and onto CD/DVDs), scan 35-mm film and flat artwork up to letter in size, plus have a handy photocopier function too. You can also use it as a direct printer with any memory card, PictBridge-enabled camera, or camera phone. Unlike previous multipurpose devices where quality is often sacrificed for versatility, recent models offer high-resolution scanning and printing, all in one neat package. Many devices like the Canon MP980, shown below, have a range of connecting options including USB port, plus Wi-Fi and Bluetooth for connecting PDAs and camera phones. If you're planning to revamp your home office, these four network options can help you sort out the logistics of printing from multiple PCs, funding the ink habits of multiple printers, and even pacifying the differing demands of your family members. One of the real benefits of this device is its network capability at no extra cost. If you've ever been frustrated at trying to link more than one PC to your inkjet (or through unreliable USB printer sharing), then you'll be glad of the MP980's facility to connect through an existing local area network with standard Ethernet protocols.

Summary

Great workstation tool offering multiple functions, networking, low running costs, and enough resolution to scan and print to a very good standard. Great for proof-prints, contact prints, and working prints, fast to scan and print, this is the ultimate desktop device for the creative office.

Professional Desktop Printer

The Professional Inkjet Printer

Adopted by many professional photographers due to its sophisticated software, speedy output, and seven or more ink colors; able to produce exhibition quality prints at high resolution and work with a variety of media including roll paper, panoramic sheets, and the thickest of cotton fine art papers; and designed to operate at much higher levels of control in a professional workflow, this kind of device will produce the highest quality output of all. Most professional inkjets are equipped with seven or more separate ink cartridges, including a light black for better tonal gradation, and this printer will produce true photographic quality output.

Inside the case is a complex printer head, able to emit ink in different-sized dots. Different to basic inkjets that print with a fixed-sized dot, the variable dot printer provides a more convincing end product. Working at output resolutions up to 2880 dpi, ink is much less visible on the printed page. To provide commercial photographers with lightfast prints for resale, the professional inkjet is designed to use pigment ink cartridges and can also be used with a range of specialized third-party products such as Lyson Small Gamut or Quad Tone inks. Software controls offer more flexibility to manage accurate color and neutral monochrome output. For maximum lightfast prints, the printer is best used in conjunction with purpose-made archival papers rather than cheaper general purpose materials. Unlike office style laser printers, inkjets are sold without built-in memory and network cards and are designed primarily for use from a single workstation. However, through the use of a software raster image processor (RIP) residing on a networked printer server, the printer can be shared easily among a group of users. Using a software RIP will inevitably present another layer of color management issues to be solved, but it can provide a flexible solution to managing heavy use between users. Any PC can be used as a print server, and this is an ideal use for an older, slower machine that you may have tucked away in a cupboard.

Why You Should

Fully supported by most paper profiles

Rugged and designed to be used repeatedly

Able to use roll paper media, so you can keep your costs down

Why You Shouldn't

High unit cost

Inksets can be expensive

It goes without saying that print sharpness from a professional printer is exceptional, with no perceptible ink dots on any area of the print, either near white highlight or elsewhere. Using the highest-quality output setting available, prints require little or no further manual color or contrast adjustments when used with the correct profile. Using two or more strengths of black, this kind of device makes a fine job of separating out very dark tones, especially in the 90–100% blacks.

Large Format Printers

Proofer Style Inkjets

A good entry point to the world of large format printing is the 17" wide proofer style printer. Designed primarily for graphics and repro studios producing contract proofs for prepress clients, the proofer style has also become a firm favorite with many professional photographers. Able to output up to 17" wide in size and 17" wide rolls, on both sheet and roll paper, this larger style device can help keep your running costs as low as possible. Most proofer style printers like the Epson 4800 series, shown below, run with three values of black ink, plus the option of either Photo Black or Matte Black.

Why You Should

Lowest cost large format

Rugged professional shell

Why You Shouldn't

Ink cartridges sets can cost as much as the device itself

RIP software is usually an extra purchase

High-Capacity Ink Cartridges

Proofer style printers like the 4800 series can be used with different-sized ink cartridges, so you can fit a range of sizes depending on your workload. Better printers also have the choice of paper feeding mechanisms including roll paper, individual sheets, and preloaded trays.

Connectivity

Better proofer style printers have both USB and Firewire connectivity, with Ethernet usually available as an optional extra. For connecting multiple workstations in a studio environment, a good idea is to use a wireless print server.

Large Format Devices

Designed specifically for reprographics, point of sale, and exhibition display, the photo-quality large format printer is available in widths up to 60″. Operated through a software RIP to maximize the return from both ink and paper, the large format printer is typically offered as a cost-effective option for small run printing and one-off jobs that would be too expensive to produce using lithographic printing. Large format devices are essentially scaled up basic inkjets offering midrange resolution, as super fine photo-quality is largely invisible on large-scale prints due to your viewing distance. Like the proofer printer, such a device has a built-in paper cutter and will output slowly. Although a large format printer can be operated directly from a PC, most labs drive their devices through a print server or hardware RIP, so several jobs can be stacked ready to go.

Most large format lab services are offered with a limited range of paper types, due to the high cost of paper rolls and the inconvenience of changing rolls repeatedly. Not all fine art papers are available in roll formats.

High Dynamic Range Printer

At the top of the large format print quality scale is the high dynamic range (HDR) device, newly created with an exceptional inkset. Epson's 900 series HDR printers are now setting the benchmark for all other professional devices. Watching the printer in use, it's easy to see the practical benefits of Epson's redesigned printer head with double the amount of nozzles and throughput, print speeds are very fast and can achieve 40 m²/h in operation, so there's no need to wait around for your print to emerge. Armed with a simpler roll feeder mechanism and a brand new rotary cutter, too, canvas and other thicker media can now be cut internally. The device also sports a new professional printer driver, with several new control panels and the new 16-bit output option (currently for Mac OS X Leopard users only) as found on similar large format drivers released in 2008. There's no need to chop and change different black inks, too, as the driver automatically swaps between Photo Black and Matte Black, depending on your media selection. To support the new color performance, Epson have redesigned new look-up tables to improve the translation of RGB image files into 10-color CMYKOG inkset. Like the hexachrome inkset used in high-quality lithographic printing, the addition of orange and green inks in the HDR device enables much more subtle colors to be reproduced and hardly any drop in saturation from monitor to paper.

Profiles on the Fly

Not only does the 7900 offers the facility to reproduce more colors that may otherwise have fallen out of gamut, it also provides an optional built-in profiling device. Provided as an optional bolt-on, the SpectroProofer box can be clipped to the underside of the printer, providing an easy way to create bespoke profiles for your own workstation or output circumstances. Inside the SpectroProofer is an X-Rite spectrophotometer, which creates the necessary data on the fly, i.e., reading the color patches as the print emerges from the printer. There's no need for a separate patch-reading device and all the associated hassle that is usually involved in this process. It's neat and quick and saves on space.

Prices and Running Costs

To support its new 900 series printers, Epson have introduced an optional super-sized 700-ml ink cartridge for each of the 10 standard HDR colors. This offers the potential of lower running costs per print, but with a higher start-up cost when compared with using 350-ml cartridges. Like many other Epson large format printers, you can use a mixture of cartridge sizes all at once, helping you to economize and really useful if your workflow demands more of one color than another. Although at present the new HDR inks are only used in the 24-inch wide Stylus Pro 7900 and 44-inch wide Stylus Pro 9900, it's unlikely that the new ink technology will be used in prosumer 11x17 and 17" wide desktop printers. However, there is a strong rumor that the 900 series may be extended into a 17-inch wide model to complement the existing Stylus Pro 4880 proofer-style workhorse.

Kodak Kiosks
Used as a basic walk-up print station in photo stores worldwide, this kind of kiosk can be connected to a range of printing devices.

Direct Printers

Connecting straight to your camera, a direct printer can save you time and effort but still produce great results.

Recently, great advances have been made in the design and quality of direct printing units, those curious peripherals that print directly from your memory card without the need for a PC. Although originally targeted at those photographers who were less concerned about manipulating their digital files before print-off, the newer models like the Epson PictureMate create top quality results that would satisfy the most discerning of photographers. With a six-color inkjet cartridge using pigment inks rather than cheaper dyes, and producing up to 4800 dpi resolution, it's capable of producing stunning prints in just under 2 minutes. With micro-fine ink droplets, the smallest in its range by far, image quality is high and without the tell-tale specks of a typical inkjet print. The best way to produce prints for friends and the family album, your results cannot be distinguished from top-quality conventional photo lab output, and all at a fraction of the cost.

All of the major players have a direct printer within their product range, but there are many different types of technology to choose from. As standard, they all print directly from your camera using the universal PictBridge or USB Direct Print protocols, but fewer models actually accept memory cards directly. All are fitted with a USB input terminal, so cameras and other devices can be connected without the need for a PC. Most printers in the range use a dye-sublimation technology to create color prints, an effective process for producing color, but not in the same league as a top-quality inkjet printer. The cost of consumables for this kind of printer can range from 25 pence to over 50 pence per 10 × 15 cm print, so it's well to think about your oncosts before committing. Like many printing systems, there are plenty of third party consumables on offer, but you'll never achieve the same print quality if you opt for cheaper materials.

Most direct printers produce index-type prints with thumbnails, so you can make a decision on which to print, and many also offer the option of printing passport-sized images, too. Borderless prints, the firm favorite for family albums, are less universal, with many systems using paper with tabs or perforated edge media. The PictureMate produces immaculate borderless prints, provided that the paper media is loaded correctly into the feeder, without smudges or loss of print quality at the edges. With ultra fast drying ink, prints are ready to hold once fully emerged from the printer. To create top-quality prints, the PictureMate makes good use of compatible cameras Exif data, by interpreting the settings saved at the time of shooting. The printer then interprets camera settings such as white balance, sharpness, and contrast, and makes adjustments to create enhanced prints. The printer can also respond to a DPOF compatible camera, whereby you can tag the files and print quantities on your camera before connecting up to your direct print device. Despite the attraction of setting your camera to shoot in enhanced contrast, sharpness, or color mode, direct printers can make all the adjustments for you between connection and printout, while you are left with a raw unprocessed file for further trickery in your image editing application. It's a much better idea to leave camera contrast and sharpness presets switched off, as you can easily restore these on your PC. If in doubt, opt to shoot and save in the high-quality JPEG mode, as other less universal file formats like TIFF and RAW may not be compatible and will certainly take a lot longer to process and print if they are.

Polaroid PoGo
Smaller than most digital compact cameras, the innovative PoGo printer makes 3 × 2 inch prints without a direct electricity supply.

The top-of-the-range PictureMate provides a built-in CD writer, so that you can archive important files straight from a connected camera of memory card. This direct printer can also be driven by a rechargeable battery, making it an ideal device for taking on location.

Inks

Ink Essentials

Good inks are an expensive necessity for a professional photographer, much like the expense of professional film and processing. There's simply no compromise to be made with ink, but it's important to understand the different qualities available. When photo-quality inkjets were first introduced to photographers, initial skepticism centered on poor lightfastness and unreliable quality. Nowadays, the big two hardware manufacturers are on their fifth-generation inksets and great advances have been made.

Third-Party Inks

Desktop inkjets are designed to work best with their own manufacturer's dedicated ink cartridges and paper and will give unpredictable results with anything else. Printer software is designed to respond to a predictable supply of color and may not be able to fully correct color imbalance caused by a rogue product.

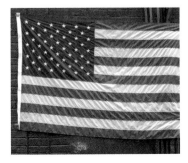

With all of the problems associated with color accuracy, using cheaper inks will only make things more complicated. Research has also shown that these inks offer drastic reductions in print life, with many offering less than a year at top quality. In addition to the drop-off in life expectancy, many products can seriously clog up your printer heads, and in extreme cases of damage, their use will invalidate standard warranties on your investment. In printing as in life, you get what you pay for.

Better inkjet printers have individual color ink cartridges, so you only have to replace the one that runs out. Light Magenta is usually the color that runs out first.

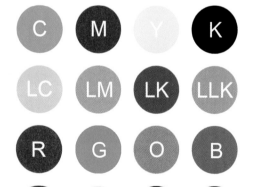

Ink Colors and Image Quality

Currently, there are 16 common colors used in the world of professional and consumer inkjet printing. In addition to the standard CMYK, and their lighter versions, recent innovations have introduced red, green, orange, and blue into the equation. Prosumer inkjets are based on an eight-color set, which includes three strengths of black, but at the professional end of the scale, the latest high dynamic range (HDR) printers use an inkset based on the lithographic printing industry's hexachrome set, which includes green and orange inks. These two extra colors really extend the gamut of the device and enable the reproduction of far more sophisticated skin tones. Brighter colors are also created by two new colors: vivid magenta and vivid yellow, similar to fluorescent inks used in the printing industry.

Comparing 3D Color Models

No subtractive color output device can encapsulate the entire range of colors within the Adobe RGB color space. However, by loading inkset profiles into a simple profile application such as ColorSync Utility, you can compare and contrast their range against larger color spaces such as Adobe RGB.

Dye-Based Inks

Although not in the same league as lightfast pigment inks found on professional photo printers, basic dye-based inksets claim a 30-year light fastness or 300 years for prints kept permanently in albums. Dye-based inks are perfectly acceptable for printing reference prints or contact prints, as shown below.

Inks in Detail

Most consumer printers are fitted with a three-color inkset: cyan, magenta, and yellow, plus photo black and gray (which is effectively light black). Dye technology has come a long way since the early inkjet inks, which were prone to fading within months, now offering the end user the choice of a reasonable life span with cheap running costs.

Running Costs

Better consumer inkjets have separate dye-based ink cartridges, which are much more economical to run compared with a professional 10-color pigment printer. There's no sense in using a professional pigment printer to output office-type documents or even working photographic prints, so a dye-based device makes very good sense if you are running a small business.

Lightfast Dye-Based Inks

Most low-price ink is made with cheaper dyes, which are naturally unstable in daylight. Better results are achieved with products claiming an extended life span. Epson's own ink system replaced their earlier range, which was prone to rapid fading within months. Another alternative is Lyson's Fotonic Archival Color inksets, which claim a life span of 25–30 years. These types of ink should be used for producing prints that need a guaranteed life span, e.g., for a portfolio, indoor display, or photographic album.

Pigment Inks

The printing and textile industries rely on dyes to color their products, but many dyes are inherently unstable in light. Curtains fade and book covers discolor in sunlight, and the same results occur with inkjet prints. To complicate things further, some dyes, such as yellow and magenta, are more unstable than others, leaving the faded print a characteristic cyan color. A much better way to make stable color is to use pigments rather than dyes. Paintings from the Renaissance survive due to the quality of pigment used in the artist's oil paints, and only pigment inks should be used for any print that is sold as an artwork or editioned print. Unfortunately, pigments are more expensive than dyes, and this is reflected in the price paid by the consumer. When it comes to color saturation, early pigment inks tended to be less vivid than dyes.

Pigment ink is the only kind of ink to use for making commercial photographic prints, as it's guaranteed to last as long as a sheet of conventional photographic paper, providing that it's kept away from airborne pollutants.

Pigment Ink Costs

The cost of replacing an inkset for a good quality professional inkjet can be as much as 30% of the original hardware, so it's important to work out the running costs before you commit to a new printer.

Special Inksets

Lyson, a manufacturer long associated with quality printing, manufacturers the innovative Quad Black and Small Gamut Inksets. Using standard four-pod cartridges, the Quad Black set replaces CMYK color with custom colors of the same tonal value such as black, dark gray, midgray, and light gray. Color casts are eliminated from the resulting prints, which have an enhanced tonal quality. Small Gamut inksets use the same principle but are biased toward a single color, e.g., brown, for creating photographic printing effects such as sepia toning. The one drawback is that only a limited number of printers are supported by these products. Unfortunately, some of the latest desktop printers will only work with their own-brand ink cartridges. Many have a microchip on the cartridge to prevent third-party inks being used, so if you'd like to try special sets, it's important that you check the compatibility of any new purchase first.

High Dynamic Range Inks

Ultrachrome HDR is Epson's fifth-generation pigment inkset and contains the familiar vivid magenta and light magenta colors used in the standard Ultrachrome K3 set. At present, the HDR inkset is only available on two large format inkjet printers, the Stylus Pro 7900 and 9900. Both sport a new green and orange ink color, enabling much better results in the reproduction of skin tones, making it a serious consideration for portrait, fashion, and product photography. Epson's new Ultrachrome HDR inkset has been developed primarily for the printed packaging market, where previous inksets have been unable to provide accurate contract proofs when spot colors are specified to boost the allure of a product packaging. When nonprocess ink colors are used in traditional lithographic reproduction, it becomes extremely tricky to proof their appearance when using a professional inkjets Cyan, Magenta, Yellow, Black, Light Magenta, Light Cyan inks, leaving many Pantone special color mixes out of range. Recognizing this gap in the market, Epson have introduced a new inkset containing green and orange ink, which, like Hexachrome, can successfully reproduce 90% plus of the Pantone color range, compared with around 60% achieved by standard CMYK inksets. However, by mimicking the CMYOK or Hexachrome process in conventional lithography with orange and green, Epson have radically extended the range of colors available to photographers, too.

Soft Proofing with Profiles for Ultrachrome HDR Inks

To compare the performance of the ink, a vivid test image was soft proofed under three different profiles: a standard profile for 900 series HDR inks and Epson's PhotoPaper Gloss 250; a standard profile for Ultrachrome K3 inks with the Stylus Photo 2880 and Photo Glossy 250; and, finally, an Ilford profile for its Premium Plus Gloss 270 with the 10-color inkset as found on Canon's Pixma Pro 9500.

Proofed against the 7900 HDR inkset, notice that no gamut warning occurs in the yellow and orange and only a tiny amount in the ultra vivid magenta areas. This is the best result by a long way.

Proofed against the set used on the Canon Pixma Pro using green and red inks, the results were slightly better than the K3 set, no doubt due to the additional red color.

Proofed against the K3 inkset on the Stylus Photo 2880, notice how most of the vivid colors lie outside the range of the inkset.

Practical Implications for Photographers

The most important benefit offered by HDR inks is the vastly expanded color gamut. This means fewer colors are clipped in transition from screen to print, which is clearly evidenced by Photoshop's Gamut warning and View Proof tools. When 900 series profiles are targeted in Photoshop's View > Proof Setup > Custom command, the resulting soft proof and gamut warning are far less modified when compared with alongside standard Ultrachrome inkset profiles. Effectively, the disappointing experience that we all encounter when proofing vivid colors is now a thing of the past. In preparing test images for this feature in CS4, I was able to extend the saturation values of a standard RGB image up to +35 with very little evidence of clipping, compared with my usual modest saturation increases of around +10.

Evaluating Test Results

To judge the performance of the new HDR inks, I ran three prints off the Epson 7900 using off-the-shelf profiles, rather than custom profiles made by the built-in spectrophotometer. The new HDR inks provide an improved D-Max of 2.6 when used with Epson Premium Lustre Photo paper (260), which creates a rich and punchy black, visually similar to a good quality C-type print. The extra two orange and green colors provide better rendition of colors lying in the green to yellow and yellow to red ranges. The new orange ink also contributes to minimizing the graininess of previous inksets when reproducing skin colors. The vivid colors encountered in the resulting prints cannot be reproduced by the CMYK printing limitations of this printed journal, but a better indication of the range is illustrated by the soft-proof screengrabs.

Duotone, Tritone, and Quadtone Potential

With a better reproduction of both process and Pantone special colors, Ultrachrome HDR inks suggest a greater potential for photographers working with Photoshop's duotone, tritone, and quadtone image modes. Traditionally, inkjet printers have proved restrictive when working in these modes, essentially unable to reproduce the range of press ink mixes offered by Photoshop controls. Unfortunately, duotone image modes can't be soft proofed like RGB or CMYK images, so there's no way to predict the outcome before printout.

A detail showing bright colors and strong performance of yellows, reds, and blues with HDR inks.

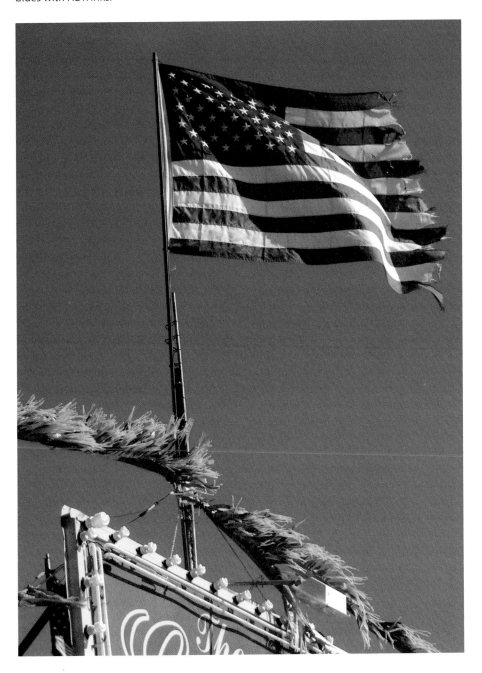

Dye-Sublimation

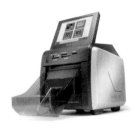

Many years ago, the dye-sublimation printer was the only quality device for digital printing. Dye-subs produce a continuous tone image, with little evidence of pixelation, provided the image file is prepared at the right resolution, i.e., 300 ppi. Compared with the output resolution needed for a photo-realistic inkjet, image data files will need to be at least 50% larger. Dye-subs use four colors, cyan, magenta, yellow, and black, and they work by fusing dye into specially manufactured transfer paper. The receiving paper is pulled four times through the printer making a separate impression with each color. This can give problems with registration, and if dust or fibers get in between passes, there'll be a very visible glitch. Consumable cost is very high, especially the dye ribbon, with receiving paper costing more than equivalent-size photographic paper. Priced at four times the cost of a professional inkjet, the dye-subprinter is no longer a competitive option for keen photographers. Queries have arisen over the stability of these dyes, particularly when prints are placed in contact with protective plastic sleeves. There's much less creative intervention possible with this type of device, no textural papers and no special inksets. As an alternative to the inkjet direct printer, there are now several devices using dye subtechnology including the impressive Canon Selphy range. Compared with the pigment ink PictureMate, predicted results for these kinds of device are variable but nowhere near the same longevity. In the mini dye subdirect printer range, print life span is estimated to last between four and seven years.

Event Printers
For social, public relations and event photographers, a compact dye-sublimation printer with a kiosk interface provides a fast way to turn out large volumes of prints. This device from Sony can print up to 8" wide and is an ideal companion for selling prints onsite.

Portable Dye-Subs

Canon's innovative Selphy CP770 device is a truly portable printer powered by a rechargeable battery and housed in a family friendly bucket-like container.

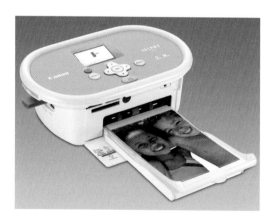

Continuous Ink Systems

Designed by a handful of third-party consumable companies, the CIS option is now a firm favorite with many busy photographers. Lyson and Permajet both produce excellent CIS products together with their own good quality ink products to match. The CIS works by replacing the standard ink jet cartridges within your printer with a simple plug-in series of feeder tubes, connected directly to large reservoirs of color. In practice, this means that you can always see what is happening to your ink quantities, before they run out and considerable savings can be made on the cost of your inks.

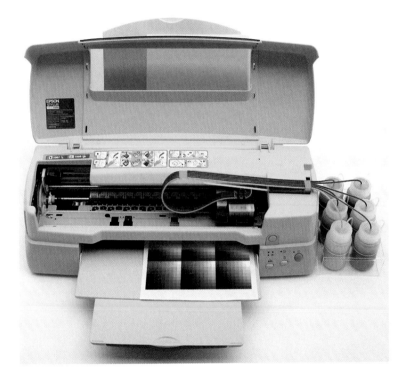

The Lyson CIS works by delivering constant ink through a network of tiny tubes connected to your printer head.

Although the better CIS kits are far from cheap with many systems costing close to the price of your original printer, savings can only occur if you are a frequent user and abuser of ink. Other cost-effective alternatives to buying branded inks, such as do it yourself syringe-type refills or cheaper brand replacement cartridges, are not really worth pursuing. Using cheap and unstable dyes with no guarantee of consistency or lightfastness, you really do get what you pay for when you opt for the mail-order specials.

Like many developments in desktop printing, the CIS is largely based on a similar ink delivery system used in large format printers that of a print head connected to substantial reservoirs of ink outside the moving mechanism. The desktop design is compact and desk friendly and compromises a very small footprint. With many of the top printers from Canon and Epson now sporting individual color pods, space is still at a premium under the bonnet.

Setting Up Your CIS

The system contains a syringe, various clear plastic tubes, and a modified printer cartridge and works by fooling your inkjet into thinking it has accepted the transplanted cartridge as one of its very own. Most modern printer cartridges are now microchipped and are often written to as well as read from by your printer software to prevent reuse and recharge. Lyson's own cloned cartridge is cleverly designed with a read-only chip, so the printer software can't suddenly insist on a cartridge change when it's totaled up the last 50 sheets of frenzied printing activity. Instead, the chip allows the cartridge to remain and be reused without bother, all you have to do is keep your eye on the ink levels elsewhere.

The good news about CIS conversion is that it's completely reversible should you want to revert back to your original factory-made printer. After taking out the original ink cartridges, it's advisable to use a head cleaning product that purges the printer of its native ink and paves the way for the new product. If this is not available, it's very well worth using your printer software utility to clean the printer heads and make sure that all is well beforehand. The CIS is equipped with a syringe, which works as a mini vacuum pump to clear all of the plastic tubes leading from the ink reservoirs to the printer head. With a clever use of clamps and valves, the vacuum pump removes all the air from the tiny ink line, allowing each chamber of the cloned cartridge to fill with ink and no air bubbles. Each tube is labeled with a color, so you don't connect cyan to magenta by mistake, but most importantly you must take great care in getting the sequence of colored reservoirs correct in the external bottle rack. Once the first color airway has been primed, the remaining colors take much less time to set up. Once connected, you will have a cartridge connected to six thin veins of ink, each connected themselves to six small bottles sitting in a rack.

The inks must not be raised higher than the height of the print head or you'll get ink flooding out of the head when not in use. On most Epson printers, a small print head-locking pin can be released by manually adjusting a nearby gear wheel, and this will enable the head to move freely along the tracking rods. Move the head into the cartridge change position, then remove the cartridge holder lids carefully. Keep these to one side, should you ever wish to remove the CIS. Once the lids have been removed, the CIS cartridge can be installed carefully in place with a little persuasive force.

Of course, once you step outside the same brand of printer, ink, and paper combination, you'll need to consider color managing your new materials to get the best of them. With your printer software designed to produce finely tuned results from familiar inks and paper, you really need to install an additional color profile that recognizes the innate characteristics of your ink and paper.

Setting Up a Mono-Only Printer

Designed only to work with certain models of inkjet printer, due to the adapted printer cartridge, CIS products are widely available for most recent Epson inkjets, some Canon models, and fewer still HP printers. It is useful to note that most contemporary printers are supported with some of the very recent models as yet in development. If you are thinking of upgrading your printer, a good idea is to keep your old model and convert it into a CIS and keep it for running special colors or for monochrome only. With many top-quality inkjet printers in the secondhand market, such as the Epson 1200 and 1270s, having two different print units to separate mono output from color will save you time and money spent on cleaning fluids. With a dedicated mono printer, you can also establish your own profiles and custom color settings particular to that device.

Zink

How Zink Technology Works

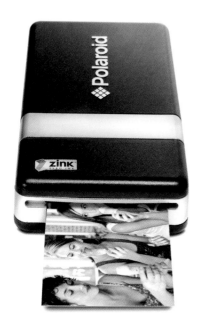

Zink is the latest instant print system adopted by Polaroid after the withdrawal of their traditional instant film. Like SX70 and peel-apart instant film, Zink has its coloring agents embedded into the actual print paper, so there's no need for a separate ink cartridge or toner ribbon. In Zink technology, the paper media is heated on release from the unit, which activates the coloring agents embedded in the dry paper, to make an instant print in seconds.

The PoGo Printer

Polaroid's first device to adopt Zink technology is conveniently small, about the same size as a mobile phone, which can easily fit into your coat pocket. At this size, it's a very handy device to carry on location and can be powered by rechargeable batteries to make it fully independent from a power supply.

Connecting Up

The PoGo printer can receive image data from a digital camera through a mini-USB connector, provided that the camera is PictBridge-enabled. The device does not permit printing from a USB-cable-connected PC or Mac, but it will accept data sent via a Bluetooth wireless device (which can be a PC or Mac) such as a camera phone.

Installing the Paper Media

Like most instant printing systems, the PoGo paper media is supplied in a ten-sheet pack, for insertion into the printer.

Preparing Your Files

The PoGo printer only accepts JPEG files and works best with images prepared in the sRGB color space. There's no limit on the actual data size of your file, but the image will be cropped automatically if it has a different aspect ratio to the 3:2 paper. As there is a slight contrast increase between desktop image and printed image, you may consider dropping the contrast of your source file before sending.

PoGo Instant Digital Camera

The latest portable device from Polaroid provides a built-in Zink printer, so you can make instant prints on location. At around 45 cents per sheet of paper, the prints are good value and ideal for record shots.

Print Characteristics

PoGo prints are small in size at 2" × 3" and are printed edge to edge. There's no development that takes place; the images emerge from the unit dry and ready to handle. Compared with inkjet prints, Zink prints have a little more contrast and have their own unique tonality, which is as idiosyncratic as the color of SX70 prints.

Uses

The Pogo printer is an ideal companion for the reflective traveler, small enough to carry around, and convenient for making reference prints for sticking into a notebook or journal.

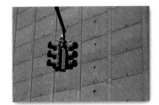

Digital On-Demand Services

How On-Demand Works

The revolution in photobook publishing has been made possible by the continued improvement in the quality of digital printing presses, particularly the HP Indigo range.

In the early days of digital printing technology, few would have suspected the impact it would make on commercial lithographic printing. Conventional photobooks were typically produced in large print runs, involved expensive reprographic processes, and were well beyond the means of most photographers. Nowadays, the introduction of the digital press permits the operator to run off just a single copy. The digital press is constructed from different modules, each with its own specific function. At the front end of the process is a raster image processor (RIP), equipped with job-management software, which schedules the delivery of different jobs to the press. Within this job-management software are familiar color-management

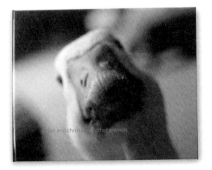

tools and image-enhancing processes to prepare the document for best quality output. The front end also manages the tricky task of arranging page designs into the correct imposition for double-sided printing and, later, collating and binding on a different device. The printing engine itself works using an electrophotographic technology and can output several thousand impressions per hour. The typical maximum paper size for presses such as the Indigo is 13″ × 19″, and most work on a resolution of 1200 dpi (or 300 dpi for each of the four process colors). High spec presses can also work at 2400 dpi.

Currently, the dominant press in printing on-demand services is the HP Indigo. The new Indigo solves the quality problems of early digital presses by using an innovative oil-based ink to avoid the cracking problems associated with presses using dry toner. Latest inksets for the press also use organic pigments, free from solvents, which are much less prone to conventional fading. The Indigo press works within the familiar four-color CMYK mode found in standard lithographic printing, but photographic quality can be improved greatly with the addition of two extra ink modules, light cyan and light magenta. Quality can be further improved with the use of violet and orange inks.

The implications for a photographer preparing a job for this kind of press are very significant. Compared with the flexible desktop inkjet system, where color profiles can easily be used to improve print quality, the digital press offers a smaller gamut and less access to color-management technology for the end user. The best option for optimum quality is to carefully color-manage your workflow from shooting through processing and finally during the preparation of your press-ready document.

The photo below shows the HP Indigo 5500 digital press, with individual ink cartridges in the open cupboard, the large-volume sheet feeder on the right, and the finished prints within the unit on the left.

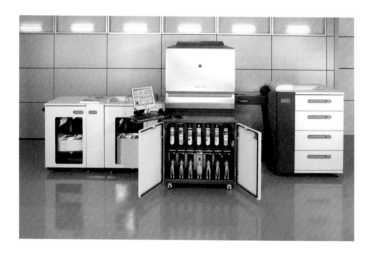

On-Demand Workflow

Design Delivery

Most on-demand providers don't offer a walk-up service, instead opting for fully integrated web-based delivery at the point of order. This offers convenience but comes at the expense of a truly transparent process. For all photographers who are keen to manage color in the most effective manner, it's essential to contact your printer early and get as much information as possible about their workflow and color-management procedures and as many tips on file preparation as you can. In a typical on-demand operation, finished book designs are delivered to the server as a PDF and can go through additional automatic processing before reaching the press. Unlike a typical photographer's workflow, where color can be managed from start to finish, there can be enormous gaps in the process, critical loopholes that could limit the quality of your final book. Some of the larger printing on-demand services will route your delivered files to a network of different output devices (some in other countries), making the entire process much less predictable. If you are preparing design work for an important book production run, it's always a good idea to prepare and print a test book first, so that you can see the likely results beforehand.

Preparing Your Images

All of the major photobook service providers recommend the use of the sRGB color space when preparing images for the digital press. The reason for this is simple: the smaller sRGB color space is closer in extent to the CMYK space used by the press, so there will be fewer differences between the on-screen and printed versions of your image. It's essential to get your files into this space before any image editing takes place or your results will be unpredictable. If you are unsure about the color space your project files have been created in, first check them in Photoshop. On the basis of the image window, click-hold the tiny right-facing arrowhead until two pop-up menus appear. Select the Document Profile option and watch how Photoshop displays the tag information at the base of the image window for you to see.

At this stage, there are three likely scenarios. First, the image has been shot in-camera using the sRGB space, so no further work is required. Second, your image has been created without a profile altogether (a possibility if it has been scanned or generated from an older device). Third, it has been created with a different profile, which now needs converting. From the Edit menu, choose Convert to Profile and set the options as above. Start in the Destination Space pop-up menu and choose the sRGB color space from the long list that appears. Next, choose the Adobe ACE color-management engine together with Perceptual as the Intent to make the most visually acceptable results. Finally, select Black Point Compensation and Dither.

Image Resolution

In commercial litho printing, the subtle tones of a photographic image are reproduced by tiny dots of printing ink of varying sizes. This optical illusion tries to mimic the continuous tone of a photograph without separating into areas of flat color. In practice, there are many different kinds of screening patterns and dot sizes, both designed for use with specific printing papers, but the finer screens produce the most "photographic" results. Screen resolution for digital/litho printing is defined in the terms of lines per inch (lpi), whereas inkjet printers are rated by the number of ink droplets (dpi) sprayed onto printing paper. For digital printing, the resolution is normally between 150 and 180 lpi. Since digital printing requires two pixels to be provided for every printed dot, you need to prepare your images with a resolution of 300 pixels per inch (ppi). The absorbency of the printing paper itself determines whether the dot of ink will remain a discreet size or whether it will spread into a slightly bigger shape than intended, a phenomenon called dot gain. This common problem found in litho printing is largely eliminated on the digital press by processing software.

Compared to color-managed inkjet printing, photobook design and production is largely a hit-and-miss affair.

Photography has now entered its third revolution, little more than 15 years after digital technology changed it forever. Running alongside the development of the photographer's favorite, the desktop inkjet printer, another revolution, this time in the commercial printing industry, has fast been gaining momentum.

The new digital printing press shares much technology with the humble inkjet and, unlike conventional presses, can be configured to print a succession of unique copies rather than several thousand copies of the same document. This capability to cater for short-run, or even single-copy, jobs has made possible the growing popularity of the personal photobook. In the early days of digital printing technology, few would have suspected the impact that it would make on commercial lithographic printing. Conventional photobooks were typically produced in large print runs, involved expensive reprographic processes, and were well beyond the means of most photographers. Nowadays, the introduction of the digital press permits a photographer to run off just a single copy for less than $20.

Resolution

In traditional commercial litho printing, the subtle tones found within a photographic image are reproduced by tiny dots of printing ink of varying sizes. This dot screen is an optical illusion, which tries to mimic the continuous tone of a photograph without separating into areas of flat color. In practice,

there are many different kinds of screening patterns and dot sizes, both designed for use with specific printing papers, but the finer screens produce the most "photographic" results. Screen resolution for digital/litho printing is defined in the terms of lpi, whereas inkjet printers are rated by the number of ink droplets (dpi) sprayed onto printing paper. For digital printing, the resolution is normally between 150 and 180 lpi. Since digital printing requires two pixels to be provided for every printed dot, a screened image will typically have a resolution of 300 ppi. In broad terms, coarse uncoated printing papers such as newsprint can only cope with larger dots, but smooth-coated printed papers, as found in art books, can hold the finest of dots in place. The absorbency of the printing paper itself determines whether the dot of ink will remain a discreet size or whether it will spread into a slightly bigger shape than intended, a phenomenon called dot gain. This common problem found in litho printing is largely eliminated on the digital press by processing software.

In a typical on-demand operation, most book are designed using the providers free template-driven application. Once completed, the final documents (one for the insides and a separate document for the cover) are exported online as PDFs and can go through additional automatic processing before reaching the press. Unlike a typical photographer's workflow, where color can be managed from start to finish, there can be enormous gaps in the process, critical loopholes that could limit the quality of your final book. Some of the larger printing on-demand services will route your delivered files to a network of different output devices (some in other countries), making the entire process much less predictable.

Soft Proofing for On-Demand

Despite the fact that all inkjet paper manufacturers provide free ICC profiles to support photographers' quest for color accuracy, the same cannot be said about digital press manufacturers or book printers. With so many ink and paper variables in the commercial printing industry, this is hardly surprising, but there are some generic ICC profiles for the latest HP Indigo press models in existence, if you search the photoblogs for long enough.

A desktop preview of an RGB color image viewed without using Photoshop's soft-proofing functions.

The same file viewed in Photoshop, but under custom proof conditions, matched to an HP Indigo 5000 press. Notice the very different color reproduction.

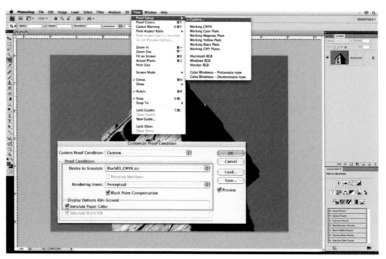

After loading the ICC profile into your system, open your image in Photoshop, then do a View > Proof Setup > Custom command. In the dialog box, choose your desired profile from the Device to Simulate pop-up menu; in this example, the Blurb B3 CMYK profile. Next, select the Perceptual rendering intent, plus Black Point Compensation and Simulate Paper white options. These three selections will present the closest possible recreation of the printed outcome on your screen. Before clicking out of the dialog, tick the tiny Preview option on and off, so you can see the difference between the soft proofed and the straight screen image. The current profile, which you are proofing with, will now be displayed across the image's top window bar.

There's really no point in adjusting the contrast of your image unless you soft proof it to your destination output device first. To maintain maximum flexibility and to avoid degrading your image, the soft proof effectively presents you with the worse case scenario straight away. Your task from that point onwards is to edit the file into visually better shape, and while the soft proof remains visible, you will always stay within the gamut of your chosen press/ink/paper combination. This example shows how a midtone red reproduces differently when soft proofed under a HP Indigo 5000 profile. The left half of the montage is seen without the soft-proof option, while the right half is viewed with the soft proof switched on. Notice, how the red is much more muted in the soft-proofed version.

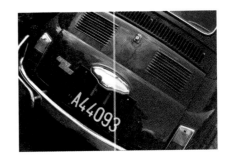

Color-Managed Service Providers

One of the better online booksellers and printers, Blurb.com offers plenty of tools to help you get your project off the ground. Based on the United States, Blurb provides a freely downloadable book-design application for both Mac and Windows, BookSmart, so you can lay out your content without any previous design experience. Fast to take advantage of early anxieties about print quality and color management, Blurb will launch their business-to-business book service, B3, this autumn in the United Kingdom. The service provides comprehensive color-management tools and reprographic advice, enabling professional photographers to exercise the same level of control over book production as they do over desktop inkjet output. In addition to advice and technical support, the service also provides ICC profiles, so you can soft proof and prepare your images with prior knowledge of their likely appearance on the printed page. The difference between this advanced service and the standard is just like the difference between a professional photolab and a one-hour photoprocessor but expect to pay a premium for this extra level of control. At the time of writing, Blurb adds approximately $10 per book for color-managed production and allow you offer both color-managed and noncolor-managed options to potential purchasers through your individual bookstore. B3's initial features include a bespoke color profile matched to their own presses, offering better color reproduction and shadow detail, accessible through a new feature called Custom Workflow. To back up these advanced features, Blurb offers a useful fast turnaround service for those last-minute professional jobs. The bespoke ICC profile provided for members of the B3 service is also effective for reproducing neutral black-and-white images with a CMYK inkset rather than unexpected color casts found in a noncolor-managed workflow. For this accurate black-and-white work, B3 is well on the way to becoming a GRACoL Certified Master Printer.

Photobook Software

Using BookSmart

BookSmart is a free application for designing your own photobooks, using simple templates and a straightforward drag-and-drop method of assembly. No desktop-publishing skills are required.

How BookSmart Works

Like many other on-demand printing services, Blurb offers their software, BookSmart, free to registered users. The application is available for both Mac and Windows PC users and is easily downloaded from the Blurb Web site. BookSmart is primarily aimed at nondesigners and is equipped with plenty of layout tools to help position both images and text. Once launched, BookSmart prompts you to choose the style and shape of your book, but like all other decisions made in the application, this is reversible at all times. BookSmart cleverly enables you to define your source images not only from a local disk or drive but also from your own online source like Flickr. When your source images are identified, they become visible in BookSmart and can be simply dragged and dropped into position on to your page layout. The book project is essentially divided into two components: the cover and the insides, and BookSmart allows you to add, move, and delete individual pages as you work. Each of the two components has a set of predesigned templates, which you can use to provide the layout grid for your book. With so many options to choose from, it pays to experiment with a few before committing to an overall style for your project.

The Cover Component

The most important part of any book is the cover design. BookSmart offers two kinds of book to design and purchase: the hardback with dust jacket and fold-around flaps and the simple paperback. This example, left, shows a hardback book-cover template in use, with images positioned on both rear cover (left half) and front cover (right half). Additional space is also made available on the fold-over flaps for more images and text, as this will be printed on a single sheet of paper on the digital press. BookSmart also allows you to use your computer's entire range of fonts rather than a restricted few, so you can deploy your creative talents to the full.

Ordering, Proofing, and Exporting

At the end of the design process, BookSmart creates a repro-ready file for online submission to Blurb, so you can order your book and place it on public sale. The ordering process is contained within BookSmart, so there's no need to open a separate web browser. Before this stage, you can also save the cover and the insides (but not both together) as PDFs, so you can make simple proof prints to check before ordering. BookSmart also allows you to save your project file through a File > Export command, creating a book format file that can only be reopened in BookSmart but offering you the flexibility to take your project to another workstation.

Assembling the Insides

BookSmart enables you to drag-and-drop your source images quickly into the page and create crops and rotations to improve the page composition. This example, right, shows a rectangular image that has been pasted into a square template. BookSmart allows you to position the image within this template, so you determine the exact point of cropping. Notice also the tiny horizontal thumbnails at the base of the window, describing the layout sequence in spreads.

Desktop Preview

With a mass of tools, panels, and window furniture surrounding your book design, it can be difficult to visualize the end result. BookSmart usefully provides a Preview mode, removing all editing tools from the desktop to help you contemplate your work in progress. In this example, right, the full-bleed image of a street sign looks much more effective when the template guides are removed.

Using Photoshop Layouts

There is no reason to restrict yourself to the use of template software; you can easily supplement it by using CS4 to generate artwork.

Reason 1: To Use Type Effects

Most template-based book-design software gives you access to your own individual font pack, as installed on your own workstation. This won't allow you to apply type effects to your images, but there are ways a round the problem. A great way of making your book covers stand out from the crowd is to apply a type effect in Photoshop, as shown left, and save the finished file as a high-quality JPEG for importing into your book project folder. Book covers, all start to look the same when you visit the bookstore pages of an on-demand provider like Blurb, so it's well worth spending time preparing your cover to look different. This example was created using Photoshop's Type Mask tool to copy and paste pixels into the type outline shape. Always use a thick, heavy-bodied font, preferably sans serif.

Reason 2: To Make a Montage

Multi-image layouts can look really effective, but most template applications provide only family-oriented examples that are not suitable for all subjects. A good reason for stepping outside the template software is to make use of Photoshop's layers and transparency techniques to make a unique montage image, which can then be imported into the template. The example shown left combines three different aspects of the same location, arranged in a way that would be impossible using template placeholders. Making composites like this also allows you to crop and transform images into the right shapes and to remove any unwanted areas. Always work at 300 ppi resolution when making montage pieces and scale down to the required repro size at the very end of your editing.

Reason 3: To Use Creative Edges

Creative edges can add a personalized touch to your layouts, mimicking
the look of a traditional album or journal. The example above was created
using the excellent OnOne PhotoFrame Pro 3 application, a Photoshop and
Photoshop Elements-compatible plug-in. The plug-in works by providing a
huge range of creative edge effects in a library, so you can present your image
with style. The edges can be used to further crop an image into a particular
shape, such as a square, or to assemble a multi-image layout for importation
into your book assembly application. Look out for the additional frame-like
edges that provide a simple way to make a personalized album-style layout.
Always apply your frames to a new layer in Photoshop to allow maximum
flexibility when blending and masking the results.

Glossary

A

Artifacts By-products of digital processing such as noise and JPEG compression, both of which will degrade image quality.

Aliasing Square pixels can't describe curved shapes, and when viewed in closeup, they look like a staircase. Antialiasing filters, found between the camera lens and image sensor, lessen the effects of aliasing by reducing contrast, which has to be put back during image processing.

C

CCD Stands for charge-coupled device. It is the light-sensitive "eye" of a scanner and "film" in a digital camera.

Clipping Clipping occurs when image tone close to highlight and shadow is converted to pure white or black during scanning or exposure in camera. Loss of detail occurs.

CMYK Image Mode Stands for cyan, magenta, yellow, and black (called K so it is not confused with blue). It is an image mode used for litho reproduction. All magazines are printed with CMYK inks.

Color Space RGB, CMYK, and LAB are all kinds of different color spaces, with their own unique characteristic palettes but also limitations in their reproduction of color.

Compression Crunching digital data into smaller files is known as compression. Without physically reducing the pixel dimensions of an image, compression routine work by creating a smaller string of instructions to describe groups of pixels rather than individual ones.

Curves Curves are a versatile tool for adjusting contrast, color, and brightness by pulling or pushing a line from highlight to shadow.

D

Dithering A method of simulating complex colors or tones of gray using few color ingredients. Close together, dots of ink can give the illusion of new color.

Dropper Tools Pipette-like icons that allow you to define color selection and tonal limits such as highlight and shadows by directly clicking on parts of the image.

Dye Sublimation A kind of digital printer that uses a CMYK color infused dry ink sheet to pass color onto special printing paper.

DPOF Digital Print Order Format is a set of universal standards allowing you to specify printout options directly from a camera when connected to direct printing units such as Epson's Picture Mate range.

Duotone A duotone image is made from two different color channels, chosen from the color picker used to apply a tone to an image. It is used to create subtle toned monochrome images.

Driver A small software application that instructs a computer to operate an external peripheral such as a printer or scanner. Drivers are frequently updated but are usually available for free download.

Dynamic Range The measure of the brightness range in photographic materials and digital sensing devices. The higher the number, the greater the range. Professional scanners and media are able to display a full range from white to the deepest black.

F

File Extension The three- or four-letter/number code that appears at the end of a document name, preceded by a period—for example, landscape.tif. Extensions enable applications to identify file formats and enable cross-platform file transfer.

File Format Images can be created and saved in many different file formats such as JPEG, TIFF, or PSD. Formats are designed to let you to package images for purposes such as e-mail, printout, and web use. Not to be confused with disk formatting.

Fire Wire A fast data transfer system used on current computers, especially for digital video and high-resolution image files. Also known as IEEE1394.

G

Gamma The contrast of the midtone areas in a digital image.

Gamut Gamut is a description of the extent, or range, of a color palette used for the creation, display, or output of a digital image, used by Photoshop in the Gamma Warning control.

Grayscale Grayscale mode is used to save black-and-white images. There are 256 steps from black to white in a grayscale image, just enough to prevent banding to the human eye.

H

Highlight The brightest part of an image, represented by 255 on a 0–255 scale.

Histogram A graph that displays the range of tones present in a digital image as a series of vertical columns.

I

ICC The International Color Consortium was founded by major manufacturers to develop color standards and cross-platform systems.

Interpolation All digital images can be enlarged, or interpolated, by introducing new pixels to the bitmap grid. Interpolated images never have the same sharp qualities or color accuracy of original, noninterpolated images.

J

JPEG JPEG is an acronym for Joint Photographic Experts Group and is a universal kind of file format used for compressing images. Most digital cameras save images as JPEG files to make more efficient use of limited capacity memory cards.

L

Lab Image Mode A theoretical color space—i.e., not used by any hardware device—used for processing images.

Levels A common set of tools for controlling image brightness found in Adobe Photoshop and many other imaging applications. Levels can be used for setting highlight and shadow points and for correcting camera exposure errors.

M

Megapixel Megapixel is a measurement of how many pixels a digital camera can make. A bitmap image measuring 1800×1200 pixels contains 2.1 million pixels ($1800 \times 1200 = 2.1$ million), made by a 2.1 megapixel camera.

P

Pigment Inks A more lightfast inkset for inkjet printers, usually with a smaller color gamut than dye-based inksets. Used for producing prints for sale and for ensuring maximum longevity.

Pixel Taken from the words PICture ELement, a pixel is the building block of a digital image, like a single tile in a mosaic. Pixels are generally square in shape.

Profile The color reproduction characteristics of an input or output device. This is used by color-management software such as ColorSync to maintain color accuracy when moving images across computers and input/output devices.

R

RIP A raster image processor translates vector graphics into bitmaps for digital output. RIPs can be both hardware and software and are used on large format printers to maximize the use of consumables.

RGB Image Mode Red, Green, and Blue mode is used for color images. Each separate color has its own channel of 256 steps, and pixel color is derived from a mixture of these three ingredients.

S

Selection A fenced-off area created in an imaging application like Photoshop, which limits the effects of processing or manipulation.

Shadow The darkest part of an image, represented by 0 on the 0–255 scale.

Sharpening A processing filter that increases contrast between pixels to give the impression of greater image sharpness.

T

TFT Monitor Thin Film Transistor monitors are the flat panel type of computer screen.

TIFF A Tagged Image File Format is the most common cross-platform image type, used in industry. A layered variation also exists, but this is much less compatible.

U

Unsharp Mask This is the most sophisticated sharpening filter found in many applications.

USB Stands for Universal Serial Bus. This is a type of connector that allows easier setup of peripheral devices.

W

Whiteout In digital images, excessive light or overexposure causes whiteout. Unlike film, where detail can be coaxed out of overexposed negatives with careful printing, white pixels can never be modified to produce lurking detail.

Pictures

All photographic and illustrative images reproduced in this book are copyright Tim Daly.

Product images are reproduced courtesy of the following: Apple, Dell, Nikon, Tenba, Lyson, Adobe, Manfrotto, X-Rite, Epson, Canon, Polaroid, Moab, Breathing Color, Harman, Blurb.com, Lulu.com

Index